A
ROCKWELL PORTRAIT

An Intimate Biography

A ROCKWELL PORTRAIT

by Donald Walton

SHEED ANDREWS AND McMEEL, INC.
Subsidiary of Universal Press Syndicate
KANSAS CITY

First Printing, October 1978

Portions of chapter one were first published by the au-
thor in the *Franklin Mint Almanac*. Reprinted by permis-
sion.
Excerpts from Norman Rockwell's interview in *Friends*
magazine, which appear in chapter nine, reprinted by
permission of *Friends* magazine and Ceco Publishing Co.

Library of Congress Cataloging in Publication Data

Walton, Donald
 A Rockwell portrait.

 1. Rockwell, Norman, 1894– 2. Painters—United
States—Biography. I. Title.
ND237.R68W34 759.13 [B] 78-13076
ISBN 0-8362-6602-1

Contents

NORMAN ROCKWELL
STOCKBRIDGE
MASSACHUSETTS

January 19, 1978

 Donald Walton has been a collaborator of mine for many years. He has given generously of his time, advice and encouragement. Our happy professional relations have led to personal friendship, and I send warm best wishes for the success of this book.

Norman Rockwell

*Note: The final manuscript for this book was not reviewed by Rockwell prior to typesetting—his illness precluded such a chore—nor was it edited by his family. This interpretation of Rockwell's life is the author's alone.—*D.W.

1

"Some people have been kind enough to call me a fine artist. I've always called myself an illustrator. I'm not sure what the difference is. All I know is that whatever type of work I do, I try to give it my very best. Art has been my life."

Artist Extraordinary

Everyone is familiar with the art of Norman Rockwell. *Life* magazine once estimated that his pictures have been seen by more people than all of Michelangelo's, Rembrandt's, and Picasso's put together.

But few people really know very much about the *man* behind those paintings. That's a shame. Because he is a fascinating character—a rare human being with all the warmth and gentle humor and understanding that shines forth from his pictures. Through a storybook life filled with a full share of heartbreaks as well as joys, he has gathered the wisdom to look inside us at our dreams and trepidations. Yet through all the years, he has never lost his naive, childlike wonder and trust. The world may be wicked. We may be mean. Storm clouds may loom ominously overhead. But Norman Rockwell prefers to look past those perturbations and remind us that the sky will brighten, a bird will

sing, the wind will rustle the leaves of the maple tree, and the beauty of it all will tear at our hearts.

How can there be such a person in this day and age? Especially one who is worldly-wise, who has traveled everywhere, known the great and powerful, seen it all? How could a man who came from an obscure and unhappy background to become perhaps the most famous artist in all the world remain unspoiled by it all?

Those are some of the questions people ask about Norman Rockwell. When they find out that I have known him well for many years, they also ask many other things. They want to know how he lives, what he does, where he goes, what his family is like, all about his wife, Molly. The questions are endless—and often very hard to answer in just a few words. Because Norman Rockwell, despite his unaffectedness and the apparent simplicity of his life in the little town of Stockbridge, is quite a complex personality—an enigma in many ways.

My first contacts with the enigma that is Rockwell go back to a period—perhaps difficult for many to recall now—when his visibility in the public eye had ebbed a bit. This was at the very end of the 1960s. No longer was there a *Saturday Evening Post* for which to paint cover pictures. Most other magazines and most advertisers had forsaken painted illustrations in favor of photographic art. Of course, for a man then seventy-five years old, Rockwell was not exactly in retirement; he had all the portrait assignments he wanted, along with calendars and an occasional big painting for *Look*. But compared with the hectically busy old days, things were a bit too quiet to suit him.

Then, in 1969, it seemed as if one of his lifelong dreams would come to pass—he might finally be accepted by the art experts in his home town, New York City, as a really outstanding artist. After a spectacularly successful career of about *sixty years*, he was at long last slated to have his first one-man show in Manhattan, at Dannenberg Galleries, in the heart of art row on upper Madison Avenue.

I watched the results of that show closely with a professional eye. As director of fine arts at the Franklin Mint, I was searching for the ideal artist to help us create a new kind of collectible which could start our company on a broader path—from the

traditional medals, which is all we had made up until that time, into other, more art-oriented objects. Norman Rockwell was at the top of my list of candidates as the American artist with the greatest appeal and the talent to pull off such a very difficult assignment.

The reviews he received from the critics who attended his one-man show scarcely supported that assessment. Harold Rosenberg, art critic for the *New Yorker* magazine, tried to be gentle with a gentle old man who never put on pretensions with anyone. He said simply, "I find Rockwell's modesty very sound." Others were not so understanding or so restrained in their comments. None praised the show.

In referring to that show, Rockwell repeated an observation he has made many times about the art columnists, "I could never be satisfied with just the approval of the critics, and, boy, I've certainly had to be satisfied without it."

But there were plenty of dissenters to the critical assessment of the reviewers, who, after all, make their living by writing sharp and sophisticated witticisms about the canvases they deign to view. Like nearly all of Rockwell's efforts, the show was a huge popular success. Most of the nearly fifty paintings assembled there were sold instantly at the preview party held the evening before the regular opening of the exhibition. It was a million-dollar sale. And the excitement stirred up by that first mass showing of Norman Rockwell's works was to lead to a country-wide touring exhibition a couple of years later that would bring record crowds swarming to museums to appreciate the paintings of their best-loved artist.

My colleagues and I ignored the erudite analyses of the critics. We were more impressed with the general response and the feeling that Rockwell had undoubtedly created a special place for himself over the years as the folk artist of our country. And we also felt that many people who had pleasant, nostalgic memories of the magazine covers he had painted years ago might now like to see some new art of his created in a more enduring medium—something like silver—which they could purchase and treasure in their own homes. I was given the green light to contact Norman Rockwell and to persuade him, if I could, to accept a commission

to create a series of drawings which the Franklin Mint would etch into a series of silver collectors' plates.

I managed to get Mr. Rockwell on the telephone and convey some idea of what I had in mind. That brief, long-distance description did little to convince him that he should take on our project, but he did agree a bit reluctantly to see me if I insisted on coming all the way from Philadelphia to Stockbridge, Massachusetts, to explain our plans more fully. And so I set out to meet the man who was not only a universally known artist, but also a folk hero of sorts to many of his countrymen—as his friend Bob Hope so aptly observed in a letter to me, "He's the *Mark Twain* of American art."

I'll never forget the first time I came face to face with Norman Rockwell. After staying the previous night in the echoing emptiness of the historic Red Lion Inn, nearly devoid of guests on that wintry, off-season date, I showed up promptly at 9:00 A.M. at the big, white, century-old Rockwell house, as agreed upon. There was no one visible there when I arrived, so I headed back to the converted carriage house in the back which serves as his studio. At the small door at the side, I studied the sign which reads "Artist at work. Please do not disturb." Noting the bell and chain beside, I yanked the chain and set the whole bouncy contraption to jangling loudly.

The door soon opened, and there he was, just as I had always pictured him. Silvery hair and craggy face with a pleasant expression. Khaki shirt open at the collar under a paint-stained blue jacket, a debonair silk cravat at the neck. Chino pants and canvas sneakers. Certainly not a fancy outfit, but just right on Norman Rockwell.

Finally facing the real, live Norman Rockwell, I must have been gawking. It was like coming suddenly upon a mythical character you had heard much about, but never really expected to meet. I was at a loss for words for a moment. Until he took the pipe out of his mouth and said hello in a questioning tone, but with a smile that took the edge off my apprehension.

When I had introduced myself, Mr. Rockwell shook hands warmly and invited me inside. His friendliness and totally unpre-

L. LAMONE

Ready to start the day's work, Norman Rockwell enters his studio, an old carriage house which he completely rebuilt inside.

Built in the late 1700s, the main section of the Rockwell home is a "four square" design. The smaller wing was added later. The studio is back in the spacious yard.

tentious air instantly made me feel a little better about my uncertain mission.

Right then, I got my first sample of what a kind and sensitive man Norman Rockwell is. I was a stranger, and at that point I don't think he expected there was much likelihood that he'd want to accept a commission from me or my company. But he sensed I was ill at ease, so he did his best to make me feel relaxed and at home. Relighting his pipe—which he does about every ten minutes—he began to show me around his studio. I saw scores of trophies, awards, and letters from notable personages on the walls. I learned something about many of the colorful mementos and knickknacks—all of which had a story behind them. We

talked about people he had known, painters we both admired. About everything, it seemed, but the business I had come to discuss.

I began to wonder if he was avoiding the subject, though I knew he was sizing me up during all that time. Later I was to realize that Norman Rockwell doesn't do business with anyone unless he feels he can work compatibly with them—he doesn't have to. But we had been chatting for more than an hour, and I knew better than to conclude that he ordinarily spent so much time in idle conversation. No artist as busy as he could afford to waste such a big chunk of his working day.

Finally he said, "I think I might like to do something on that project you mentioned. Maybe. But only if I can be sure I'll have to work only with you—just one man. I won't talk to any committees. No, sir, that's a mess! I tried that just once, and never again." When I had assured him that he'd not be subjected to any big-company committee machinations, he continued, "Okay, tell me some more about what you have in mind."

Breathing a sigh of relief at that, I began outlining some ideas my colleagues and I hoped he'd work on. They seemed to intrigue him. Rockwell sat down at his drawing board and invited me to pull up a chair beside him. He began to sketch various ideas as we discussed them. It was fascinating to see how quickly a thought either of us voiced took shape in small, rough, pencil sketches on the tissue layout pad—thumbnail sketches, as artists often call them. One sheet after another became filled with these miniature drawings as Rockwell changed an idea into several different forms. Or took off in an entirely new direction.

We both forgot about time until the studio door opened. The attractive, silver-haired lady who entered was pleasant but firm. "It's time for your nap, Norman," she told him.

I was introduced to Mrs. Rockwell, whom I was later to know as Molly. She told me it was her custom to come to the studio punctually at 11:00 A.M. every day to make sure her husband stopped work in time to get a brief nap before lunch. "He's liable to work right through without eating if someone doesn't remind him that it's time to rest," she laughed.

Mr. Rockwell promised his wife that he'd be right over to the

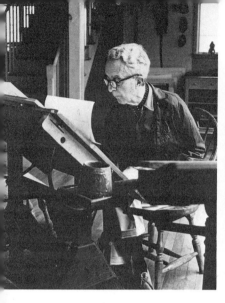

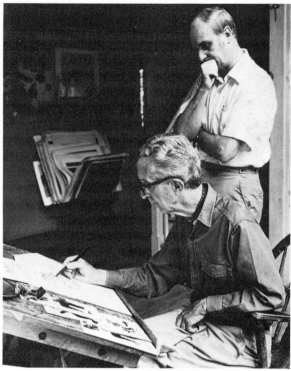

At top, the man at work is as neat as his studio. Note the ascot, which he almost invariably wears, and his painting jacket. At right, Walton ponders over a Rockwell pen-and-ink sketch for one of more than eighty projects on which the two collaborated.

PHOTOS BY L. LAMONE

A nap before lunch on the couch in the studio helps an octogenarian through a long day's painting. His pipe rests briefly, too, on the footstool.

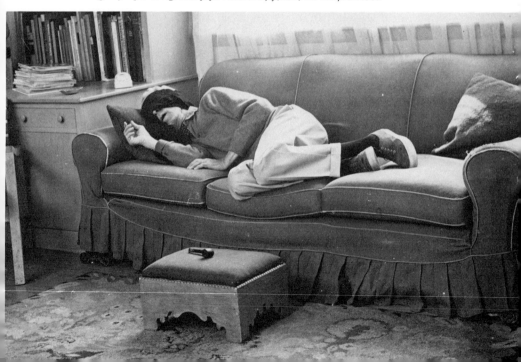

house, so she headed out the door with a parting, "Don't forget, now!"

Mr. Rockwell explained to me that he regularly takes a short nap before lunch. "Getting old," he commented. Then, he continued, after lunch he and his wife would go for their daily bicycle ride. "Just a short one—about five miles." I was invited to come back to the studio at 1:30 P.M.

In the afternoon Mr. Rockwell resumed his sketching. We talked about a few more possible designs. Finally we went back over the whole pile of sketches and picked out a couple we both liked especially well. It was agreed that I should take these back with me to discuss with some of my colleagues so we could decide on the first choice before Rockwell made the finished design.

As I packed up my briefcase a few minutes later, I reflected that this really had been a momentous day. Not only had America's best-loved artist agreed to work on our project, but he had already developed some excellent idea sketches for it.

When I was ready to go, I shook hands again as we settled the date for our next meeting. "I'm so glad you decided to accept this commission, Mr. Rockwell. And I'm delighted that you started on it immediately," I told him.

"Gee, it was my pleasure," he replied. "Very interesting for an old duffer like me to try his hand at something new. If I don't do that once in a while, I might just turn into a fossil, you know!" He laughed at his own joke and tilted his head back as he blew a cloud of pipe smoke toward the high ceiling of the studio.

"And, say, please call me Norman, won't you? I hate to be formal if we're going to be working together."

So Norman it was from then on. And we did work together closely in the following months and years. The project we started that first day ended up as a sterling silver Christmas plate etched with a Rockwell scene of a boy and his father bringing home the tree. It was a new kind of collectible, and it proved to be so popular and attracted so many imitators that it practically started a new industry. Naturally, we were pleased with the success of that first venture, and it led to many more with Rockwell—not just more silver plates, but also several sets of medals, plaques, two big paintings, designs for ten porcelain

sculptures, a series of crystal plates. In all, there were more than eighty individual creations over the years.

All those projects required a lot of consultation, so much that I began to regard Stockbridge almost as a second home. During certain periods I'd be running back and forth from Philadelphia to Rockwell's studio almost weekly to work with him on preliminary idea sketches, model posing, finished art, publicity and promotion photos, and articles for our collector magazine. I even helped to direct two short public relations movies about Rockwell, one of which won the gold medal award for documentaries at both the New York Film Festival and the International Film Festival.

With each succeeding trip, I got to know the town and its people a little better, which also gave me some added insight into its leading citizen, Norman Rockwell. Everyone in Stockbridge is his friend—the people at the hotel, the fireman, the policeman, the owner of the grocery store, everyone he passes as he goes bicycling down the road.

Norman puts them in his paintings because he knows them and likes them. And when he visualizes a new painting or an etching or a drawing, he names the people who should be in the scene. "George at the gas station would be just right for this character. His cousin Elsie should be in the scene, too. And Jimmie, who lives down the street, would be great for one of the kids." You know that he can see them perfectly in his mind's eye, and he paints them perfectly, too.

Observing Rockwell's close and warm relationship with the people of his town was certainly an eye-opener to someone from the impersonal world of the city. He seemed to be regarded not just as an honored citizen, but almost like everybody's favorite uncle. That this view of Norman Rockwell extends far beyond the limits of Stockbridge became increasingly evident to me every time I visited his studio. I was expecially intrigued by the constant deluge of mail addressed to him. He receives long, personal letters from all over the country, from people of all ages. Yes, even the young folks, who never knew the simpler and supposedly happier days he depicts, respond to the nostalgia and identify with him. In the plastic and not always pleasant world we live in,

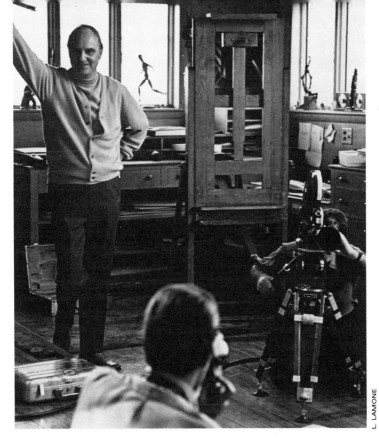

Moviemakers with their cameras and cables take over the studio as they get ready to make a film of Rockwell. Walton directs.

it is obviously reassuring to share with him his affectionate views of an earlier time. Norman Rockwell has become a symbol of all that is right with America—an unchanging figure with a pipe in his mouth and a paintbrush in his hand, comforting to have around.

Of course, that simplistic view of the man does not do justice to someone with so many facets to his background and character. Gradually over the years, I became aware of more and more of them—such things as the little-boy devilishness that is still in him; the mistakes he makes and the lengths he then goes to in order to wriggle out of them; his complete lack of pretense and

dislike of phoniness. I learned about the many ups and downs of his personal life, and of his career, in the long, eight-decade journey from the West Side of New York City to the open spaces of the Berkshires, interspersed with numerous jaunts to the far corners of the world.

Besides getting Rockwell to reminisce occasionally about himself, it was easy to start him talking about his creations. This covered not just the projects we were engaged in, but all sorts of other works past and present, particularly those other commissions he always had on his easel in various stages of completion, for he likes to have several things going at once. We'd discuss his current projects at length. He'd explain what he was trying to do, point out problems he was running into and solutions he was trying to develop.

The important thing in these discussions was not so much the technique of his painting and drawings as what he was trying to put into them. On each visit to Stockbridge, I felt that I got just a little bit closer to understanding the man, his background, his family, and way of thinking—all those elements in which art is rooted.

When I said to Norman and Molly that the story of it all ought to be told and that I'd like to attempt the telling, they were delighted. They opened to me both their memories and a treasure of photographs, including scores which have never been seen by anyone outside the family.

Particularly they hoped that this book might lay to rest the view, too often held, that Norman Rockwell is some sort of historical character who hasn't done much or changed much in a generation—a two-dimensional cardboard figure standing in a corner gathering dust. It is no wonder that this particular image confuses the Rockwells, for he entered his eighties still at work every day, including Sundays and holidays, and still one of the most sought-after artists anywhere. Both Norman and Molly are the sort of young-at-heart individuals who would rather look forward than backward. He summed up their attitude a few years ago, when he turned eighty, by jetting out of town to a secluded Caribbean island to avoid all the fuss and congratulations. Before scooting away, he said to me, "To hell with birthdays!"

It is not easy to get any sort of definitive perspective on Norman Rockwell. The task is like trying to size up a person in one of those amusement park mirrors. You see a different man at every glance, because he has been so many disparate things: a city boy, a country gentleman, widely read and astute, a high-school dropout, devoted family man, bon vivant, swinger, and recluse. He is also, of course, a fine artist of rare skill, an illustrator who has often squandered his talents on the most pedestrian of assignments, the all-time, number-one magazine cover artist, and perhaps the most sought-after portraitist of our century. Contumacious; a diffident sort of person, never altogether sure of himself and always anxious to please; not afraid to look a president or a dictator in the eye and set him straight; a traditionalist, recalling an idyllic past; young in viewpoint and always intensely interested in the latest events; proud, but yet humble; Norman Rockwell is all of these—and he is tired, very tired, but so driven that he cannot rest.

A person eminently qualified to understand Norman Rockwell, if anyone really can, is Erik Erikson. He is a world-renowned expert at such analyses. *Time* magazine, in March of 1975 in a lengthy review of one of the many books he has written, called him "probably the most influential living psychoanalyst." When I learned from townspeople in Stockbridge that he had put a great deal of thought into trying to figure out "what makes Norman Rockwell run," I contacted him.

Dr. Erikson is now in semiretirement in Tiburon, California, but he lived for years in Stockbridge, where he not only became a close friend of Norman's but also gave him professional advice at the famed Austin Riggs Center, a psychiatric clinic there. Dr. Erikson could, of course, not comment on any of the personal roots of the bouts of depression which occasionally bothered Rockwell, but he was pleased to enlighten me on some of the general problems such an artist faces.

He explained that artists like Rockwell who are very serious and intense about their work often tend to be greatly worried by the fact that they can never be quite sure of what they are doing. They depend on a mysterious creative process to produce something they can never be certain of until it is finished. Until that

moment of completion, and maybe even afterwards, they worry that it should have been better.

Even if their work is going well and they produce one highly successful picture after another, that too creates a tension. The very fact of always riding on success becomes more than they can handle. They must work themselves up to a driving sort of exhilaration during the creation of each new work of art, and they simply can't hold that peak all the time. It becomes unbearable.

Dr. Erikson likened the creative process for someone like Rockwell to the creative cycle a woman goes through when she has a baby. After the hard, painful process of creation and the exhilaration that comes with its successful completion, she may experience a down period, the so-called postpartum depression. So may an artist who has been involved for a long period in producing one or a series of paintings that have absorbed him completely. Whether he likes it or not, his body and mind demand a rest.

Dr. Erikson also pointed out some things I was already well aware of—that Norman Rockwell is a complex individual; that he really is not a folksy man at all, as he is so often perceived and described, but a very private person. He observed that Rockwell's personality is well suited for illustrating life as he does since he is extremely sensitive to the nuances of life and perceptive of all that goes on around him. He is also extremely sensitive to how people like to be seen—a prime requisite for a portrait painter.

Dr. Erikson ventured another comment, one which I think does more to explain my friend Rockwell than any other observation I have ever heard. The doctor referred to the fact that America's best-loved artist has not had a very happy life. Then he speculated, "Perhaps that is why Norman Rockwell aims constantly to put so much happiness into his paintings, to be enjoyed by himself as well as by others. *Perhaps he has created his own happiness.*"

2

"Some folks think I painted Lincoln from life, but I haven't been around that long. Not quite."

In the Beginning

An artist like Norman Rockwell doesn't just happen. It's easy to recognize that in addition to his God-given talent, many decades of study and painstaking labor were required to perfect his skill. Even more important, it took a lot of living, with heartache as well as joy, to develop the sensitivity that sets his work apart. The deft hand is merely the recorder for the perceptive eye and the understanding heart.

The story of how Norman Rockwell developed his rare perception and understanding begins quite a long time ago, so long ago, in fact, that the length of his career alone makes him something of an oddity. He has had more than eight decades in which to learn things about art, life, and his beloved countrymen. For six of those decades he has been one of the most famous of painters.

During that lengthy span, he has seen the march of many wars, been swept time and again through cycles of boom and bust, lived in the biggest cities and quietest hamlets, traveled everywhere, puffed his pipe at everyone from presidents to Tibetan peasants, painted them all. Although he is as much a part of our day as his friends the astronauts, he also belongs to another century. His beginnings go back to 1894.

The world was a far different place then. A young mechanic named Henry Ford was just beginning to make horseless carriages in a little garage in Detroit, and Tom Edison was fooling around with something called "moving pictures." The great land rush out West had just poured homesteaders into the empty Cherokee Strip south of Kansas. In 1894 the first sizable hydroelectric power plant ever built was completed at Niagara Falls. The Sino-Japanese War over Korea began. Grover Cleveland, president of the United States, recognized the Republic of Hawaii. Congress decided to make Labor Day a legal holiday.

It was a time of uncertainty and trouble. There were strikes and riots throughout our country. Coxey's Army marched on Washington to demonstrate the plight of the unemployed. The effects of a stock market crash persisted. A 2 percent income tax was levied on wealthy individuals—a move labeled "communistic, socialistic." The U.S. Treasury was trying desperately, but unsuccessfully, to replenish our dwindling gold reserves. Many things were different then; some basics never seem to change much.

What must it have been like to be a boy then, back before the turn of the century, in an era named after Victoria, who reigned as queen of England and arbiter of fashions and mores? Fortunately, Rockwell himself was still able to provide some of the answers.

There were many talks about it out at the studio after we had finished our day's work together. While I sat on the cushioned seats below the huge north window or on the sofa at the other side of the broad room, Norman always settled himself down in his painting chair in front of the big easel. He had to be there even if he didn't have a brush in his hand.

After restuffing and lighting his pipe, usually a favorite old briar, his eyes would narrow as he silently carried himself back, digging through the rich alluvium of the years. Back past the days when the kids were little in Vermont. Beyond the early glories and the heartache in New Rochelle. Before the navy in World War I. Even earlier than Mamaroneck, when he was a skinny, awkward lad with strange ambitions. Way back to Manhattan in those distant days when there were still a few vacant lots on it.

This is his story as it was woven together from those many talks with him, and with his wife, Molly. Pieced together also from a thousand questions and many journeys to locate old next-door neighbors, former art directors, relatives and former in-laws, those few artists still around who knew him in the early days. Aided by the reading of every available book and article written about him—especially the articles by Rufus Jarman in the *New Yorker* in 1945 and the autobiography, *My Adventures as an Illustrator*, as told to Thomas Rockwell in 1958—as well as a stack of laboriously accumulated newspaper clippings several inches thick.

Norman Rockwell, noted painter of bucolic scenes, is really a hick from Manhattan. His earliest remembrances of green, open country are of the wooded lawns of Central Park. As a young boy he lived a couple of miles north of the park, and he recalls that he and his older brother would go there to spend an afternoon at baseball or playing at the lake, sometimes forgetfully remaining until after dusk and trudging back in the dark through the center of Harlem up Lenox or Eighth Avenue to St. Nicholas.

Actually, Rockwell was born just a couple of blocks west of Central Park in a fifth floor walk-up on Amsterdam Avenue at 103rd Street. That was on February 3, 1894.

The Rockwell family left that apartment when Norman was only two, so he has no memories of it. They moved to 147th Street near St. Nicholas, and then to a place just off 153rd on St. Nicholas. These moves farther uptown were considered improvements in the family situation, though the homes were far from sumptuous.

Both of the apartments where Norman spent his early boyhood were of the railroad type. Long and narrow, with no windows other than those in the front and back rooms, they were dark and ill ventilated. The only outstanding features he still remembers are that the apartment on St. Nicholas had two elm trees out in front, a rarity in that neighborhood, and a simulated fireplace in the parlor.

There were only two children in the family. The first son was the elder by about a year and a half. He was Jarvis, named after his father, Jarvis Waring Rockwell.

When the second son came along, he inherited a family name, too. It was one selected by Mrs. Rockwell. Nancy Hill Rockwell was inordinately proud of her English ancestry, and especially of one shining ornament on her family tree. This was an obscure nobleman who gained momentary notice when he kicked Guy Fawkes down the stairs of the Tower of London after Fawkes tried to blow up the House of Lords. This vicious-toed ancestor had been named Sir Norman Percevel. In his honor, the new baby was christened Norman Percevel Rockwell.

It was a name the boy came to hate. Throughout his childhood, his mother was forever telling him about Sir Norman. She always emphasized that ancestor's glorious surname, which had become her son's middle name. It was a most uncommon one, spelled with an *e*, not a plebeian *a* or *i*, she pointed out. But from an early age, the boy suspected that Percevel, or the inevitable Percy, would forever be regarded as a sissy appellation by his friends.

Mrs. Rockwell always insisted that her second son spell out all three of his illustrious names whenever he wrote his signature. As soon as he left home and ventured out on his own, however, Norman shortened the Percevel to a simple *P*. Then he dropped even the initial. Today he never uses anything but plain "Norman Rockwell," even on legal documents.

He told me that just shortening his middle name hadn't been enough. Some people had still asked what the *P* stood for, and then he was right back to Percevel. So he got rid of it entirely.

Although Nancy Rockwell liked to romanticize about the high-born ancestors of her mother, it was her father who interested young Norman. Grandfather Howard Hill was an artist who emigrated to America from England a short while after the Civil War and settled in Yonkers. Although Norman was fascinated by some of his grandfather's paintings, he certainly was never encouraged by his mother to follow in the old man's footsteps. Nancy despised her father—and all artists—because he had been a failure and, as Norman puts it, "a little on the alcoholic side."

When he came across the ocean, Norman's grandfather had dreams of opening a studio in the new land to win fame and wealth as a painter of portraits and landscapes. His portrait commissions proved to be few and far between. He did produce

some scenic oils which met with at least moderate success. Norman recounts that several of these were owned and displayed at the Union Square and Murray Hill hotels, which were two of the finest hostelries in all of New York at that time, so the pictures must have shown some professional competence.

Grandfather's steadiest production, though, was children. He sired twelve of them. The exigencies of trying to feed them all drove artist Hill not only to drink, but also to soliciting from door to door in order to peddle his paintings. He offered a variety of landscapes and animal pictures, and he sought all kinds of assignments, sometimes even including house painting.

Norman's paternal grandparents were people of much more substantial means. Grandfather Rockwell owned a coal business at Number One Battery Place, and his wife's family had accumulated some wealth as rug merchants in the Yonkers area. But although frequent allusions were made in the home to the gentility and prosperity of this side of the family, none of the money seems to have trickled down to Norman's father.

Mr. Rockwell is described by his son as "an old retainer" of a Philadelphia cotton textile mill for which he managed a New York branch office. "My father's salary was so small that he was ashamed of it, so he never told us how much it was. But I've never in my life seen anyone more devoted to a business firm," Norman says. Jarvis Waring Rockwell preferred to sign his name J. Waring, and generally was addressed as Waring. He was a dignified, handsome man with dark eyes and hair and a luxuriant but always well-trimmed mustache. Pictures show him with a rather long face, reminiscent of Norman's. He was quiet and cautious, as you'd expect of a man who spent all his life diligently serving a penny-pinching firm where he started as an office boy.

Staying strictly within the confines of proper conduct of those Victorian days, Mr. Rockwell never took his suit coat off in the presence of ladies. He never drank. He smoked cigars as was the habit of many gentlemen in that era. Sometimes he was stern with his two sons, and he was always distant. He treated them more like adults than children.

One custom he did observe, which pleased Norman, was reading aloud to the family as they gathered around the dining room

table before bedtime. During these reading sessions, Norman's active imagination would conjure up visions of the storybook characters as father's mellow baritone described them.

Life with mother was equally sedate. Nancy Rockwell was frequently ill and constantly complaining about it, though Norman does not fail to point out that she lived to be eighty-five. Her husband coddled her devotedly. Family life revolved around mother, resting on the couch with a cold towel on her head, while the rest of the members trod softly. On a Sunday night, if mother's headache wasn't too bad, the Rockwells might gather around the piano in the parlor and sing hymns.

Waring Rockwell, a vestryman in the Episcopal church, saw to it that his sons had little time that was not devoted either to their schoolwork or to some sort of church activity. The children were forbidden even to read the comics in the Sunday newspaper. The family regularly attended *all* services at Saint Luke's Episcopal Church and later at the Cathedral of Saint John the Divine. Norman was a choirboy at both these congregations. At the cathedral, this entailed singing at four services each Sunday. With three mid-week rehearsals, plus a dress rehearsal on Friday evening, this occupied most of the time not already taken up with school homework. Norman developed an aversion to church activities in those early years which still persists. He says churches are fine for anyone who wants to go. His wife, Molly, attends regularly, but he simply won't.

Outside the home, the Rockwell boys found themselves in not quite so circumspect an environment. "It was a pretty rough neighborhood where I grew up," Norman remembers. "There were gang fights around there sometimes, though not with knives and guns like today. The really tough places were over around Third Avenue where it ran into the Harlem River, but we weren't far away."

One out-of-bounds devilment the boys enjoyed was to sneak up the narrow stairs onto the rooftop of their apartment building. There they would lean precariously over the wall of the roof to spit down on pedestrians several floors below or to toss stones at their buddies playing in the street.

There was a saloon on the corner—a place of dark mysteries

which the teetotaling Rockwells warned Norman and Jarvis not to go near. Naturally the boys peeked inside every time they crossed that corner. The only harm they met there was a few whacks on the skull, because they and their friends would squat down on either side of the doorway to stick their curious little heads under the swinging doors. They never did find out much about the new evils they weren't supposed to see; drunks were no novelty in that neighborhood.

Another spot the boys couldn't resist was the firehouse. They'd stand around there for hours, watching the men on duty polish and repolish the beautiful, gleaming red wagons. On those wonderful occasions when a fire broke out in the neighborhood, all the kids would get excited as pups at a picnic when they heard the first clangings of the bell. They'd dash outside to watch the mighty pumper come tearing hellbent down the cobblestones. It was a pleasantly terrifying sight as the powerful horses plunged past with the big engine bouncing behind them, spewing sparks from the boiler. Throughout his life, Norman couldn't go past a fire station without wanting to pause and look inside.

The neighborhood had an abundance of children in it, so there were always plenty of games going on. The streets and alleys, as well as the sidewalks, served as the playgrounds. If you were a good athlete you could always get into a game of one-old-cat or tag or touch football. Jarvis, superb in all sports, was a top choice for any team. Little brother tagged along after him, but he soon learned that no one wanted to be bothered with a pigeon-toed youngster who was the slowest runner on the block. At a very early age he began to tend toward more sedentary forms of entertainment.

He discovered what he liked best by watching his father dabble with a pencil and sketchpad. A dilettante artist, Mr. Rockwell would find an illustration that appealed to him in a magazine and then would attempt to make a similar sketch. When little Norman tried to mimic him, father was pleased and tried to show the boy some of the rudiments of drawing. It became a common occurrence for the two of them to spend an evening sitting side by side at the dining-room table as they penciled away at some simple scene from *Leslie's Weekly* or *Harper's Weekly*.

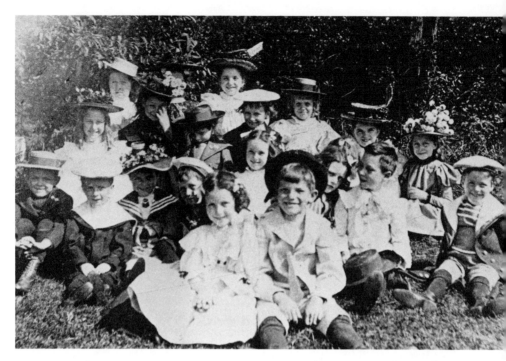

Little Norman Rockwell (second from left in second row) enjoys a picnic with friends. He is about four years old. Like several of the other little boys, he wears the flat-topped sailor hat and white middy blouse so popular in those days.

One of Norman's earliest recollections is of making drawings of warships at the time of the Spanish-American War. He must have been barely five years old at the time, because he remembers that this occurred after he and his family went downtown to witness a big victory parade for Admiral Dewey. There were bands playing, people cheering, and much excitement. All anyone could talk about then was the great naval victory at Manila Bay. That was in the spring of 1899. In photographs taken at about that time, Norman and his brother Jarvis wore the little sailor suits which became the standard uniform for every young boy in the United States in the wake of our naval victories in Cuba.

Norman became the marine artist of his peer group. Dewey's victory inspired many naval games among the young lads of his time. These involved moving miniature battle fleets around on

the floor. Since Norman and his friends lacked the funds to buy fancy metal ships like the rich kids uptown, they were reduced to using cardboard substitutes. Norman sketched these on pieces of cardboard, and then the boys cut them out and bent the edges to make them stand up. He was hard pressed for time to turn out enough of these ship drawings to keep himself and his pals supplied for all their make-believe battles. It may not have been the greatest end use for art, but at least it was appreciated.

He was often called upon too, he told me, to sketch various objects on the sidewalk with chalk for the amusement of his friends. "Draw a horse," they'd beg him. "Draw a soldier, an automobile, a dog." And he'd oblige. It was one skill for which he was recognized. Not in the same class as being able to slam a baseball a mile, but for the ungainly, unathletic boy, it was a means of belonging.

Young Norman's progress at drawing was enhanced by another mutuality of interest with his father. Mr. Rockwell liked to read aloud to the family in the evenings. A favorite author of father and son was Charles Dickens. Artist Norman Rockwell remembers that one of the first pictures he ever drew was of Mr. Micawber, whom he visualized as his father read Dickens's description of that likable character from *David Copperfield*. During the nightly reading sessions, Norman's active imagination would also conjure up visions of Tiny Tim, Bob Cratchit, Little Nell, Oliver Twist, and others which the young draftsman would proceed to transform into penciled sketches.

In doing so, he took the big jump which made him something his father would never be, a true artist. He had gone beyond mere copying and was creating images in his own mind's eye. By listening to the stories and then drawing, he was in a sense teaching himself to be an illustrator of books.

Besides the examples of his father, Norman began to notice the paintings of Grandfather Hill which decorated several of the apartment walls. These included some of his animal pictures, which were notable for the extreme detail he meticulously painted into them. The little boy must have looked at these as examples of how a real artist should create.

Norman says, "I'm sure all the detail in my grandfather's

Two drawings by Norman's father—one in pencil (above) and a small pen-and-ink (at right). J. Waring Rockwell first inspired his young son to become an artist when the two of them would copy illustrations from magazines. It wasn't long, however, until the lad moved beyond mere copying and began to use his vivid imagination to create new pictures of his own, based on the stories of Charles Dickens and other authors he admired.

Another treasured picture Norman Rockwell proudly displays on his studio wall is this painting by his grandfather, Howard Hill. A small oil executed with extreme detail, it is one of many pictures by the first professional artist in the family, who undoubtedly influenced Norman's meticulous style.

pictures had something to do with the way I've always painted. Right from the beginning, I always strived to capture everything I saw as completely as possible. It has influenced me ever since."

Many of Grandfather Hill's paintings were landscapes, either of the English countryside where he grew up or of imagined scenes of forests and lakes. His young grandson loved to study them and to fantasize about such faraway places and about others he would like to see someday—the streets of London that Dickens had written about, the American West that a journalist-illustrator named Frederic Remington pictured in the magazines, some of the strange lands that Howard Pyle painted for his story illustrations.

His world was at that time circumscribed mostly by the immediate neighborhood or environs that he and Jarvis could walk to. Occasionally the family would travel the few miles north to Yonkers to visit an aunt, though the boys never looked forward to those trips especially. What they did enjoy and regard as a safari to distant parts was a trolley ride, which was then a popular and economical form of family recreation. You could ride all the way from the Battery to the Bronx and back for a dime per person, getting a chance to cool off on a hot summer's evening or Sunday afternoon, as well as seeing the sights.

The boys' favorite seat on the trolley was directly behind the motorman. There they could watch that skillful pilot deftly manipulate the power handle and brake to squeeze the last ounce of speed from the clattering contraption, while they speculated on the possibility that the rocketing vehicle might hit a curve too fast and jump the track—as they had heard could happen.

During the last part of the run, out in the far Bronx, the stops were few and far between. It was a different world there. Neat houses icicled with white gingerbread fretwork around porches and eaves. Trees and brooks and spacious lawns. Even an occasional confetti of cows on a hillside. And at the end of the line, where the motorman and conductor turned the car around, a small park where the passengers could walk around a bit or enjoy a picnic supper on the tables provided for that purpose. Norman could have stayed there forever.

His love for the open, green country was shared by the rest of

the family. They began to spend a few weeks each summer at farms which boarded vacationers from the city. These were nothing like the huge, elaborate resorts that dot the Catskills or Poconos today. They were simply working farms with large houses. Rooms were let to those who expected no more than a place to stay in a rural setting with clean accommodations and wholesome food.

At these resort farms, the adults enjoyed games such as croquet or merely strolled about or rocked on the wide veranda. The children were left to find their own amusements. Norman found plenty to do. He could fish, swim, catch turtles, snakes, and frogs. There were woods and fields to explore. Visiting the barns was fun. And the farmers were willing to let their young guests help with such chores as feeding the chickens or brushing the horses.

A summer vacation on a farm always included hayrides. Norman (in back row at the right) loved his brief, annual trips away from the city. When he moved to Vermont several decades later, he adapted quickly to rural life.

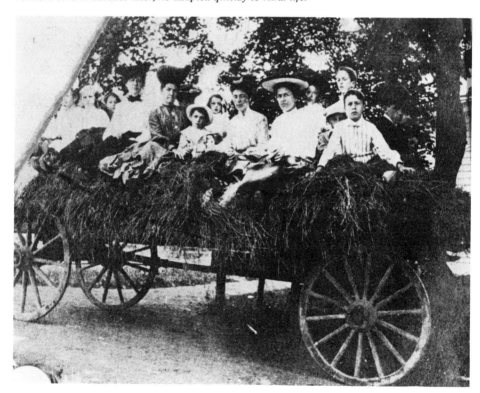

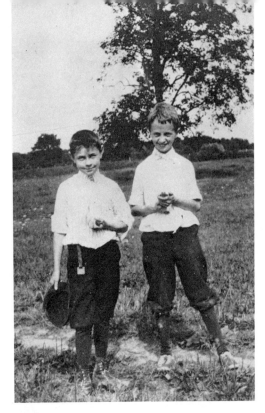

*Out hunting toads in the fields of a vacation farm,
Norman (at right) and friend show their catch.*

Those happy interludes during the summers left many
memories: days spent at the old swimming hole back in the
woods; barefoot walks across fields of stubble; hayrides with
children and grownups alike packed together in the sweet-
smelling hay while the horses trotted along and everyone sang
the popular songs of the day; afternoons spent lying in the tall
grass of the meadow, daydreaming. The memories of those days
never faded; they came to life again years later in paintings on the
covers of magazines.

One of the most important events of Norman's life occurred in
1903, when he was nine years old. The Rockwells moved to a
house in Mamaroneck, New York. This was far out of the city at
that time—on the road to Connecticut along Long Island Sound.

Just beyond the Bronx and New Rochelle, this section is jammed solid with houses nowadays, but seventy years ago it represented an almost rural setting, which Norman loved. A pleasant contrast with what he has called "the cold world of the city." At last he had the breathing room that his personality needed so much.

Always a quiet boy, Norman became more withdrawn as he grew older. He was what people of that day called puny. His mother and aunts used to refer to him as "Snow in the Face" because his complexion was so pale. He had spindly legs, narrow shoulders, a prominent Adam's apple, and rather curly, dark reddish brown hair. Then as now he was pigeon-toed. To try to correct this condition, his parents fitted him out in heavy orthopedic shoes when he was ten years old. He had always been about as agile as a penguin on rough ground. The new shoes only made him walk more clumsily, and just about put an end to all athletic activities.

"I never could run very fast," Rockwell explains, "but when I got those clumsy shoes to wear, that did it! After that, I didn't try very much anymore to keep up with the other kids. The shoes didn't do any good, of course. I'm still about as pigeon-toed as you can get. But I learned to manage pretty well on a bike. Should have had a bicycle then, when I was a kid, but our family didn't have the money for such luxuries. I saved up to buy one myself a few years later."

When he was twelve, Norman was fitted with glasses. This detracted even further from his chances for engaging in rough-and-tumble games and earned him a new nickname. They were a new type of glasses, big and round with black rims. The other boys in the neighborhood decided they looked like round moons around his eyes. They promptly began calling him Moony. The name stayed with him for years. The boy tried to ignore it, but he didn't like it.

The fact that Norman was always the fielder who stumbled and the batter who struck out was emphasized all the more by the way his brother starred at every game he tried. "Jarvis was the best athlete in the entire school," Norman states. "He was good at baseball, wrestling, gymnastics. He sure outshone me in everything."

But not in *everything*, really. The sketching that Norman had begun to engage in when he was only five years old grew more and more into a special ability that allowed him to excel. By the time he entered Mamaroneck High School, he knew that creating art was the one big thing he wanted to do in his life.

When he was supposed to be reading his textbooks in school, he was often busy instead "illuminating" the margins with intricate drawings of all kinds. Naturally, this didn't win him any high grades in the subjects he should have been studying. Surprisingly, though, it didn't even get him good grades in art classes, a fact that never fails to bring some loud, long chortles from Rockwell every time he recounts it. He used to get only seventies and seventy-fives in art throughout elementary school, he says. Why? "Probably because I'm not much good going by the book in anything I do," he guesses. But he did begin to gain some recognition for his drawing talents from one perceptive teacher.

Miss Smith, Norman's eighth-grade teacher, also saw that he wasn't drawing exactly as the lessons indicated he should. But she was smart enough to sense that there was little she or anyone else at Mamaroneck High could teach this shy, skinny teen-ager about what to do with a drawing pencil. Instead of trying to inhibit him, she encouraged him.

It was Miss Smith who gave Norman his first, and therefore his finest, one-man show. To decorate the classroom at Christmas time, she turned over all the blackboards to the young artist, gave him a box of colored chalks, and told him to go to it. Norman had a great time covering the walls with huge, colorful murals. The Christmas scenes not only gave him a chance to express himself on a grand scale, but also brought him many compliments from students and faculty. He needed that spur to his confidence. The Christmas display that year meant more to him than any show he has ever had since in the great galleries and museums of the world.

During that freshman year at Mamaroneck High, young Rockwell used some of the few dollars he had earned at odd chores to pay for lessons at an accredited art school. Every Saturday he commuted to New York to attend a class at the Chase School of Fine and Applied Art. This required a two-hour subway

ride each way, but it opened a new world to Norman.

Later that same year, 1908, he received permission from the principal of the high school to take off every Wednesday afternoon so that he could attend classes at Chase on that day as well as on Saturday. He was only fourteen, but already he thought about little else than a career in art.

This attitude received little support at home. Maybe a little from Father Waring, but none at all from Mother Nancy. She could never forget what it had meant in her childhood to have an unsuccessful painter as the erratic breadwinner of the household.

When Nancy Rockwell was a girl, even the children had been pressed into service to try to scratch out a living for the family. Along with his few portrait commissions, his animal pictures, and his shamefaced laboring at painting houses, Grandfather Hill had also *manufactured* a line of standardized scenes in oil. Norman says that the old man had his home organized "just like a sweatshop" to duplicate three or four popular scenes over and over, with no variations.

To do this, he stationed all his older children at a long table which served as the assembly line. Each was given a pot of color and one brush. Grandfather Hill would start a picture, painting only the central figure in it himself. Then he'd shove the canvas down the line so each of his helpers could in turn add other elements. For example, one child washed in a pale blue sky, another daubed some white clouds on it, a third spotted an orange sun near the top, a fourth might blue in a lake or river, a fifth would add waves or reflections on the water, and the sixth would scrub in a green ridge of trees along the shore. Because each worked with only one color, repeating the same simple thing time after time, the process was speedy and the results looked good enough for the few dollars Grandfather Hill was able to get for these pictures. With twelve children in the house, he always had plenty of free labor to draft.

Nancy Rockwell had been one of the little "elves" in this no-pay painting factory. To her the word *artist* conjured up not paintings or drawings, but the specter of poverty. She couldn't see her son entering such an impoverished field of work as she believed the art business to be. Far better to start off as an office boy in some

solid firm, as her husband, Waring, had done. "My mother thought I would end up dying of starvation in an attic," Rockwell told me, "but it didn't work out that way."

Norman had to earn his own tuition in order to attend art classes. He recalls: "My brother and I never got an allowance. Our family never had enough money for that. We'd go out and earn our spending money at odd jobs. I had to scrape up the tuition for art schools, or I couldn't have gone."

That summer, Norman was fortunate enough to add to his earnings by giving art lessons each Saturday. He had confided some of his financial problems to his minister. That sympathetic man was able to help, because a wealthy parishioner had just been asking him to recommend someone who could provide sketching instruction for her and a friend. The friend turned out to be Ethel Barrymore.

It proved to be a delightful job for the young man. His function was mostly one of escorting the two ladies on their Saturday outings to the beach. Norman would take them in a canoe out to some quiet spot along the Long Island Sound shoreline. Then he'd help them set up their easels. From there on, it was mostly a matter of looking wise and professional (not so easy at the age of fifteen) and making a few helpful comments from time to time as they applied watercolors to paper.

The young instructor would offer suggestions to his older students as their paintings progressed, but he admits he was so overcome by Miss Barrymore's glamour that he really didn't know what he was doing. After a couple of hours, the ladies would have finished their sketchy watercolors and would be ready for the light repast they had brought along in a wicker basket.

Those Saturday sessions with Miss Barrymore and her girlfriend out on the Sound were the start of Norman's never-ending love affair with the theater. Whenever he gets a commission to paint the portrait of a famous actor or actress, Rockwell drops everything else, like the star-struck fan he is.

Norman had a marvelous time in that first art teaching assignment and was well paid for his efforts in the bargain. More than thirty years later, he was to meet Ethel Barrymore again. This occurred in Hollywood, where he was arranging to paint a

Post cover of a group of movie stars. The cover never materialized, but Norman still has many photographs of the posing sessions. While this book was being put together, he reminisced about the photos and recounted how Miss Barrymore had remembered him.

"It was many years later—sometime in the 1940s I think—when I met Miss Barrymore again, to start that *Post* cover with her and the other movie stars. When we went out to take the photographs of her on the studio lot," Norman recalled, "the photographer and I had to wait for a while in a small room where he had the camera set up. People kept coming in. There was some kind of agent, her maid, and another woman who arranged her makeup. Then Ethel Barrymore swept into the room, like the grand lady she was. And she walked right over to me and said 'Why, it's Norman Rockwell. I remember you used to give me sketching lessons.' In that marvelous voice of hers, so deep and dramatic. There was no one else like her and still so beautiful. Golly, I was so thrilled to think that she still knew me after all those years. We talked about those days out on the Sound. It was great."

In the autumn of 1908, young Rockwell picked up another job, which led to his first art commission. He heard of an opening as a mailman, not as part of the regular postal service, but supplementing the delivery to some of the big summer homes at the edge of town. The regular U.S. postman didn't go that far with his route, so the wealthy residents were willing to pay a quarter a week to have a boy deliver their letters to them every day by bicycle.

Norman recalled that the job required him to get to the post office every morning at 7:00 A.M., when it opened. There he would pick up his customers' mail and bicycle it along to all the houses out at the Point on the shore. He would finish just in time to hurry on to school. Saturday was payday. When he picked up all his quarters then, he told me, he felt like a millionaire.

Naturally the boy became well acquainted with many of his customers on the route. One who often chatted with the lad and asked about his art studies was Mrs. Arnold Constable, the wife of a famous New York City merchant. That Christmas, she commis-

sioned the budding artist to design four Christmas cards, which she then had printed from his drawings.

As for the fee he was paid for his work, Rockwell recalls only that it seemed a fortune at the time, and he observes that it was far more generous than his experience or the results warranted. He would give anything now to find a copy of one of those cards which represented his first step into the ranks of professional artists.

3

"Everyone in those days expected that art students were wild, licentious characters. We didn't know how to be, but we sure were anxious to learn."

Teen-aged Artist

At fifteen, in the middle of his sophomore year, Norman Rockwell left high school altogether to become a full-time art student. He would shed his childish ways and soon, he hoped, put on the glittering panoply of a glamorous, famous artist. That was his one dream.

His decision to make an abrupt jump toward the adult world was prompted by the discovery of a new art school that he felt was just what he needed. For some time he had been bridling at the circumscribed and jejune atmosphere of the Chase School, which he had been attending a couple of days each week. He wanted a larger school with a broader scope in its staff and curriculum. He found it in the National Academy School, the biggest institution of its type in New York. Attendance there offered a certain prestige as well as the chance to select instruction from a wide choice of distinguished teachers.

Even more important to Norman was the fact that there was no tuition at this public academy. The little spare time he had for earning money wasn't putting enough jingle in his pocket to pay for train fare to Chase twice a week as well as the cost of class fees.

41

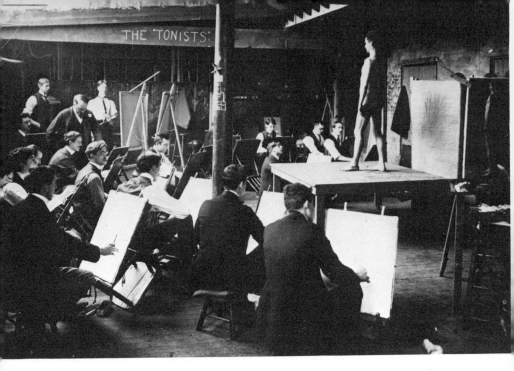

THE 'TONISTS'

A men's life-drawing class at the Chase School of Art in New York City in the era when Rockwell studied there. At fifteen, he left high school to become a Chase School student. FROM THE BYRON COLLECTION, MUSEUM OF THE CITY OF NEW YORK

He had been commuting to school with a sandwich and a nickel in his pocket. Now, with no tuition to pay, his finances would be in much better shape, and he could take all the courses he wanted at no charge.

The National Academy School, as the name suggests, was as classical as the Corinthian curlicues on its diplomas. It rigidly followed the grand French tradition. The curriculum demanded that all students start out with intensive concentration on sketching the human form. This involved endless hours of practice in drawing antique statues. The students had to remain in the antique drawing class until they had proved their ability to portray three-dimensional form. Only then were they permitted to advance to the life class.

For eight hours a day, six days a week, Norman labored away

with his charcoal pencils and pad in the antique cast room. It was circled with pedestals on which stood copies of classical statues—everything from the major gods and goddesses to an assortment of straining athletes. It looked like the basement of the Louvre, loaded with all the broken-limbed marbles that Napoleon had stolen in his forays. Of course, the copies at the Academy were not marble but plaster, much the worse for years of abuse by careless students. Many had lost noses, fingers, feet, or other protruding vital parts. Those which had no pieces missing often had accents added. These might be ordinary things, like a moustache or beard penciled on a face, or more unusual ones, like a butterfly painted on a smooth, white tummy or dimpled derrière.

Sketching all this battered plaster was boring, tedious work. Not as much fun as drawing from live models, but since plaster ones never move or require any rest, there's no time lost. Norman maintains it's the fastest way to learn the fundamentals of anatomy and how to portray all the contours of the human figure with penciled light and shade. Too bad, he believes, that most art students today skip this tiring but valuable basic training.

There were live models at the Academy, too. The life class was held in the room right next to the antique class, in fact. Naturally, all the young beginning students were like tots outside an ice cream shop, unable to wait until they could get into that fascinating room next door with the living models. So impatient were they, in fact, that the plasterboard wall separating them from the life class was riddled with peepholes they cut into it so that they could catch a glimpse of the living, breathing, undraped young ladies who posed there for the advanced students.

Norman admitted to me, "There really wasn't much to see if you peeked through one of those holes in the wall. But we thought there was. It was exciting, I guess, mostly because we were excluded."

Norman must have been a fast study, for he was promoted from the antique class in just two months. In that short time, he sketched just about every part of all the Apollos and Aphrodites in the cast room. What was even more difficult though, was that he managed to impress a stodgy art professor who was used to

Brother Jarvis, Mother, and Norman pose in their Sunday best. Notice the high starched collars, even on Norman, who has not yet made the transition from knickers to long trousers. This photo probably was taken in Mamaroneck, N.Y., when the young art student was getting prepared to launch his career as the "boy illustrator."

teaching students much older than Norman and who didn't believe in shortcutting the curriculum.

That was a great day when the aspiring artist was allowed into his first life class. It didn't bother him that he was directed to a spot way in one corner of the room to set up his easel. Each student was assigned a definite location for a particular posing period, which would last for two weeks. Norman's view was a strange one during that first two weeks. Every day, the model posed in the same position, lying on her side on the dais, facing away from him. From his location at the back of the room with several other students in front of him, all he could see clearly of the nude young lady was her feet and her rear end, which was of generous proportions. That's all he saw; that's all he drew, over and over again, for the couple of weeks. As he notes, he started his career in figure drawing from the bottom up.

During the next posing sessions, the new model for the period stood up and turned around. Norman was closer, too, so he did begin to get an education into the differences between plaster nudes and real, live ones that jiggled when they walked. For a shy sixteen-year-old, back in the days when the girls in burlesque shows would be arrested if they even took off their stockings, it was quite an education. Previously, all Norman had known about feminine underthings was what he'd seen in the Sears, Roebuck catalog. Now, suddenly, his pencil was detailing what was under the undergarments.

Both female and male models were employed, of course, but there were no women students in his life class. Mixing the sexes would have been unthinkably embarrassing, so the girls did their sketching in a separate room. Even that seemed scandalous to people outside the art world, for they imagined both men and women artists to be a wild, wicked crowd.

Actually, the students at the Academy were a pretty conservative group, most of whom were considerably older than Norman. Many were "tired" students who stayed on in the vain hope that someday they'd be awarded a Prix de Rome fellowship. That would give them foreign credentials, which would bring prestige and lucrative commissions.

The faculty and the courses were conservative as well. More time than Norman thought necessary was devoted to still-life pictures, which he had never liked particularly. (Practically none of the paintings he has done since art school are still lifes.) He wanted most of all to learn about illustration, and there was none of that at the Academy.

After several months, some of his acquaintances told him about another school, called the Art Students League, that sounded like a swinging place. It was the most liberal art school in the country. It had been founded (in 1875) by a group of students who wanted instruction more suited to their needs than the usual classical courses. The avant garde artists of that day came from the Art Students League.

The clincher that settled Norman's decision to switch to the League was its long list of distinguished alumni. Winslow Homer, the greatest watercolorist America had ever produced, had

studied there. So had Charles Dana Gibson, perhaps the most highly paid illustrator of the time and the creator of the famous "Gibson girls." Best of all, from Norman's viewpoint, one of the founders of the school had been his idol, Howard Pyle, the dean of American illustrators.

In 1910, at the ripe old age of sixteen, Rockwell enrolled at his third art school. At the Art Students League, he found exactly what he had been searching for. The atmosphere was excitingly bohemian, with the students at least *talking* a wild life. They were all wrapped up in art. They tried to help each other and spurred each other on when things got discouraging, as they often did. Besides finding the kind of friends he could relate to, Norman also discovered two outstanding teachers, who inspired him to become the fine artist he is today.

George Bridgman was one of the teachers of draftsmanship at the Art Students League. Norman selected Bridgman's life class purely by accident, since he didn't know one teacher from another, but it was one of the happiest accidents in his life. The serious, ambitious young student soon discovered that Bridgman could show him much more than how to draw a tibia. He could spin fascinating stories about a generation of highly skilled artists who achieved wide fame for their illustrations for books and magazines. He would inspire young Rockwell to "bust his galluses" in trying to do as well—or maybe even better.

Bridgman was a bohemian sort of a character. Norman describes him as always looking as if he had just fought his way through a rush-hour subway crowd. He was a stocky, ruddy-faced man who combed his hair with his fingers. His clothes invariably presented a steamy, weary appearance. He had a habit of tugging at his tie which caused it always to be a bit offside, especially if he had much to drink. He always stopped for a few nips at a neighborhood saloon before coming to class, but that didn't seem to bother either him or his students. It only made him more enthusiastic about the knowledge he must impart to his pupils. And they loved him. Both Rockwell and his close friend, cover-artist Mead Schaeffer, delighted in telling me stories about their teacher, Bridgman.

This burly, loud, Brendan Behan type, with his black cigars and

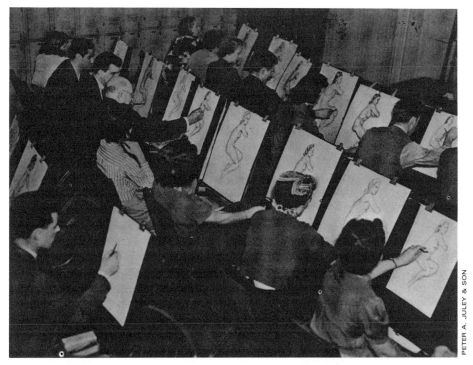

PETER A. JULEY & SON

Superb draftsman George Bridgman teaches a life class at the Art Students League. This photo of Rockwell's favorite teacher was taken in 1940, after classes had become coeducational–an unthinkable situation in earlier days.

profane speech, was an artist of formidable talent, recognized by his fellow professionals as one of the finest draftsmen in New York. He demanded of his protégés that they learn everything about the bones and muscles of the human figure and that they make that structure apparent in their finished drawings.

Sometimes he'd illustrate anatomical points with the help of a skeleton he kept at the school. Dangling it from a ring imbedded in its skull, he'd grab whatever part of its anatomy an inept student needed instruction in and shake the appropriate bones under the lad's nose. "Look here," he'd shout. "This is how that

model's put together. She has bones and muscles under the flesh. Don't just look at her skin!"

If the skeleton wasn't handy, he was apt to illuminate the bone structure right on the model's skin. Walking up to the posing stand, he'd fish a piece of chalk from his pocket and proceed to mark with it right on the hapless model's back or legs or stomach to indicate where bones and muscles were hidden. The models would flinch when they saw him approaching with the chalk, but few of them dared to voice their objections. Jobs were too hard to find.

"I can still see him doing that," Norman chuckles. "It didn't seem so funny then—we were all very serious about our work—but it seems hilariously outrageous now. Once in a while, when I'm trying to get some muscle right, I'll remember old Bridgman tracing it with chalk on some poor model's hide. It certainly was a way to teach that made you remember. He was a great teacher, and I owe more to him than to anyone else who ever helped me with my art."

Concerned about all of his students, Mr. Bridgman walked around the studio constantly and commented on the work of every one of the thirty or forty who might be in the class that afternoon. After peering over the apprehensive student's shoulder for a moment, he might nudge the poor fellow and gruffly growl, "Get up." (He had no time for niceties of speech.) Then he'd sit down in the pupil's place and indicate corrections with a thick piece of charcoal.

Where the pupil had been pecking away delicately at his paper with a finely honed sliver of charcoal, the Master would slash his big, black chunk of the stuff right across the meticulous pencilings. "Here's the spine," he might say. "Can't you see, dammit? Build it all around this." And he'd overlay a broad, powerful line right through the whole composition.

"Oh, that was when he *liked* your work," Norman explains. "If you were doing what he thought was a lousy job, he was much worse! You see, he never smoked that cigar of his, hardly. He just chewed on it till it was all out of shape and juicy. If he really hated your drawing, he'd sit there in your chair for a while glaring at your sketch and chewing on the cigar harder and harder, until he

couldn't contain himself any longer. Then he'd sort of lurch forward and *spit tobacco juice right on it*. Jeez, it was awful! Usually up near the top of the paper, so it would run down to hide your horrible drawing.

"It wasn't a neat way to teach, but you sure knew what he meant. And the poor guy it happened to would go red as a beet and wish he could die. Golly, I'd feel sorry for him. If it happened to a person very often, it was Mr. Bridgman's way of telling him he better go to another school, or else find some other career in life."

Norman can't recall that he himself ever got Mr. Bridgman's juicy "zero" rating on any of his sketches. On the contrary, he was often the student picked for the only accolade that Bridgman ever condescended to award. This was the signal honor of having one of your sketches exhibited in a glass case on the wall, which automatically identified it as the best example of the week.

One accomplishment of Mr. B's which still amazes Norman was his ability to draw with precision on a pad hanging almost directly above his head. In those days before projectors, this was his way of showing the entire life class exactly what he wanted. He had a large drawing pad suspended from the studio ceiling, up near the dais where everyone could see it. He'd walk up to the front of the room, position himself below the big pad, and start sketching on it with a bit of charcoal fastened to the end of a stick about four or five feet long.

"He could barely see the surface of the paper," Norman explains. "He'd be standing directly below, looking straight up almost, at the bottom edge of the pad. As I recall, he didn't even try to follow what his charcoal was doing on the pad. He'd just stare at the model in front of him, and reach up over his head with that stick and create the most beautiful drawing at pretty near a direct right angle to his line of vision. I still don't know how in the world he ever did it. Gee whiz, what an artist he was."

The other teacher Norman had at the Art Students League was Thomas Fogarty. That gentleman conducted the illustration class. There were a few ladies, as well as gentlemen, in his class. In that respect as well as others, it differed considerably from life drawing, where ladies were excluded because their delicate sen-

sibilities presumably would have been unable to cope with viewing a nude female in mixed company (or a nude *male* model, heaven forbid!).

Mr. Fogarty was quite the opposite of Bridgman in most ways, though not in dedication. He was a very neat, tiny man, nervous in manner and always immaculately dressed, as Rockwell described him to me. He too insisted on authenticity, not so much in the anatomical sense, as in regard to being faithful to the setting and intent of an illustration. He emphasized continually that the artist had first to understand exactly what the author of a book or article had in mind, and then to meticulously research every item to be included in the illustration.

One of his favorite dictums, repeated over and over, was *"An illustration is an author's words in paint."* He also repeatedly admonished that the artist must *"learn to live in the picture; learn to step inside the frame."*

From him, young Rockwell acquired the habit he has always retained of searching for authentic costuming and settings. Over the years, Rockwell accumulated a wealth of authentic costumes and decorations of all kinds so that he'd have just the right things for his paintings. Most of this treasure was lost when his studio in Arlington, Vermont, burned in 1943. In later years, when he began to make use of the camera in establishing backgrounds and model positions, he increasingly insisted on going out to real doctors' offices, real schoolrooms, and other authentic locations, where every minute item would be precisely correct.

An eminently practical man, Mr. Fogarty followed the modern-day principle of helping his students prepare for a career by actually searching out real work assignments. Because he was a professional illustrator himself, he was able to get a few of the minor magazines of the day to permit his classes to try some actual illustrating. All the better students would get a whack at it. Some of their work proved to be acceptable (and very cheap, too, which the magazines liked), and so they were able to acquire some practical experience, a little money, and a sample they could add to their portfolios.

Probably more important than the instruction they passed on to their students was the enthusiasm about illustration that

Bridgman and Fogarty imparted. In those days, there was little of the false snobbery that considers a man who paints for books or magazines inferior to one who paints portraits or landscapes for living rooms. There were designations such as "illustrator" and "fine artist," but it was recognized that "fine" simply meant the opposite of "applied." Artists were rated chiefly as to whether they were *good*, *bad*, or *indifferent*, regardless of the particular sphere they operated in.

The high regard in which illustration was held owed much to the exceptionally high state of the art at that time. The period around the turn of the century is often referred to as the golden age of illustration. The great books of that day, such as those of Mark Twain and Thomas Hardy, were filled with fine illustrations. Newspapers and magazines commissioned great illustrator-artists, such as Frederic Remington, to travel throughout the West, sketching the life of an exciting new frontier. One of the finest American artists of all time, Winslow Homer, was an illustrator for *Harper's Weekly* for almost twenty years.

The golden age was coming to an end, though. While Rockwell was in art school, three of the greatest illustrators—Frederic Remington, Edwin Austin Abbey, and Howard Pyle—died. Of these three, Pyle was Norman's foremost idol. Among Norman's most treasured possessions today are a couple of Pyle's pen and ink drawings. Question him about them, and he'll tell you that Howard Pyle was not only a super artist, but also a true historian who painstakingly researched every niggling little detail that was to appear in his illustrations. For example, he became an expert on colonial dress, homes, and habits of everyday living so that he wouldn't be likely to make any errors in the pictures he frequently painted of early American scenes.

It was Norman's dream that he might someday walk in the footsteps of these great ones. As it turned out, he did—literally—in a way he never expected. In a few years, he would rent a studio in New Rochelle which the famous Frederic Remington had used for a time, so he would stand where one of the big names of the art world had stood before him.

In the meantime, at the Art Students League, Rockwell and his young fellow dreamers kept trying to inch their way along in an

environment in which there were a lot more thorns than roses. Norman did receive an important break in his second year at the school when he was named monitor of Mr. Bridgman's life class. This saved him from paying any further tuition, at a time when staying in school was a touch-and-go proposition from a financial standpoint.

The monitor's job also helped to bring Norman even closer to Mr. Bridgman. Along with routine chores, such as taking attendance and handling any details which came up in the instructor's absence, he did confer often with the Master. And he was expected to show his gratitude for the scholarship by working harder, longer, and better than the paying pupils.

One of the monitor's chores provided some fringe benefits. The several monitors throughout the school met at the end of each week to hire models for the coming week. When Norman confided this to his friends, it greatly enhanced his stature in their eyes as a true man of the world. He told me that they never ceased being impressed by the fact that he helped to interview and select the young women who would pose "bare nekkid" for the drawing and painting classes.

Norman didn't bother to inform his buddies of the fact that many of the ladies were not young and few were beautiful. He didn't want to spoil their illusions on that score. And there was no percentage either in trying to destroy the conviction they shared with the world in general that all artists were roués who would die early but happy as the result of their dissolute lives.

Actually, Rockwell admitted to me that the task of picking the models was usually about as exciting as judging heifers at a county fair. All the board of monitors expected of the applicants was that they show an average figure with a little muscling under the fat so that there would be some contours to catch the light. Most of the women who applied were old-timers at the job, easily able to show the boys that they could meet the lenient structural standards and to assure them that they were experienced in taking a pose and holding it without fidgeting.

The only time the selection process got interesting at all was when a novice model showed up. These new ones, who had been lured into this iniquitous place by the enticement of easy money,

almost invariably showed more than a little hesitation in removing their clothes. This made for a sort of bashful striptease, which was much more intriguing than the blasé "Here I am, boys" of the well-seasoned posers. Some who applied—and needed the income badly—came in not realizing that taking their clothes off really and truly meant taking them *all* off. They never got past the fourth petticoat; it was just too much for a girl who had been taught never to expose an ankle. Norman and the other boys sympathized with these bashful novices, but the requirements of art came first.

Even with a scholarship to take care of tuition, Norman continued to have some trouble with finances. He did have expenses for commuting and art supplies. To take care of them, he managed to locate a part-time job at Childs Restaurant on Columbus Circle at Central Park. He describes this work as being a waiter, but actually it consisted mostly of busboy chores. It seemed like a real find at the time, but Norman soon tired of mopping up floors and cleaning up tables. He worked four hours each evening, made little money, and was bored stiff.

Soon he found better employment—or at least a more interesting job—through a fellow student, Harold Groth. The two lads became extras at the Metropolitan Opera House on Broadway. That may sound like a grand step up, but the pay was only fifty cents a night.

It was better than Childs anyway, Norman decided. Ever since he had given watercolor lessons to Ethel Barrymore, Norman had remained hopelessly stage-struck. Opera was show biz! And the *singing* type of show business, too, which seemed especially appropriate for young Rockwell. After all, he had for years warbled eight times a week in church choirs, which practically made him a pro.

He soon learned that the management of the Metropolitan Opera Company couldn't have cared less about his choral ability. Instructions to the extras were not exactly to "keep your mouth shut," but they amounted to practically the same thing. The unskilled help were supposed to move their lips when on stage, as if singing, but not to spoil the sound by actually letting any loud off-key noises come out.

His true assignment was to be something like a spear carrier or a peasant. The military operas all required phalanxes of soldiers who marched back and forth. Other scenarios called for masses of people milling around in the town square while the principals of the show pranced in front of them, singing their arias.

It was fun. And it brought Norman in contact with the most famous of all the opera stars, Enrico Caruso, then at the height of his career. The mere mention of Caruso's name still brings a whoop of laughter out of Norman—not the reaction to the ultimate opera star that you'd expect of a former choirboy and lowly back-row extra. Maybe you regard the great Caruso with awe—Norman fully recognizes his immense talent, but he prefers to remember him, fondly, as a fellow artist with a weird sense of humor.

Caruso discovered somehow that two of the young extras were art students. He sought out the pair, Rockwell and Groth, and confided in them that he also was interested in art. Norman says that Caruso was actually quite good as a caricaturist though he never took any formal art lessons. And the great singer was immensely proud of the fact that some of his caricatures were published in *La Follia*, an Italian-language magazine printed in New York.

During waiting periods at rehearsals, Caruso would get pencil and paper from one of the directors and proceed to make bitingly pertinent caricatures of some of the hefty divas or his fellow male singers. He'd always show them to the two art students to get a professional evaluation of his efforts. Accustomed to applause on stage, he also loved to receive some acclaim for this additional talent of his.

As you may imagine, the two extras who were thus accorded the honor of having their opinions sought by the world-famous star of the opera tended to be highly enthusiastic about his sketches. And seeing how smart they were, Caruso reciprocated by singling them out for special little favors.

One such instance, which Norman loves to recount, is an incident which relates to Caruso's sketching. It occurred when the troupe was putting on the opera Aïda. For the last act of that opera, in which Radamès, the Egyptian general (played by

A self-caricature by opera star Enrico Caruso in his role as Canio in Pagliacci. Amateur artist Caruso developed a fondness for Rockwell, art student and opera extra.

Caruso), was arrested, the famous tenor requested that Rockwell and Groth be selected as his guards.

Their parts were simple; they merely walked beside Caruso carrying spears as he sang about his being sentenced to death and his remorse at this sorry turn of events. The key element of the staging, however, was that Radamès and his guards would then parade down a stairway leading to the tomb where Radamès would be sealed in and left to suffocate.

As soon as the trio got below the stage level, where no one could see them anymore, Caruso seated himself on one of the chairs provided in the little room below floor level and proceeded to draw some of his caricatures for the two boys. He had to do a little singing while he was supposedly suffocating (a strange bit of vocalizing), but this posed no problems. Whenever the time came for Caruso to let out a moan, groan, or other lament, he'd turn his head briefly toward the stairwell to shoot the sound up from their subterranean hideaway. Rockwell says that the famous singer kept sketching away the whole time. This was the best part Norman ever had in his short operatic career.

One other part he also recalls vividly required him to haul a heavyweight female lead singer offstage. He was paired with his buddy Groth in this chore, too, probably because Caruso was again involved.

In the scene, Caruso, who naturally played the hero, had been wounded and was dying one of opera's typically slow musical deaths. While singing his death aria, Caruso was discovered by his sweetheart, the hefty diva. As you'd expect, she was stunned to find him in such poor health. After expressing her shock in a brief song, she swooned, plunking heavily to the stage boards. That's where Norman and his friend came into the act. As experienced extras and good buddies of Caruso, they had been selected from the ranks of the villagers witnessing this tragic scene to pick up the diva and gently carry her offstage.

This wasn't easy, for Norman insists that the heroine was one of the biggest sopranos in the whole field of opera, and they grew them exceedingly hefty in those days. Even though she was "about the size of a small dray horse," Groth and Rockwell managed to lug her into the wings during the first several performances with some strain, but no insurmountable difficulties. This was mostly owing to Groth's efforts. He was an extremely sturdily built fellow, and he naturally assumed the task of grasping the big woman around her ample bosom while Norman picked up the lighter end, her legs.

One night, though, disaster struck. When the soprano finished wailing about her expiring lover, she spun around when she executed her swoon, altering her customary position on the

floor. Groth darted forward as usual and grabbed the nearest part of her. This turned out to be her legs, not her torso, which he had always previously tackled. Norman was left with no choice but to take hold of the heavier main section of the fat lady.

He simply couldn't manage the task of hoisting her. Although he kept trying valiantly to get her big rump off the floor so they could carry her offstage, nothing moved. The best he could do was to bounce her up and down a few times.

This broke up Caruso. He was supposed to be about 95 percent dead by this time, and so both quiet and rigid. Instead he rose up to watch the ridiculous spectacle the boys were providing and shouted advice to them. Instead of dying of his grievous wounds, he was dying of laughter.

The stage manager was dying, too, during these shenanigans—of apoplexy! His male star was rolling on the floor, laughing, during the saddest scene in the opera. His female star was being bounced around by a couple of clowns who couldn't lift her. Even she began to laugh at the crazy spectacle she had become enmeshed in.

After just plain screaming at the boys for awhile, the stage manager finally got his head together enough to diagnose the problem. "Switch positions, you idiots," he yelled. "Switch places!" They did. Norman took hold of the big lady's feet. Groth wrapped his arms under her voluminous breasts. They pulled up in unison and managed to get her airborne and into the wings. Then the curtain was hurriedly dropped to blot out the whole mess.

That was the last time Rockwell and Groth were ever entrusted with that particular job. It's a wonder they even stayed at the opera house after the fiasco. Their continued tenure probably was due at least in part to the fact that Caruso found them too much fun to do without, and he always got what he wanted at the Met.

Rockwell also admitted to me that Caruso was perpetually amused by the baggy tights Norman wore. Because bare legs were not allowed on stage in those days, all the extras had to wear tights, but skinny Rockwell's were always too loose, especially in the seat. Caruso would come by, grab a handful of extra fabric at Norman's rear, and yank it up to take up the slack.

"I've never met a wilder character," Norman says of Caruso. "He sure was a strange one. But, my God, what a voice! I got to hear a lot of singers, most all of the best ones. But no one else could touch Caruso."

Asked if he ever attended the opera much in later years, Rockwell confessed that he had never pursued that interest. "Not ever, I guess," he said. "I just got too busy later on, and always stayed too busy. Anyway, it wouldn't have been near as much fun out in front of the curtain, you know. I like to remember it from the days when I was part of it."

Being part of the colorful panorama of the opera, even for just a short time and in a very modest way, enriched the impressionable young artist more than a little. Perhaps his witnessing how an unlettered young tenor from the slums of Naples could become the idol of the world gave him some confidence. The shy boy certainly had his eyes opened by the flamboyant star with his fondness for silk-hatted elegance, potent eau de Cologne, and beautiful women, whom he was apt to pinch on the bottom at first meeting as he modestly asked, "Do you know who I am?" After exposure to such a character, it was hard to be surprised or awed by anyone afterward.

While meeting new people and new ideas during his almost nightly spear-carrying sessions at the Met, Norman was also learning about a whole new world at art school. He discovered his favorite, Rembrandt, whose pictures showed him how to uncover the character of men and let it shine from the dark background in a halo of soft, clear light. In Breughel's and Steen's works, he found the Flemish equivalents of Enrico Caruso and his raunchy pals, delighting in their horseplay. He marveled at the intricate perfection of Vermeer, the faultless draftsmanship of Ingres and Dürer. Many others he met, too, that he never forgot: Michelangelo, Velásquez, Goya, Holbein, Van Dyck.

These were some of the greats of days past he came to know. He also learned about artists still living who were to influence him considerably in his work. The moody, sensitive Whistler. Happy, inventive Klee. The imaginative surprises of Matisse. Versatile Picasso. And perhaps most of all, the outstanding masters of the difficult art of illustration.

In addition to Howard Pyle, the great illustrators included N. C. Wyeth, the Leyendeckers, J. C. and Frank, whose almost brittle virtuosity greatly impressed the young artist, and the fabulous Edwin Austin Abbey, who taught himself to paint and excel just about all the others, first in watercolors and later in oils. Abbey left America to live permanently in England, but his book illustrations were still widely noted and admired in this country; they were so strongly distinctive that "Abbey red" was a color any art student could identify and drool over at a hundred paces.

Norman P. Rockwell (he still hadn't broken completely away from ancestor Percevel's heritage) soaked it all in. He devoured the books and haunted the museums where pictures of the masters were to be found. The artists he came to know there were as real to him as his own family.

Their world would be his.

Records at the Art Students League show that Norman Rockwell enrolled there sixty-seven years ago and was in attendance for a period of little more than a year.

					ROCKWELL, NORMAN	
APPLICANT'S NAME	Rockwell, Norman			DATE		
CITY ADDRESS		CHANGED TO			TEL. NO.	
HOME ADDRESS	121 Prospect Ave Mamaroneck, N.Y.	CHANGED TO			TEL. NO.	
STUDENT COURSES				MEMBERSHIP RECORD		
PERIOD	COURSE	INSTRUCTOR	ADMITTED			TYPE
10/11 3/3/12	Am. Illustr	T Fogarty	YEAR	DUES	PAID	
'9/11 1 mo	Aff. Illustr	E Blumenschein				
1/1/11	Aft Life	G Bridgman				
1 mo						
7/16/1Y	Anatomy					
					REMARKS	

One of the earliest pictures of Rockwell as a professional artist. He poses here with one of the many young models he recruited for illustrations for popular boys' magazines of the day. Exact date of this photograph is unknown.

"There was so much to learn then, so much to do. There still is. I'll never have enough time to paint all the pictures I'd like to."

A Restless Time

Impatience and independence are two characteristics that have always played a major role in shaping Norman Rockwell's life. At the age of eighteen, when such forces are likely to heat up to a lively simmer in young men, they had bubbled to a full boil in Rockwell and were impelling him to move out in many directions.

Even today, when this quiet gentleman is painting one of his happy pictures, he often becomes upset with himself and fearfully anxious about doing his work faster and better. At such moments, he volubly disprizes his talents and bemoans the fact that he never can reach the perfection he aspires to. At eighteen, that never-satisfied drive was already eating at him, and he was chafed as well by everything at school or home that kept him from going full tilt ahead. There were so many irritations that combined to produce an uneasiness for which he could find no relief.

In the two years since his sophomore days at Mamaroneck High, he had sampled the instruction available at three different art schools: Chase, the National Academy, and the Art Students League. Now he was no longer satisfied to spend his days at the League, even though he admired both Mr. Bridgman and Mr.

Fogarty and continued to go back occasionally to sit in on some of their classes. There was too much to learn outside the school in actually working at illustration jobs. Thanks to Fogarty's introductions, young Rockwell had been able to get started in a few professional assignments, and he managed to keep going with an assortment of odd jobs covering everything from painting posters to catalog drawings to pictures for a medical textbook. But he was anxious to move up to a higher level of illustrative assignments, and he needed full time to go out and conquer the art world.

With this in mind, he stopped his attendance at the Art Students League. The fact that he made this decision without asking his parents' advice didn't seem strange to him. Although he was still very young and living at home, he felt little dependence on the family because he was pretty much paying his own way.

In any case, his father now tended to encourage him in his career moves. After all, Norman had received free tuition as a monitor in Mr. Bridgman's class and had won a scholarship in Mr. Fogarty's class, too, at the end of the first year for producing the best drawing of the year. Those were accomplishments a man

Painted for Boys' Life *in 1912, a wash drawing for an adventure story. At this period, Rockwell was art director as well as chief illustrator for that magazine. Note that he still signed his name with the middle initial P.*

A watercolor painting from the first book Rockwell illustrated, the Tell Me Why Stories. *His fee of $150 for producing a dozen illustrations for that book seemed like a fortune to him at the time.*

of business—and amateur artist—could appreciate. His mother, who had frequently carped about the futility of wasting one's life painting, had at last lapsed into a silent neutrality. That suited Norman.

Hardly had he begun haunting the art directors' offices in search of work when the "boy illustrator" struck it rich. He landed a well-paying assignment with a good publisher. The title of the book was *Tell Me Why Stories*. Each chapter in the book opened with a child's asking his parents why certain things hap-

By 1915, when this illustration was made, Rockwell's style had begun to mature. He regards this as one of the best pictures he painted for the youth magazines of that time.

pened; the parents would then tell a story to provide the answer.

Illustrations from this first book still exist in Rockwell's files. One is a painting of a lighthouse done basically in white and gray watercolor. There is a limited amount of color tone added, or "washed," over it, as was common in those days before full-color printing was available. These tones consist of some blue at the tops of the sky, water, and lighthouse, plus a faint yellow added lower down in the sky and water to give an effect of sunlight there and also on the sides of the tower and house.

The signature "Norman P. Rockwell '12" may be seen in the lower left corner of the painting. He had already dropped the hated Percevel. In a few more years, he would eliminate even the *P*, so there would be no reminder at all of his middle name.

Norman was paid $150 for illustrating the *Tell Me Why Stories*, a task that involved about a dozen pictures. None of the varied

painting and drawing jobs he had obtained previously had paid anywhere near such a sizable sum. More important, these book illustrations gave him a start toward getting new assignments from additional publishers, particularly those who produced children's books and magazines.

A charcoal drawing dated 1912, which Norman created for one of the youth magazines, and two other magazine illustrations, undated but from the same period, exhibit a growing sophistication in the young artist's work. One is of an Indian fight and is a complex action composition that is beautifully executed. Unfortunately, the date has been obscured, if one existed, but since Norman was still using the middle initial *P*, this must have been a very early effort.

The second picture, of a boy telegrapher, is still remembered by Norman as one of the best he did in his beginning years; the draftsmanship is quite mature and the composition is interesting. In this early illustration, Rockwell successfully attempted a complex visual device. He drew a complete scene inside the room in light values and another dark plane outside the building for atmosphere.

As he began to paint for pay, Norman became more and more dissatisfied with the inconvenience of working in cramped quarters at home. Lack of space was aggravated by the fact that the Rockwell family had sold their home in Mamaroneck when Norman's mother grew increasingly sickly and unable to keep it up. They had moved back to New York City into a roominghouse, where they had but one room for the parents and one shared by the two boys. Jarvis, of course, insisted on using half of this small room for his personal things, including paraphernalia for baseball and other games he played. The space left for Norman barely enabled him to squeeze in a desk, which doubled as drawing board and supplies cabinet, and a single folding easel, which could be set up in a poorly lighted corner when required.

As soon as he started to illustrate some books and earn what he considered to be sizable fees, Norman made up his mind to get a studio of his own, or at least one shared with some other young artist. He approached one of his fellow students at the Art League about the idea, and they agreed to find a place and split the rent.

Once they made up their minds to this, he and his young friend, Eddie Ward, decided they'd make the move just as quickly as possible.

The very next morning, they searched through the newspaper "Rooms for Rent" columns for a suitable place. They spotted one on the upper West Side of New York which was described as having a skylight window and being available at a very reasonable rate. Those were the only two qualifications of any great importance to the two young men. They caught a streetcar to the address listed. Norman recalls that it was on Forty-first Street near Sixth Avenue. After a cursory look at the quarters, they paid the first week's rent in advance. Norman was delighted at having finally found a decent place to paint.

Maybe the description "decent place" is not quite appropriate, though. There were some unusual circumstances about their new studio which Norman and his pal Ed Ward were to discover in a few weeks. Even from the beginning it did not seem an ordinary location. On the third floor of a brownstone building, the room was reached by climbing a narrow stairway and opening a trapdoor. This door then had to be closed before the artists could start to work, because it took much of the floor space they needed for setting up their two easels. In addition to this peculiarity, which the young men overlooked as a minor inconvenience, there was an unusual ambience about the place that would have raised some questions in the minds of renters who were more worldly or less hasty.

The two lower floors were a sort of boardinghouse run by the big, bosomy, hard-faced lady with the frizzy hair who had been so jolly and loud when she showed the room to the prospective tenants. Even that first day they noted that her boarders seemed to consist entirely of rather attractive girls of various ages, who peeked out of their rooms at Norman and Ed as they climbed up the three flights of stairs after the landlady. The fact that the girls were almost all clad in loose kimonos was a matter of notice to the boys, but it merely spurred them on to a quick decision. Artists do appreciate atmosphere.

Later they were to learn that this was a costume much favored by the ladies of the house throughout the day. Apparently none of

them went out to work or had husbands in evidence. There were many gentleman friends who came calling. One fellow who showed up regularly at the house every afternoon, just before the boys left for the day, was very fond of playing the piano. They could always tell it was getting on toward evening when they heard him start to pound the keys down in the parlor on the main floor.

None of this setup bothered Norman and Eddie. When they arrived each morning to get at their painting assignments, the house was always amazingly quiet. The boys would tiptoe past the bedrooms on the second floor, lift up the trapdoor, and get their easels set up. They'd work industriously with no sounds to interrupt them from the lower floors until well into the day. If they needed to dash out to deliver some art work to clients in the afternoon, as they often did, they always received friendly, cheerful greetings from any of the girls they saw or from their early male visitors.

Around noon, one or more of the girls, still in their robes, would often knock on the attic door to inquire if they might come in to visit for a while. Norman and Eddie were usually glad to welcome them up, even if it did mean pulling their easels aside because of the inconvenient entryway. Once ensconced in the studio, the ladies were always fun to talk to. They watched the artists most attentively while paint was applied to the board or canvas and asked many questions about art which the young men were only too happy to expound on.

Norman doesn't recall that the young ladies ever served as models for Eddie or him. The studio was so small anyway that there simply wasn't room to pose a model in it and stand back far enough to get proper perspective. At that time Ed and Norman mostly sketched kids they saw outside, getting someone they knew to stand still for a moment in return for a few cents' pay; then they'd hurry back to the studio to try to translate their quick sketches into more finished form.

All in all, Norman and Eddie were much too concerned with their own busy affairs to pay any attention to the atmosphere surrounding their studio, except perhaps to consider that they had been lucky to find such agreeable neighbors. Norman's

father, however, was concerned when he made his first visit to see how the boys were doing and to look over their new quarters.

Norman's father was a very conservative, straitlaced gentleman. At one time Waring Rockwell had been head of the vestry at the Episcopal church he attended, and the standards of decorum he set for his family were as rigid as the back of a pew. When he puffed his way to the top of the stairs and pulled himself to his full height in the little studio, Norman sensed immediately that the red in his face was due to far more than the exertion of the climb.

"What in tarnation do you boys think you are doing in a place like this?" he demanded.

When the two lads professed they could see nothing wrong with their quarters, he told them what he was huffing about. "You're renting a room in a house of prostitution, you young idiots!" he yelled at them. "Start packing right now, because you're moving out of here just as soon as you can get all your things together." He then turned on his heel and bolted down the stairs again, refusing to stay another minute in the den of iniquity his son had fallen into. Maybe Nancy was right; a man who took up art instead of pursuing some honest means of earning a living was bound to come to no good.

The boys did move out immediately after that, much to the discomfiture of both of them, now that they understood some of the strange goings-on they had casually noticed before. They slunk furtively down the street when they left, imagining that everyone on the block was watching them. Their uneasiness was increased by the fact that their former neighbors insisted on shouting noisy goodbyes to them from the windows and doorway as they exited with their belongings. Whatever their shortcomings, the girls who lived below that first studio were as friendly a crowd as ever you'd want to meet, and they evidently would miss having two such polite and interesting young men in the house to chat with in the mornings. Too bad those poor girls would now be culturally deprived, with no more free education in the arts.

Norman and Eddie quickly found another studio. They moved in with some friends who had a large place in Brooklyn. It was in a studio building right next to the elevated tracks at the foot of the Brooklyn Bridge. Every time a train roared past, just a few feet

away from the windows, it just about shook your teeth loose. The building vibrated so that the artists had to lift pencil or brush away from their boards to keep from getting wavy lines in their work. Every location has some hazards.

Despite such little difficulties in working, Norman's career continued to progress. Yet he worried. Sometimes he'd wake in the night, too excited with the many things happening to him to sleep soundly. He'd be happy and proud as he lay in the dark, silently recounting the achievements of the day. But then a nagging doubt would set in.

Could he continue to please the editors? Was he really as good as they thought? Would they find him out if he slipped a bit on an assignment and cut him off from future work? Beads of perspiration would pop out on his brow, and he'd worry himself slowly back to a fatigued slumber. If he was never satisfied with his work, Norman was also far from satisfied with life in the city. The boardinghouse the Rockwells were staying in was filled with an unhappy collection of losers—people whose dreams had soured or who had never even had a dream to reach for. Norman found the place especially depressing when he came home from his studio for lunch each day. He was the lone male at the noon table among a gaggle of wives, still flopping about in their morning robes and intent on nothing but gossip and complaints about their husbands, who admittedly were nothing to brag about. Those luncheon conversations alone were enough to spoil Norman's day.

He decided to get away for the summer at least. He had money now; he could do it. He'd go far away, to Cape Cod. That would be much better than the New York farms where the family had spent summer after summer. There were many artists who went to the Cape, he'd heard, and a fine art school up at Provincetown run by a teacher named Charles Hawthorne. The instructors at the League spoke well of him. One of the young artists he knew had attended Hawthorne's school the year before and told fabulous tales about living right next to the sea with Portuguese fishermen all about and a thousand beautiful things to paint. That was for him.

Living frugally with his family and picking up good commis-

sions practically every week, Norman figured he'd saved enough money to pay for his tuition and live through the summer. Besides, he might still be able to handle an assignment or two even while he was away. He wrote to Hawthorne one day in May of 1912 to make the necessary arrangements and soon after told his folks he was taking off.

In those days, you didn't go by car to Cape Cod. Aside from the fact that few people owned automobiles, there were no paved roads out on the wilds of the Cape, especially way out at Provincetown. You could take a train which went all the way up to the tip of the Cape (or *down* the Cape, as they say), or you could go first to Boston, then come back southeast a ways via a pleasant steamer ride to Provincetown harbor. Norman decided on the quickest way, direct by train.

It was the first time the lad had ever been completely on his own and so far away from everyone he knew. This suited him fine. He felt like a canary that has just pushed the cage door open. He looked forward to a carefree vacation. After all, even though he had been self-supporting for many months, he still had another year to go before he ceased to be a teen-ager. That summer of 1912 in Provincetown did prove to be an idyllic period that Rockwell would always remember.

Laden with boxes of brushes, pencils, and paints, as well as a slim valise, the young artist impatiently scanned the scenery as his train chugged along the New York and Connecticut coasts. Once they rattled across the bridge over the canal, which was then under construction, he knew he was on the Cape at last. They continued eastward out the long arm of the Cape to the elbow where it bent sharply upward. Then north to the fist and Provincetown, enclosed right in the palm to form a well-protected harbor.

Norman had been following it all on his railroad map. When he stepped from the train at the little station at the end of the line, he could truly appreciate this remote place. As he lugged his belongings away from the smoke of the engine, he breathed deep of the smell of the sea that would always be with him on this narrow strip of land between the Bay and the Atlantic. And he marveled at the light.

The light: only an artist could truly appreciate it. Not dank city light with its brilliance diluted by dirty air and absorbed by gray buildings. Here the light was pristine and all-pervading. There was direct brilliance from the sun, a bounce of light from sand and water, and over all a soft, cold wash of illumination reflected from the shell of the sky.

He saw gold over the crest of the land to the west, where the sun was beginning to dip toward the water and flicker across the Bay toward Plymouth Rock on the mainland. Lemon, clean as the taste of citrus, where the rays lay lightly on the west planes of buildings. Oblivious to his ultimate destination, the artist stumbled along with his gear slung around him, moving, fascinated, toward the harbor area, blues and greens shimmering, miles of wind-sculptured sand glittering like dusky silver in every direction. As he walked, the painter was already mixing the palette in his head; squeezing the pure color from the tubes in shades that perfectly matched the magical light he drank in with his tired eyes.

Later he found his way to the boardinghouse whose address he carried in Hawthorne's letter. It was on the edge of the little fishing town, not far from the school. Everyone at the boardinghouse was an art student. The proprietress proved to be a huge, round mound of a woman who greeted each day with a smile and delighted in feeding her young summer visitors plenty of hearty fisherman's fare to put some fat on their skinny city bones. In this respect she never succeeeded with Norman, though he loved her chowder and fish cakes as much as her disposition. No whining or pettiness here; clean rooms with fresh sea breezes day and night—the atmosphere seemed just perfect to young Rockwell.

From the very first day in Provincetown, he was stimulated by the people around him, as well as by the freedom of being in this almost primitive seaside community that seemed a million miles away from anything he had known before. Breakfast was a picnic, with a dozen enthusiastic young students around the big kitchen table all trying to tell him at once about the school, the town, and the island. Having been here only a few days themselves, they were ecstatic about Mr. Hawthorne, who was going to teach them all to be great painters, and about the Cape, where genius such as

theirs was bound to ripen in a climate of casual artistic culture.

As soon as the pancakes (and fish) were out of the way, they hustled him down to the town so he could get a good look at the harbor before classes started. There was no clear definition of where country ended and town began; the houses just became closer together and the sand less pervasive, though there was always some of it gritting underfoot no matter where you went on the Cape. In a few blocks, they came to the wooden sidewalks along the main street that bordered the water. Here were the rows of canneries where silvery, slithery fish by the tons were scooped from the holds of boats riding scupper-deep when they came in each evening with their catch.

At this morning hour only a few fishermen clumped along the boards in their heavy rubber boots, and none lounged in the vacant lot across from the harbor where they liked to sit and chat in the evenings, an eye always to the water. The only seamen on the street now were a few extra-early lobstermen who had already emptied their pots and come in to shore with their squirming green and black crustaceans. The lobstermen started out before dawn so that they could spot their floats easily before the breeze came up to crinkle the water and puzzle the eyes that sought the colored corks bobbing amid the sparkle and froth.

With his new friends exclaiming and pointing out the paintable beauties of their favorite weathered sheds and water-battered piers, Norman soon came to the turnoff up a little alley south of the main docks where the boat yards were located. In a moment they were facing a big, low-peaked barn made with cedar shingles grown iridescent from age, and in a few more steps they had been swallowed into the doorway, which stretched almost the width of the building. Years ago, this had been a sail loft. Now it was the art school. Large windows, tilted open along both sides of the one huge room, provided ventilation and good light for painting. Both end walls consisted mostly of barn-type doors, which had been swung wide to let the breeze from the sea waft right through the studio and out the back toward the not too distant dunes, where the plume grass could be seen waving.

Norman was introduced to Mr. Hawthorne, a bright-eyed, round-cheeked gentleman who was the only one in the room

dressed up in a blazer, though like all his students he wore comfortable rubber-soled sneakers. His handshake and quick smile were warm enough, but he didn't dawdle over amenities; there were too many details needing attention at the start of the semester. He directed Norman over to one corner of the studio where he was to join the group of half-a-dozen who had most recently arrived at Provincetown. Mr. Hawthorne's school was so popular that he split the students into several units with an assistant instructor in charge of each.

Norman introduced himself to his new classmates and joined them in studying one of Mr. Hawthorne's paintings, which stood on an easel in their corner of the loft. This particular group was to stay indoors today to paint from a nude model and get some pointers from the master as to how he achieved the effects in his painting.

Norman looked at the big canvas of Hawthorne's in calm appraisal. "Not bad, not spectacular," he judged. His fellow students were remarking on it in awe. Although most of them were a couple of years older than Norman, they seemed more easily impressed. Young Rockwell looked longingly out the doors toward dunes and docks; he'd much rather be with some of those who'd soon be parading forth with easels under their arms for some field sketching.

Fortunately, the school was an informal one, and Norman soon discovered he was free to do pretty much as he pleased. To this day, he is not convinced that most students learn very much in art schools other than theory and history. Certainly, his own way is that of the lone wolf, who listens to the teacher a bit, observes what his fellow students are doing a bit more, but mostly just goes along and tries things by his own intuition.

Maybe Mr. Hawthorne and his instructors were exceptionally brilliant teachers, because their approach to Norman was just perfect—they let him alone most of the time. As a consequence, the young student either went outside every fair day to join one of the groups and their model or simply wandered off by himself to find his own subject matter. Either way, he had a marvelous time and matured considerably in his painting in this quiet, unhurried environment in which he was free to experiment and to try things

over and over, if he wished, with no deadlines or editors to worry about.

The models were far different from any Norman had painted in the city: none of the pallid girls he used to hire when he was monitor at the League; none of the hyperactive, wiggling little brats he had to badger to sit still for his juvenile magazine illustrations. The Portuguese fishermen's daughters who made an easy dollar or two posing for Hawthorne's classes obviously enjoyed showing off their charms as they stood barelegged in the sand next to a twisted scrub oak or a bush of salt-spray roses. They were high breasted and sturdy limbed under their colorful dresses. Their skin was the color of dusty peaches, a golden tan with a blush of red showing through. They tossed their black hair back and flashed their olive eyes; and when they smiled, Norman smiled in return.

To Norman, the fishermen themselves were even better, strictly from a painting standpoint, of course. He had never seen faces with such topography—each bit of human clay eroded by a hundred storms and a thousand blistering noons into a unique pattern that challenged all his skill to duplicate. After the regular classes were over, Norman often wandered over with some of his painting gear and a sketch pad to the small parklike lot on the shore side of Main Street facing the harbor. He learned that the old salts liked to sit there on the benches and tell lies and watch the sun begin to sink. They didn't seem to mind the skinny kid with the brushes and pencils who studied them so intently and tried to capture them on paper.

At the park he didn't pay the men for posing. But on one occasion, at least, he hired a fisherman to model for an illustration, so he did mix a little bit of commercial work into the summer schedule to supplement his income. It was a picture of Captain Ahab standing on the cross-tree of a mast. A little bit later he decided he wanted to put a sea gull into one of the pictures in a certain position, so he asked the men in the park how he could snare or shoot a gull. They acted horrified at his request, told him no one must ever kill a gull (whether for legal or superstitious reasons, he never learned). His friend, the model for Ahab, didn't say a word, but Norman thought he saw him smile a little. The

next day in the park, he sidled up to the artist and quickly handed him a paper bag. "Here's a present for you," he said. "Forget where it came from." Then he winked broadly and strode away. When Norman peeked into the bag, he found the gull he had asked for.

Unlike other students, Norman didn't care much for painting the many scenic spots around the town, unless there were some people in the scene. As he explains, *he always wanted to paint stories about human beings*.

This is one of the reasons he prefers oils to watercolors. They permit him to work over details in the human face until he gets "the story" just to his liking—something that can't be done with watercolors, which permit no alterations.

Saturdays and Sundays were exceptions, however. Norman often did join his colleagues then in going far out from town on sketching expeditions, sometimes with just a watercolor box and a small pad of textured paper. One reason was that Provincetown, even in those days, was considered spoiled by tourists on weekends. A few hundred of them would pile into the Cape from Boston via the Great Eastern excursion steamship. The ship disgorged its cargo in the morning; the passengers disported themselves around the town and nearby areas throughout the day, then returned to Boston on the steamer that evening.

Having lived on the Cape for a few weeks, the students considered themselves longtime residents and didn't care to rub shoulders with any loud city slickers from the mainland. Anyway, it was an excuse to go off on a picnic to some secluded spot, usually across the low ridge of grass and trees to the ocean side of the island. This was the highlight of the week. The girls would whip together some baskets of sandwiches and potato salad; a couple of the boys would stop in the center of town for a few bottles of Portuguese wine to make sure the party got off to a fast and mellow start. There was always someone with a guitar or mandolin. Often the sketch pads that many of the students conscientiously carried with them didn't get much use. On the most successful picnics, they were never even taken out of the baskets.

As the summer of 1912 moved along, it began to look sunnier and sunnier for Norman because of a girl named Frances Starr,

who had come from Chicago to attend Hawthorne's school. Norman's trips to secluded spots on the island with the gang soon became twosomes.

Although the young man had an appreciative artist's eye for the buxom daughters of the local fishermen, he needed intellectual stimulation as well. Frances was a thin and rather plain girl who wore her brownish hair in a nondescript bun at the back of her head, but when she talked art her eyes lighted up and her animation gave her a vibrant prettiness. She and Norman could dream together.

They loved to go searching for some new spot shut away from the rest of the world. On a beach by themselves, they swam in the breakers coming in from the Atlantic, enjoying the smash of the waves and the blown spume from the strong east wind. Afterwards, they lay on the sand exhausted from the pummeling of the water. Or they wandered hand-in-hand through the hillocks and hollows inland, alone with the scraggly pines and a covey of sandpipers, talking about the great things they would do. After that summer, they never met again.

In reminiscing about the Cape, Norman recalled fondly that when his children were very young, he took his family there a few times for vacations they all enjoyed, although the area was beginning to get a bit thick with summer visitors. Then, a score of years ago, he drove back again to see what had happened to his island paradise. When the road became more and more clogged as he drove toward the sea, he pulled off onto the shoulder, got out of his car, and just stood there awhile looking in amazement at the throngs of people on the highway and walking along the sidewalks. He told me that he said, "Let's get out of here," and he never went back.

All too soon the summer of 1912 ended, and it was time to return home—to a world he had shut out of his mind. Things weren't slated to be too bad for young Rockwell, though. The lad who came back refreshed from Cape Cod would find much to challenge and excite him.

In a few months, he received a call from Edward Cave of the Boy Scouts of America which was to mark a significant step in his career. Cave was editor of *Boys' Life*, the official magazine of the

Scouts, and he also prepared all the booklets used by that organization. He first asked Rockwell to illustrate a Scout hiking book, a comprehensive handbook which would require over a hundred illustrations, many of them full-page pictures. This was a job that would have scared off many longtime professionals, but with the arrogance of youth, Norman said that of course he could do it.

He did, and in a way that was much to the editor's liking. As a result, Cave called on him the next year to do a similar job on a Scout camping book which required fifty-five illustrations. And in the meantime he began to turn to Rockwell for pictures for the Scout magazine. An amusing aspect of all these out-in-the-woods pictures Norman painted is that the city boy had never seen any wilds. He didn't know a red maple from a brown bear, but he'd skip over to Central Park Zoo, where he could find plenty of models for his animal pictures. He confided to me that he did run into one problem though. On hot summer days, when the zoo inhabitants wanted to sleep, it was often hard to find any that looked fierce enough for his purposes.

In 1915, Norman was offered a steady job with the Scout organization: the post of art director for *Boys' Life* magazine, no less. This required that he paint the cover for the magazine every month and also illustrate at least one of the stories in every issue. In that one year alone, he churned out seventy-eight illustrations for the periodical.

Despite the grand title of art director, the job paid only fifty dollars a month, but that wasn't bad in those days. It gave him a steady income he could count on. And since he was permitted to do most of the work in his own studio, he was free to take on other assignments in his free time—if he had any.

This was to be a happy relationship. Even after he moved on from *Boys' Life* to grander fields, Norman always had a warm spot in his heart for the organization that helped to give him a start in his profession. He has tried to make room in his crowded schedule to paint a picture for the Scouts each year.

In the course of the sixty-two years they worked together, the Scouts heaped every honor they could imagine on Rockwell. He has received their Golden Eagle award for outstanding service to the organization. He has been the honored guest at many a na-

tional jamboree. In many families, one generation after another has come to regard him as "Mr. Scouting."

While on the payroll at *Boys' Life*, Norman did find time to branch out into other avenues of work. He went to the magazine's office only once a week to handle production details and hand out assignments to other artists, preferring to work at his own illustrating in his studio. This allowed him to take on other jobs, and his accomplishments at *Boys' Life* helped him gain entree to other publishers. His title of art director gave him a certain amount of professional status, and he could show many examples of his work. The young fellow trying to make it in an adult world needed that. He tried to appear as grown-up as he could and kept gaining ground little by little.

Shortly before Rockwell took his job with the Scouts, his family moved from Mamaroneck to New Rochelle. In those days, both suburbs were considered way out in the sticks, since they were located far up the coast of Long Island Sound toward Connecticut. The family still lodged in a boardinghouse, but this time in a much neater and more comfortable establishment. A bright spot in the move was the fact that the new boardinghouse, Brown Lodge, catered especially to schoolteachers, including some very young and pretty ones.

Norman found a convenient studio on North Avenue, near the train station, so he could easily get into the city when necessary for his frequent contacts with publishers. He continued to work enthusiastically at every assignment he could wangle from the art directors, who were beginning to take a bit of notice of the ambitious kid they identified as "the boy illustrator."

He was beginning to outgrow that title, though, Norman thought. After all, he was twenty years old, not really a boy any longer, but getting to be a grown man. After four full years as a professional, self-supporting artist, his boyhood dreams about getting a toehold in his chosen career had changed. That was already solidly accomplished. Now he thought about how he might, just maybe, be able to climb somewhere near the top of his profession.

It was a dream which still seemed a long way off. But, in fact, it wasn't.

5

"I learned to draw everything except glamorous women. No matter how much I tried to make them look sexy, they always ended up looking silly . . . or like somebody's mother."

Sweet Taste of Success

New Rochelle played an important part in Norman Rockwell's life. He was twenty years old when he moved there in 1914. It was to be his home, except for a few brief departures, for the next twenty-five years.

During those two and a half decades, the awkward youngster became a man, reached the top rung in his profession, gained fame throughout the world, acquired a taste for travel and profligate living, married twice, sired three sons. It was a busy period: never dull, not always happy, but educational.

Today New Rochelle is an aged suburb of New York, ravaged by expressways that roar around it and bulldozers that have plowed through it to make way for urban renewal projects. Then, the little town was the Westport of its day—an artist's colony and attractive community reached by a pleasant ride on the New Haven Railroad. Like many other men in the area, Norman's father caught the train into town to his office every workday morning.

Among the more distinguished local residents were some of the most famous artists of the time: Charles Dana Gibson, still remembered for his Gibson girls, who were the epitome of stylish, slickly painted beauty; James Montgomery Flagg, whose stern "Uncle Sam Wants You" poster would be seen on every street corner in America when recruiting started for the war already underway in Europe when Norman moved to New Rochelle; Howard Chandler Christy, eagerly sought after by leading magazines.

In addition to these painters—so magnificent that they sported three names apiece—there were others almost equally dazzling to young Norman: Coles Phillips, who concentrated almost exclusively on painting pretty girls; cartoonist Clare Briggs; the Leyendecker brothers, Joe and Frank, who were later to become good friends of Rockwell's.

Norman told me, "When I first came to New Rochelle, I used to imitate Joe's walk. Since he was also pigeon-toed, I could do that. He was the leading cover artist for the *Saturday Evening Post* in those days. That was the pinnacle to me."

Norman was also much aware of the fact that Joe Leyendecker lived in a magnificent mansion that caused the young man's eyes to pop when he passed it. He vowed that someday, maybe, he'd also be able to afford such a big, luxurious house. New Rochelle was an inspirational town for Norman to live in, for he'd often catch glimpses of these famous illustrators, his heroes, at the train station or in the business district.

Norman found New Rochelle a delightful place to live for other reasons, too. He was becoming increasingly interested in girls, and there were several very attractive ones at Brown Lodge, where the Rockwell family boarded. Norman noticed the cutest ones right away. Just as quickly, they spotted him as a successful young man with a future ahead. Of course, they learned as well that he was a roué of an artist who, so they heard, thought nothing of painting nude women. It was almost enough to frighten a proper girl away, but not quite.

Norman has always had an artist's eye for a beautiful face or well-coordinated set of feminine curves. Even past eighty, he likes to bring forth a blush of pleasure from a young and pretty

woman by telling her, with sincere enthusiasm, "You're very beautiful." At twenty he must have had considerable charm, with the rather shy friendliness, warm smile, curly hair, and ready sense of humor which were his characteristics then as now.

There were hazards, though. He was soon to learn something of the pitfalls that handsome young men can run into when they chase after women.

Gertrude, the niece of Mrs. Brown, who operated the boarding-house, took a liking to Norman right away. Soon after their meeting, she announced to family and friends that they were engaged to be married. This came as a terrible shock to Norman. Although he and Gertrude had quickly developed a warm affec-tion for each other and had dated a couple of times, he couldn't for the life of him remember having said a word about marriage. Kissing was fun, but this was serious! Norman staggered through several days of confusion and misery before he finally managed to convince Gertrude that the whole situation was a big mistake, that a sweet girl like her really didn't want to marry a no-good, philandering artist like him.

That finished him with Gertrude, of course, and with her aunt. As soon as he recovered his equilibrium, he found that the little escapade hadn't done him any lasting harm with the several pretty schoolteachers who boarded at Brown's Lodge. With their aid, he quickly readjusted to his sunny, happy self. Psychologists might read some deep meaning into the penchant which the young high school dropout developed for well-educated women during this early period of his life, and they could be right. All three of the women he was later to marry were teachers.

That relatively carefree period of Rockwell's life during his first couple of years in New Rochelle was a time when the world was shrinking and changing rapidly. One of the most popular songs of the period was "Hello, Frisco," written to celebrate the amazing fact that you could make a telephone call all the way to that city from New York. In a place even farther away, called Sarajevo, an Austrian archduke had been assassinated, and the rumblings of war had become a full roar. Countries that Norman would visit in future years—Germany, France, England, Belgium, Russia, and Japan—became embroiled in the conflict. Even Americans got

involved in May of 1915, when 124 of them went down with the *Lusitania*.

Everyone talked about the war and the newspapers were full of it, but the United States clung to the neutrality we had proclaimed. President Wilson sent his ambassadors to reason with both sides. Henry Ford sent a peace ship, which was supposed to set things straight. The only effect most people in this country personally experienced was that of a mounting prosperity, as we began to sell more and more military supplies to Europe. Norman talked much about events overseas with his friends. Like most of them, though, he was more concerned with making progress in his career.

By this time he was doing very well indeed. He recalls that he often earned as much as seventy-five dollars in a single week, in an era when many adults were lucky to take home a couple of dollars a day. Although this was far from the rarefied atmosphere he someday expected to inhabit—alongside the great artists of the town—he was making progress. He had won the confidence of the editors and art directors of just about all the leading young people's magazines. Besides his own *Boys' Life*, his illustrations appeared in *American Boy, Youth's Companion, St. Nicholas, Harper's Young People*, and a children's monthly, *Everyland*. If these magazine titles seem strange to you, it is because all of them, except *Boys' Life*, have now disappeared from the publishing scene. With the growth of the movies, and then television, these youthful adventure magazines waned and died.

In the early part of the twentieth century though, such periodicals were eagerly read by boys throughout the country. Their editors evidently figured that an artist as young as Rockwell would be able to relate well to their youthful audiences. He became a specialist in illustrating all sorts of adventure stories: tales of cowboys and Indians, train robberies and bandit raids, baseball and football, historical heroes.

This specialization in pictures for children's books and magazines bothered Rockwell. Young as he was, he wanted to compete with adult artists on adult assignments. He was sick and tired of the cowboys-and-Indians bit and of grinding out picture

after picture of ten-year-olds involved in improbable adventures. He wanted to paint for the famous magazines, those the Leyendeckers, Christy, Flagg, and other artists who really amounted to something worked for. Yet even the thought of approaching the editors of magazines like the *Saturday Evening Post*, *Collier's*, or *Liberty* terrified him. His ego needed a lot of bolstering before he could ever attempt that.

Fortunately for Norman, he met a new friend who could give him direction in his work and the lift that his spirits needed. The name of this new pal was Clyde Victor Forsythe. Clyde was an artist, and a skillful one, so he could talk to Norman on a professional level. Moreover, he was a successful artist, owner of an expensive car and boat, which impressed Norman no end and gave considerable weight to Forsythe's opinions. Several years older than Rockwell, Clyde had been around in the hard-boiled newspaper and commercial art businesses long enough to get all the moonbeams knocked out of his eyes. He could tell the kid what it took to make it in the big time.

The first thing Clyde told Norman was that he absolutely must acquire more confidence in his abilities. Forsythe was honest in his appraisals of Norman's paintings, trying to point out the bad as well as the good, but he worked constantly to overcome the younger man's fears that nothing he did was right.

"Don't be such a worrywart," he'd needle. "The picture's fine, just fine! You can't become the greatest overnight."

That's exactly what Norman did want though: to become the greatest, in a hurry. He recalled to me that he actually painted "100%" (in gold leaf, no less) on the crossbar at the top of his easel. This was to serve as a constant reminder that he should shoot for perfection in every canvas. Norman laughs at this today, but he might as well still have the golden number there, because psychologically he still keeps that worrisome goal before him every time he starts a new picture.

Poor Clyde had figuratively to hold Norman's hand every time he was dragged over to the Rockwell studio to critique a new work. He'd patiently explain where he thought the picture was weak and also what parts of it rated quite high—maybe even 80

percent or 90 percent. He continually tried to persuade Norman that the caliber of his work was good enough to show to the bigger publishers.

Clyde's coddling of the younger artist was founded in the fact that he needed some mental propping up himself. He was a comic-strip cartoonist with the nerve-racking job of thinking up and illustrating a new funny situation every day of the year. Like all gag-writers and artists, he was never quite certain that a joke he dreamed up would actually draw laughs from his audience until he had tried it on somebody. Norman was the somebody.

In return for the critiques Norman received, he had to look at each of Clyde's comic strips as soon as it was roughed out. Then he was required to break up with laughter, beating his thighs and howling wildly to prove to Clyde that the newest strip really was a hilarious creation.

Obviously, this mutual admiration society the two built up required that they get together daily. It soon dawned on them that they could save considerable time and shoe leather if they shared the same studio. Norman was reasonably happy in the studio he had been renting since his arrival in New Rochelle. It was in a second-story office in the Clovelly Building at 360 North Avenue. But they heard of a larger place that would suit their dual purposes.

This was a corrugated iron barn located in a back yard near the center of town. (It was not a very beautiful or sturdy-looking structure, but it stood for sixty years until taken down in 1973.) One appeal the ugly iron barn had for Norman was the fact that it had been the sculpture studio of Frederic Remington, the illustrator who had won international fame as a chronicler of the American West. Rockwell admired Remington's sketches, paintings, and bronzes, though at that time he had no idea that these depictions of cowboys and Indians would someday become among the most valuable art ever created in the United States.

For nearly twenty years, Remington had maintained a large house and studio in New Rochelle, where he turned out most of his pictures, sculptures, and expertly written articles on the West. The barn that Norman and Clyde heard about had been used mostly as a studio and casting foundry for one huge statue

that Remington had produced. It had been standing empty for several years since Remington's death. Evidently nobody wanted the big, drafty, odd-looking structure, but its limited appeal had brought the rent down to a bargain level, and that's precisely what the two young artists were looking for.

Comfort they didn't have. The only heat in the barnlike building was one large potbellied coal stove. On frigid days, Norman and Clyde would crowd as close as they possibly could to the red-hot stove. Their faces would be almost as red as the glowing cast iron, but their rears would be freezing as the chill winter winds blasted at them through the gaping cracks in the walls. It was fortunate that they had the energy of youth to keep them going.

As they began working together, Forsythe frequently kidded Norman about his dream of someday seeing one of his paintings on the cover of the most widely read magazine in the world, the *Saturday Evening Post*. He kept urging his friend to for God's sake make up some cover sketches and show them to the *Post* editor or else quit mooning around about it. Finally Norman did prepare two pictures he thought might be elegant enough for the *Post*.

They were terrible! And Clyde told him so. Beset by his doubts that anything he, Norman Rockwell, produced could ever be grand enough to decorate the front of the world's leading magazine, he had tried to create something entirely foreign to his style. One painting was of a society girl and her escort, both in evening dress at a party—the kind of scene Norman had never witnessed himself. The second painting showed a ballerina curtsying.

Clyde sat Norman down and lectured him on the fact that he didn't know what he was painting. Furthermore, he pointed out, this was a sick imitation of what the "society" painters were producing. He warned Norman that the only real thing he had to sell was himself, so he'd better turn to what he knew best: the pictures of kids which editors and readers alike seemed to enjoy.

Reluctantly Norman tossed his two highfalutin oils into the corner and started out afresh to whip up some typical Rockwell-style creations. Only he made them better than he had ever done before. He thought up several ideas and made finished paintings

of two of them. One showed a boy of about ten or twelve all duded up in suit and derby hat. He was pushing a baby carriage past two boys in baseball uniforms who were razzing him as he went by. The second picture was built around a group of kids putting on a back-yard circus. It featured a young barker in a top hat and a strong man who was attired in long underwear with bulges at the biceps. In addition to these two finished paintings, Norman also made a large sketch of a third idea; this was a scene of a grand-father in spats and vest at bat in a children's baseball game.

Norman thought these cover pictures had some merit. He had to admit they were better than the fancy society scenes he had originally attempted. But his friend and admirer, Clyde Forsythe, maintained that the new creations were absolutely terrific. He gave the young hopeful no choice but to move ahead and get them to Philadelphia to the *Post* somehow.

Norman did proceed, but with a certain amount of heel drag-ging. After all, he had just passed his twenty-second birthday. He was still quite a young man and an almost totally unknown artist. What he was trying to screw up courage to do was nothing less than to breach the portals of the most august magazine in the world, and there to speak perhaps to its awesome editor, the great George Horace Lorimer, who reputedly deigned to give audience only to a few of the mightiest of the art and literary world. Norman was afraid even to call him or write him for an appoint-ment.

Instead, he told himself, and Clyde, that he needed a new suit before he could present himself at the *Post* offices. He bought one—a dark gray, sedate enough for his father to wear. Then he decided he needed something more suitable than paper wrap-pings for the paintings he intended to show. He went to a local carpenter and had him build a huge wooden carrying case, measuring nearly three-by-four feet and thick enough to hold several pictures in frames. This cumbersome monstrosity, cov-ered in black oilcloth, took a few weeks to complete.

Finally, Norman could delay no longer. In March of 1916, filled with trepidation and loaded down with the wooden case contain-ing two framed paintings and a sketch, he headed for Philadel-phia. Had he not been so tough and wiry he might never have

survived the trip. He had to drag his weighty box several blocks to the commuter train that went to Grand Central; carry it from there all the way to Penn Station, because he wasn't allowed on the subway with it; then maneuver it on the Philadelphia run and up the freight elevator at the Curtis Publishing building.

When he puffed his way into the elegant marble chamber that served as reception room for the Curtis editorial offices, young Rockwell learned that one did not *ever* see Mr. Lorimer without an appointment. "Boy, was that a shock," he related to me. "Here I had come all that way dragging that heavy, stupid case, and it was all a big waste of time, it seemed. I just stood there in that fancy room—you know how impressive those Curtis offices were—and guess I would have cried if people weren't watching me."

He was announced, however, to the art editor, Walter Dower. Mr. Dower, like his prestigious boss, did not grant interviews to every ragtag artist who showed up. But he did deign to take a peek at the contents of Norman's monstrous, black, oilcloth-covered case—it was too strange to be ignored. And he must have been pleasantly surprised, for after studying the pictures noncommittally for a few minutes, he directed Norman to wait, while he carried the paintings off into the inner recesses of the building. Dower was gone so long that Norman had time to worry himself damp and then dry out again. When Dower did reappear finally, it was to pronounce reverently that Mr. Lorimer himself had looked at the pictures and *liked* them—*all* of them! While Norman was still gulping air and trying to digest this momentous news, Dower handed him a slip of blue paper. It was a check for *one hundred and fifty dollars*, which, Norman was made to understand, would be the payment for the two finished paintings he had just delivered.

Before he could get his head to stop spinning, he found himself headed down the freight elevator again with a now almost empty case, trying to analyze what had just happened to him. It was unbelievable. He was rich, and he had the check to prove that it wasn't just a dream. He had sold not one but two cover paintings to the *Post*. His big black case now contained only the sketch of idea number three, which he was also to develop into a finished

painting for *Post* use. He had been invited to develop other sketches, too, with the assurance that Mr. Dower would be pleased to look at them when they were ready for submission.

Norman didn't know it at the time, but his work had made such an impression on Mr. Lorimer that he had promptly issued instructions that his art staff must henceforth look at the samples of all artists who appeared at the publishing offices. He didn't want to risk turning away any other young geniuses like Rockwell. It is indicative of the great editor's Olympian style, however, that he didn't deign to come out of his office to say hello to his new discovery, even as elated as he was with Rockwell's work.

Norman related to me that he didn't know what to do first. With the practical exuberance of youth, he decided that a couple of days' holiday at Atlantic City might be the best initial step, so he headed there instead of home. From the seaside resort, he telephoned his friend Clyde Forsythe, telling him he was right—the *Post*, had loved his magazine covers.

He also made another happy call with the good news—to Irene O'Connor, a very pretty girl with soft brown hair and even softer big brown eyes that had melted Norman's heart the very first time he met her at the boardinghouse where he lived. Irene had just graduated from Potsdam Normal School in upstate New York with a degree in education and had come to New Rochelle because she knew two school principals there (former residents of her home town) who could help her get a teaching job.

Much to Irene's surprise, she received not only the good news about her new friend's successful visit to the *Post*, but also a proposal of marriage at the end of the lengthy telephone call. In his exuberance, Norman announced that he wanted to marry her as soon as he returned home. And that was not the end of the day's surprises for Irene; her brother told me recently that her telephone rang again just a short time after the first call. This time it was Norman, in a slightly more subdued spirit. It seems that the flying-on-a-cloud young man had felt so rich with his new success and the check from the *Post* in his pocket that he had been spending freely in Atlantic City. When he settled the bill for the lengthy long-distance calls and his lodging at a fancy hotel, however, he discovered that this bankroll had melted away and that

he didn't have enough money left to buy a train ticket back to New Rochelle. He had to ask Irene if she wouldn't please wire him enough money so he could get back home. That didn't exactly thrill the young lady.

Irene's enthusiasm for Norman's marriage proposal was dampened by another factor as well. Although she admitted that she liked going out with him, she told him she was already practically engaged to a young man at Michigan State College. Rockwell absorbed this bit of news without letting it dampen his ardor or change his plans to win Irene. She was the cutest girl he knew; he didn't have much time to go scouting up a new love, and he meant to have her.

At any rate, Norman kept up his campaign to win a wife with the same persistent enthusiasm he applied to his painting. When he wasn't busy at the easel, he was pursuing Irene. Her boyfriend in Michigan was a long way off. And the always-at-hand Mr. Rockwell wasn't a bad catch by any criterion. As the other girls at Edgewood Hall, the boardinghouse where they both lived, pointed out to Irene, he was doing fabulously well in becoming a *Post* cover artist, and his prospects for the future were limitless. Irene's reluctance gradually melted, and the couple set a wedding date for the fall.

In the meantime, America saw its first Rockwell *Post* cover on the issue of May 20, 1916. It was the picture of the boy with the baby carriage. On June 3, the second cover, of the backyard circus, appeared. On August 5, he saw his scene of grandfather playing baseball on the front of the *Post*. Before the year was out, three more Rockwell *Post* covers had been published. Norman had made it as one of the select few of America's illustrative artists who would be supplying significant numbers of covers for the top magazines of the day.

As soon as his covers began appearing on the *Post*, doors to other magazine art departments were flung open and the welcome mats carefully smoothed down for him. He received assignments from such periodicals as *Life* (at that time a famous humor magazine), as well as *Leslie's* and *Judge*. The world was looking rosier all the time.

In the autumn of 1916, Irene and Norman were married

quietly. They rented a small, third-floor apartment in New Rochelle. Norman moved his painting paraphernalia out of the old Remington studio and into one of the rooms of the apartment. It was a cozy arrangement, but, even from the start, not a very happy marriage.

Soon after they began living together, Irene and Norman began to wonder why. They were both nice people, fond of each other, but not really in love. The magic was missing, and it never appeared.

Norman spent long hours painting. Irene was bored. She'd go home to Potsdam, New York, for lengthy visits. This irritated Norman, who hates to be left alone. He was even more irritated a bit later when his wife brought her mother home to live with them—and also encouraged the rest of her family, her sister and two brothers, to visit them frequently.

Norman was distressed also by the interruptions his work suffered in the workroom at home. Every time someone rang the bell, it seemed to him he had to interrupt his painting to answer the door. This he could not put up with. He rented a large room over a garage on nearby Prospect Street. It was blistering hot in summer and cold enough to chatter your teeth in winter, but it was better than working at home. Despite its discomforts, the famous artist operated from this studio for nearly ten years.

About six months after Rockwell's marriage, in April of 1917, President Wilson signed a proclamation that a state of war existed between the United States and the imperial government of Germany. In June, Norman decided he should join the navy. The doctors at the naval training station at Pelham Bay (just south of New Rochelle) thought otherwise. The young applicant was seventeen pounds underweight, and that was too much to overlook. They told him, "Thanks, but no thanks."

With his usual stubborn persistence, that didn't stymie Norman. He decided he'd try again, at the enlistment office he had noticed at the city hall in New York City. Maybe they'd be in more of a hurry there with all the enlistments they handled and thus more lenient about the physical standards.

As soon as he entered the Manhattan naval recruiting office, he figured he was in. He recognized one of the yeomen there as a

former fellow student at the Art Students League, pulled him aside, and explained his problem. His old buddy agreed to help, if he could. On double-checking Rockwell's weight, however, he pointed out that the seventeen-pound deviation from the norm was more than the doctors would allow.

"They'll go for as much as ten pounds under," he told Norman, "but that means you'll have to gain the extra seven pounds you're light." He explained that skinny applicants were routinely heavied up a bit, with the connivance of the doctors, by having them stuff themselves with bananas, doughnuts, and water. But a whole seven pounds would be a whale of a load to stuff down.

The determined patriot decided to try anyway. The food and a pitcher of water were set before him. He kept shoving bananas down his throat like an orangutan, swilling water, and gulping in doughnuts as an added liquid absorbent. If the recruiters had had a sponge, they'd probably have stuffed that into him too, Norman speculated to me. After more than an hour, it seemed that he'd never make the weight. But by that time, both the doctor and the yeoman were so fascinated by the challenge (to poor Norman) that they wouldn't let him quit. He finally did tip the scales seven pounds heavier than when he had entered. His enlistment papers were stamped, and he was escorted out the door to go teetering back all agurgle to the train station.

Any dreams the new recruit may have had about becoming a fearsome fighting man who would sail forth to battle the Germans were soon dispelled. He was shipped to the Charleston Navy Yard. There they took a few looks at the skinny kid flapping around loosely inside his uniform and decided he'd make a remarkably poor sailor. When they found out the new swabbie was an artist—a famous one at that—his assignment was quickly settled. He'd continue to be an artist. He was designated a third-class varnisher and painter.

Norman was assigned to the camp newspaper, *Afloat and Ashore*, for which he made layouts and drew cartoons. This only required a couple of days of his time each week. He was also inveigled into painting many portraits of the officers on the base, but he still had much free time left. This he put to good use in continuing his career as a magazine illustrator. He continued to

Jarvis Rockwell in his World War I sailor suit, with younger brother, Norman, who had not yet joined the Navy.

turn out many paintings for the *Post* and other magazines. In fact, he figures that his income during his brief stint in the navy probably exceeded that of many of the admirals.

All in all, though, the young sailor never achieved what he expected when he enlisted. Fired with idealism, he wanted desperately to be one of those heroic figures he read about in the flamboyantly patriotic newspaper stories of the day—a shining warrior in the service of his country. He just wasn't cut out for the part.

He mused about it to me one day when we were chatting in his studio. "When I came home on leave, I thought I would surely

After enlisting in the U.S. Navy in June 1917, would-be hero Rockwell was assigned to illustrating the camp newspaper at the Charleston Navy Yard. This page of cartoons appeared in that paper in 1918. Young recruit losing his pants at lower left is Rockwell.

have changed into a dashing figure . . . just because I was dressed for the part. But my friends laughed when they saw me decked out in my navy uniform. I guess I must have been a sight, but I didn't realize I looked that silly. And I was *so proud* to come home in that uniform!"

The war ended in November of 1918. By then, Rockwell had had more than enough of playing sailor while painting portraits of the commander and his staff. With his connections, he was able to wangle an immediate discharge. He headed home to his studio and beloved paints.

With the advent of the twenties, there began a boom period in America when living high was the thing to do. The Rockwells moved right along with the trend. Their income rose steadily throughout this decade, so they could afford to keep up with the affluent suburban executive set of New Rochelle. During the 1920s, Norman became the leading *Post* cover artist. He painted about ten cover pictures per year for that magazine, at rates that rose from the initial seventy-five dollars until they got into the thousands. He painted for other magazines, too, and for the advertising agencies, whose clients offered the highest fees of all. His income spiraled; toward the end of the decade, it began to range in the $40,000 area annually. And that was in the days of almost nonexistent taxes and all the groceries you could carry for a couple of dollars.

Rockwell's success was such a Cinderella story to the many other young artists who lived in New Rochelle that they watched his every move. John Falter, later to become a leading *Post* cover artist, told me how he and his friends would follow Rockwell down the street. "If one of us spotted Rockwell coming from his studio on Prospect Street, we'd yell to the others, and then we'd all pour out of our studio loft to see what he was doing. We'd follow him down the main avenue, at a respectful distance, of course, noting everything he did. If he paused to look in a gallery or store window, we'd have a look also after he moved on, trying to figure out what had interested him. I don't really know what we expected to learn: maybe if there was some great idea for a magazine cover there, or something he admired. I guess mostly we just wished that some of the magic he had would rub off on us.

He really had the world by the tail, and he was not even as old as some of us nobodies."

As the money began to come in at a faster clip, Irene and Norman managed to step up the outgo accordingly. This was the Jazz Age, and everything was supposed to move at a fast tempo. It was the decade of Prohibition, the speak-easy, and the hip flask. The heyday of the great Gatsby, bellbottom trousers, flappers in shimmy skirts, and "Vo-Do-De-Oh-Do."

Irene loved the social whirl. She joined some of the other socialites in founding the New Rochelle League for Service. She kept their calendar full of party dates, too. Both she and her increasingly famous husband were popular guests, invited to many of the fancy events of the season.

Norman learned to play bridge and tennis. He also took up golf, since that was supposed to be the thing to do in New Rochelle. But his friend Clyde Forsythe is quoted as saying that he was the "world's most atrocious golfer," because his mind was always on his work and not on the game. Rockwell also went along with other social customs of the town; he regularly received private deliveries of liquid refreshments from one of the very best boot-leggers in the area, who was reputed to dispense the smoothest stuff around.

Yet Norman never really did fit in completely. Maybe hostesses delighted in having vivacious Irene and her husband at a party so that they could display the popular artist to their guests, but Norman often looked for a quiet corner where he could relax and observe, rather than participate. He was too serious of purpose and worked too hard at his profession every day to carouse all night. At least, that's how it was at first.

In 1922, Norman got his initial taste of foreign travel. It was a free vacation, too good to turn down. The opportunity came about because he had done a series of advertising illustrations for the Edison Mazda Lamp Company. On that assignment, he be-came good friends with the art director, T. J. MacManus. When they had the advertising campaign all completed, MacManus decided the two of them deserved a nice, restful trip someplace, at company expense. He managed to get approval to go to South America, ostensibly to visit and inspect the Edison Mazda sales

agencies there. He also received an okay to take along an assistant. That was Norman.

The trip gave Rockwell a chance to get away for awhile from the increasing social whirl. He and MacManus sailed south in an old tramp steamer that was not much on looks or speed, but great for relaxing. They visited Puerto Rico and Curaçao on the way down to Venezuela. In Caracas, they attended a bullfight and got within gunshot of a budding revolution. At various beautiful, exotic spots, Norman went sketching. At various other times, the two got drunk on coconut milk and rum. They even stopped in to see the Edison Mazda Agency in Caracas.

All in all, the trip was a great success. It removed Rockwell for a brief while from the pressures of business, as well as the social obligations that often bored him. Above all, it opened his eyes to the wonders of travel and made him a confirmed wanderer who hasn't changed in all the years since.

The next year, late in 1923, he decided he just had to go abroad again. This time, he wanted to visit Europe, particularly France, because that was then the center of the art world and he had always dreamed about seeing it. He tried to get Irene to go with him, but she had too many things planned at home. They were more important to her. With his typical stubbornness, Norman refused to change his mind. So she packed Norman's bags for him, and he went alone.

After the steamer got him to France, Norman wandered around Paris by himself, marveling at the colorful sights that had delighted tens of thousands of artists before him. There were so many places to see that he recognized from famous paintings. The soaring buttresses of Notre Dame—butterfly wings in stone. The narrow streets and the little cafés of Montmartre, quaint to the eye and pungent to the nose. The Moulin Rouge. The Champs Elysées, the Seine flowing majestically along under a procession of wide bridges.

There was also the Louvre, that magnificent sprawl of galleries fingering out in all directions, all loaded with treasures beyond comprehension. The best of classical France and the loot of Europe, from the days when the French cannoneers rolled over it

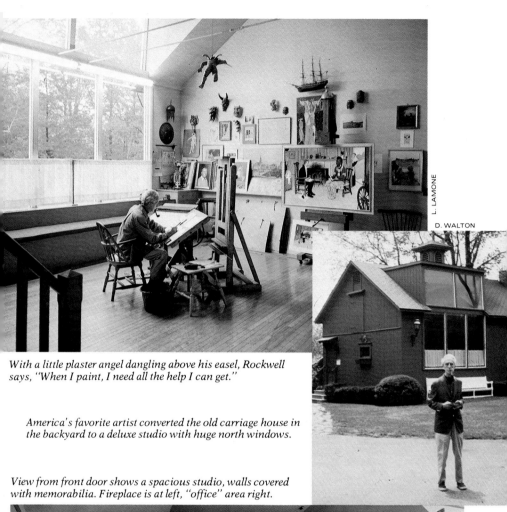

L. LAMONE

D. WALTON

With a little plaster angel dangling above his easel, Rockwell says, "When I paint, I need all the help I can get."

America's favorite artist converted the old carriage house in the backyard to a deluxe studio with huge north windows.

View from front door shows a spacious studio, walls covered with memorabilia. Fireplace is at left, "office" area right.

L. LAMONE

Always an idealist, Rockwell captured the youth and enthusiasm of John F. Kennedy and the young volunteers of the Peace Corps in this painting for the cover of Look *magazine, June 14, 1964. A jar full of brushes of all sizes forms a decorative "bouquet" within easy reach of the artist.*

An old scout paints a young would-be scout trying on his big brother's uniform. Rockwell always had a warm spot in his heart for the Scouts, who gave him his first job.

A Time for Greatness *became a* Look *magazine cover in July 1964. Rockwell was an admirer of President Kennedy.*

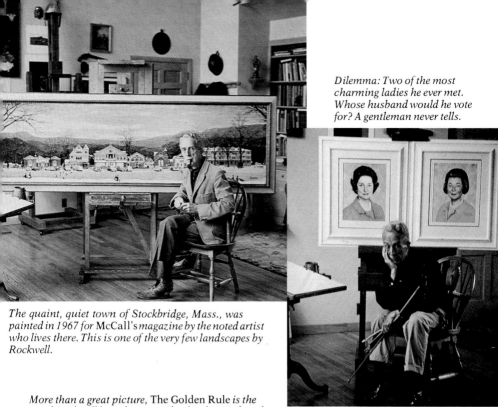

Dilemma: Two of the most charming ladies he ever met. Whose husband would he vote for? A gentleman never tells.

The quaint, quiet town of Stockbridge, Mass., was painted in 1967 for McCall's magazine by the noted artist who lives there. This is one of the very few landscapes by Rockwell.

More than a great picture, The Golden Rule *is the creed Rockwell has always tried to live by. He found the diverse models nearby for this 1961* Post *cover.*

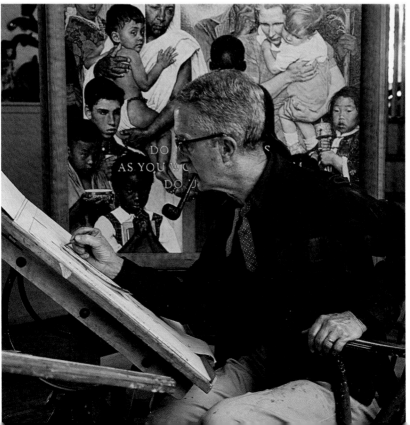

"Have to get away from the cold and snow at times to warm my old bones." An ideal place to do it is the Caribbean, one of Molly and Norman's favorite spots. Here they enjoy a sail.

Fun in the sun, for a short time, takes away the tensions of painting deadlines and of managing a busy household. But soon Norman would "get the itch" to be back at his beloved studio, and these two hard-working New Englanders would fly back home again.

Is this a sea monster? Bathing beauty? Porpoise? Strange, cavorting creature snapped by alert photographer was reported to send bathers screaming from the beaches of Jamaica. M. ROCKWELL

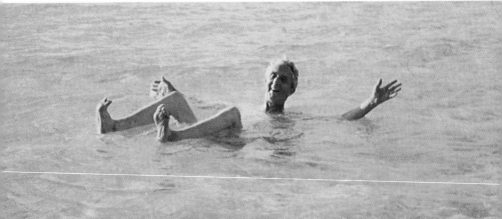

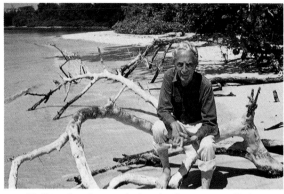

Walking barefoot on the beach all morning calls for a rest on a picturesque tangle of driftwood.

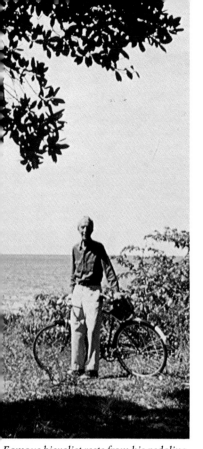

Famous bicyclist rests from his pedaling. On vacations, the Rockwells often rent two-wheelers for their daily exercise, sometimes taxiing them to a rural trail.

Crazy tourist in Nassau amazes cabbie by proposing to buy the beautiful red hat worn by the horse. He couldn't resist it.

No matter where you are when it's time for a nap, take it! With shoes off and a sweater to keep the sun out of your eyes, the sand makes a comfortable enough bed.

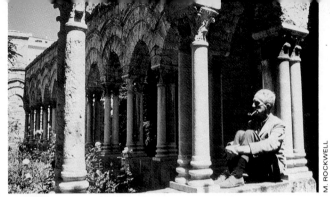

After a visit to sculptor son Peter in Rome, a side trip to Sicily led to this cloistered garden.

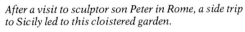

Typical tourist feeds the pirouetting pigeons in Piazza San Marco in Venice.

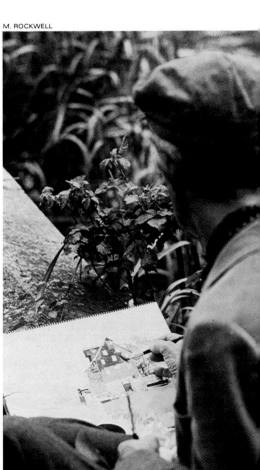

In Switzerland on a terrace high above Lake Geneva, Rockwell chats with Mrs. Walton.

Rockwell often forgets to pack his paints, then has to go buy some, because there's always something he must sketch on a trip. Here it's Houghton's Mill near Cambridge, England.

An inveterate traveler who's been all over the world, Rockwell envies his friends, the astronauts, who walked on the moon. He has witnessed several space shots.

Rockwell and Walton carefully examine the results of a day's work at the studio. Note the brushes and paints neatly arrayed on the storage chest in the background.

The artist whose works are perhaps the most widely collected in the world paints a large oil titled The Collector. *It's now at the Franklin Mint Collectors Society.*

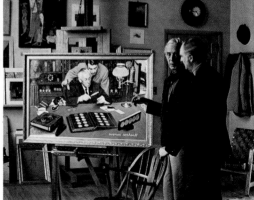

Artist and model examine a series of medallic designs with the author. This project in 1972 resulted in the first set of silver medals for the Scouts–"The Spirit of Scouting."

PHOTOS ON THIS PAGE BY LOUIE LAMONE.

Molly Rockwell snips lilacs from her garden. Sculpture at edge of the pool is by Norman's talented son, Peter.

Home from the daily ride of 4.7 miles down the shady streets of Stockbridge.

Glorious autumn comes to the Berkshires.

When a man's well past eighty, it's pleasant to rest sometimes and reflect on all the people, places, and paintings that have been a source of joy.

all. Norman walked and walked the long, dim corridors, oblivious to the tourists hurrying by as he slowly savored the paintings. The huge, dramatic scenes by the French painters of heroic spectacles: David, Gros, Géricault, Delacroix. The wine-rich colors of the baroque artists: Poussin, de la Tour, Rubens. The delicacy of Watteau and Boucher. So many other Gallic artists. And so many multitudes of them from Italy and the Low Countries.

After a week or so, he took the train down to Italy to get his first glimpse of the land where Western painting reached its first full blossoming in the stimulating atmosphere of the prosperous city-states. He went first to Florence, that treasure house by the Arno with its churches, galleries, palaces, and gardens crammed with masterpieces by such giants as Giotto, Leonardo, and Michelangelo. The few days there allowed only a partial glimpse: he would come back many times in years to come. Then he went on to Venice, the jewel by the sea, and to the stately metropolis of Milan.

With a little more than a week left of his trip, Norman returned to Paris to attend some classes at a noted art school he had heard much about. It was Calorossi's, where Joe Leyendecker had once been the star student.

Rockwell soon learned that it had changed a great deal since his friend studied there. When he began sketching during his first day at the school, the other students looked at him like something out of the Middle Ages. Instead of drawing people, as he was, they were all putting geometric shapes that resembled nothing at all or just splashes of color on their pads. There and at the galleries he visited, he soon woke up to the chilling knowledge that his art was passé.

While he had been working so busily on his illustrations and ads, a revolution in art had swept right by him. Something called Cubism had come and almost gone, without his even knowing about it. It was being supplanted by an even newer trend named Abstract Color.

Norman told me, "It scared the devil out of me. I figured I was finished for sure. If what these people said was true, there'd be no market at all in another few years for the kind of art I was doing.

I'd be *out*! And they ought to know. They were the experts from Paris, and that was the headquarters for all art in those days, you know. I've never been so scared in my life."

It isn't hard to appreciate the fact that when this knowledge hit Norman, it walloped him with a quick case of vertigo and a lasting case of indigestion. No one likes to feel he's washed up in his profession, especially when he hasn't yet reached the age of thirty.

Always a man of action, Rockwell lost no time in trying to remedy his deficiencies. Fortunately, the Cubist approach was already on the wane and could be skipped over; he never would have had much success in that style. He simply couldn't construct people out of cubes, spheres, and pyramids. Switching to the use of bright areas of color wasn't so bad. He didn't really get into pure abstractions or building pictures solely with large, flat areas of color, but he did figure out how to get away from his old-fashioned realism by splashing it up liberally with some vivid new chromatic tricks.

He worked at this idea until he left Paris. And as soon as he returned home, he prepared what was to be the first of his new *Post* covers in the modern, abstract style. He didn't follow his usual procedure of submitting sketches in advance. He just showed up at the Curtis offices with a finished picture. He wanted to surprise them.

And surprise them he did. It was now their turn to get that sinking feeling in the pit of the stomach. By this time, Rockwell had become one of their most popular artists. They counted on him to attract thousands of extra purchasers every time one of his covers appeared on their magazine. And now he had evidently lost his marbles!

As gently as possible, Mr. Lorimer tried to explain to Norman that he needn't worry about the world's passing him by. As long as he continued to paint his beautifully realistic characterizations of everyday people in interesting situations that viewers could relate to, the world would beat a path to his door. Lorimer asked him, *please*, just to go back to doing what he knew so well—and what magazine readers liked so much.

Evidently this experience and Mr. Lorimer's lecturing did

teach Rockwell a lesson. A few years later, in a magazine article, Rockwell was quoted as saying, "The commonplaces of America are to me the richest subjects in art. Boys batting flies on vacant lots; little girls playing jacks on the front steps: old men plodding home at twilight—all these things arouse feeling in me. We may fly from our ordinary surroundings to escape commonplaces, but we find it is not a new scene we needed, but a new viewpoint."

After his brief detour in Europe, Norman's life as a popular artist continued to progress. His life at home continued to drift along. It was not that he and Irene argued or fought a great deal; perhaps it would have been better if they had done that. They just existed. He continued to spend long hours at his work. She cared nothing about his painting. In the evenings, they were seldom alone, for Irene's mother was always there. Norman and Irene rarely stayed home though; more than likely there'd be some sort of invitation to go out.

One person very close to the young couple at that time was Irene's younger brother, Howard ("Hoddy") O'Connor, who was a teen-ager then. I interviewed Mr. O'Connor, now a gray-haired retired business executive, who still lives in New Rochelle. O'Connor, perhaps because of his youth, was not aware of any great conflicts or arguments between his sister and brother-in-law. They were both kindly, civilized people, always pleasant enough to him. He did tell me they were very different in personality—Irene a beautiful young woman with an outgoing nature who was at her happiest at a party; her husband a shy, awkward introvert, deeply absorbed in his work, whose limited education and social background kept him from adapting easily to the sophisticated atmosphere of upper-income suburbia.

His mother-in-law became more and more of a sore spot with Norman. He felt that every young couple ought to have a home of their own—Lord knows the Rockwells could afford one. Finally, he decided to have a showdown with Irene on that score. He proposed that they buy a house and go off, just the two of them. Irene refused to live apart from her mother, so Norman packed up and left. He headed for New York, where he took a small room at the Salmagundi Club, to which he and most of the leading illustrators belonged. (He is still a member of this exclusive artists

club.) He needed a studio, too. At the suggestion of some friends from the club, he rented working quarters in the Beaux Arts Building on West Fortieth, where many of them had congregated.

It was a congenial atmosphere. Norman knew half the renters in the building. A few of them would often go to lunch together, a type of luxury he had seldom indulged in while painting in New Rochelle. After the day's work was done, it was pleasant to have some other artist drop in to say hello and have a drink or to walk down the hall to see what was doing in one of the other studios.

If a group of them stayed late, they might take the elevator up to the top floor where Texas Guinan ran a nightclub. There you could always find lively entertainment, a limitless supply of bootleg hooch, and a noisy crowd that was bound to include at least a few people you knew. It was one of the most popular speakeasies around.

Rockwell loves to tell the story of how Texas and her "speak" unknowingly provided a certain amount of free entertainment for the artists whose studios were on the same floor as Norman's. This unpremeditated free service came about when Norman's neighbor complained about the rumbling noises that started in his wall every afternoon. This occurred about the time the speak-easy was getting set up for customers and continued with increasing frequency as the nightclub business reached its peak. As they sat quietly in this friend's room one early evening, listening to the bumping and creaking going up and down inside the wall, Norman and his buddy figured out that there must be an old dumbwaiter there. Evidently it was still in use, though the door that had previously existed on the artists' floor had been removed and papered over. They also guessed, or hoped, that the contraption was being employed to carry supplies from the basement up to Texas's penthouse hideaway. And what would you deliver by some secret route to a speakeasy?

"Well, what are we waiting for?" Norman asked. "Let's dig a little hole in the wall there to find out. You can always cover it with a picture."

He explained to me that a sharp knife ordinarily employed for slicing drawing board soon whittled a neat little hole through the plaster where the wall projected and the rumbling seemed to be

concentrated. Shining a light into the opening, the curious pair witnessed a load of bottles going heavenward. The bottles were out of the cases, too, all ready to be picked up by the bartender above or by some lucky person below.

The hole was quickly enlarged to make it big enough for a hand to go in and a bottle to come out. After a little practice, the thirsty artists found that if they were ready to pounce when a load came slowly lumbering up past their floor, they could reach in and bring something out before the carrier was gone. It had to be a fast snatch, so they were seldom sure what the catch might be until they had it in hand. But the surprise added to the fun, and in those days you didn't fuss too much about brands anyway.

Norman and his friend kept their secret to themselves. When not in use, the hole was discreetly covered with a large picture. If other tenants on other floors had started to purloin the bottles too, Texas and her cohorts would soon have been sure something was wrong. And they were tough cookies! Better not to be greedy, but only to take a bottle or two when their supplies ran low. There was thrill enough merely in realizing that they were able to pull a fast one on those gangster types from the Mob who ran the speaks. It gave an extra zest to the purloined liquor they drank.

The fun of living a bachelor life in the city soon palled, however. After the friendly lunches and the few drinks at the end of the workday, the rest of the artists generally said goodbye and headed for their trains. Norman was left to himself to have a lonesome dinner and get through the rest of the evening somehow. He recalls that he did a lot of walking up and down the avenues until he became tired enough to sleep or chilled in the clammy autumn mistiness.

That life was quite a change from the hectic, people-crowded times he had become accustomed to back home—too much of a change. It lasted for more than four miserable months. Not only was Norman lonely, but he didn't bother to take very good care of himself. Eventually he ended up in the hospital for several days with a severe case of tonsillitis.

Irene heard about his illness from mutual friends. She came to see her husband and invite him to come back home. They patched up their differences.

Success brought a beautiful home on fashionable Lord Kitchener Road in New Rochelle, N.Y. It was written up in Good Housekeeping *magazine as "a house with real charm." Studio is shown below.*

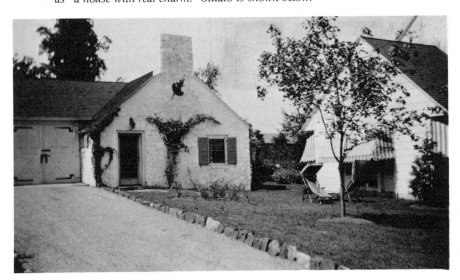

Back once more in New Rochelle, both Norman and Irene enjoyed the house they finally settled in, at 24 Lord Kitchener Road. It was up on the hill in the society district, naturally. The kid from the railroad flat on New York's upper West Side had finally made it.

To go with the fine house, he obviously needed a spacious studio in which to create the masterpieces that were bringing him increasing fame and fortune. An architect friend, Dean Parmelee, agreed to work with him in designing a studio that would turn his fellow artists in New Rochelle green, blue, and pink with envy. The studio had everything: fieldstone walls, beamed ceiling, a pegged floor, fireplace with a fake balcony above it. Some old accounts of the structure listed its cost at $18,000—far above the price of most houses then. Other articles stated that Norman poured $23,000 into his studio. (Perhaps the first figure was the builder's estimate and the second one the actual, painful total.)

Norman can't recall which price was correct, but he is sure that "it cost a helluva lot of money." In spite of this, he told me, "it was a mess. Everything in it was imitation antique. I built it right at a time when everybody was crazy about antiques. Would you believe Dean and I even took a trip up to Massachusetts to look at the old Wayside Inn so we could copy some of the colonial things there for the studio? But it was a good place to work."

Others were more impressed with the Rockwell studio and home. *Good Housekeeping* magazine published an illustrated article which bore the title "A House with Real Charm." At their stylish new location, the Rockwells were better able to entertain and participate in the social activities of the town.

They became too busy partying to see very much of their quieter friends, those with whom they used to play bridge. The Rockwells became charter members of the Bonnie Briar Country Club and the Larchmont Yacht Club. Everyone knew them as two of the smartest people in the smart set of New Rochelle. And now it wasn't just Irene who liked the fun and games. Introvert Norman was no longer so shy; he exulted in his growing skill in acting the part of bon vivant and famous artist. He now notes cynically that when the moneyed people of the community threw a big party, they didn't regard it as complete unless they dragged in

A newspaper clipping from the early 1920s shows cover artist Norman Rockwell on the lawn of his New Rochelle home with a barrow full of neighbor children. He was the subject of many articles because of his popularity and "Horatio Alger" success.

one or more of the famous artists of the area to give the affair a little color. He was a favorite guest.

It was said that "he played a good game of bridge . . . could keep a party in an uproar with his wisecracks and burlesque. He was a marvelous storyteller. His funniest moments, though, were when he was making fun of himself."

Part of his popularity, of course, was owing to the fact that Rockwell was fast becoming *the* magazine cover artist at the top of the hit parade. His works were known everywhere and talked about by just about everyone in New Rochelle. In addition to that, he worked harder than the other artists in playing the role of the colorful man of the arts. Always a ham actor at heart, he began to appear at parties with a scarlet-lined opera cape atop his tuxedo. Naturally, he needed a top hat to go with it, and he sported a fancy cane as well.

At about the time Norman acquired this elegant evening outfit, he decided that his vivid yellow Apperson Jack Rabbit roadster was a bit too flamboyant for someone as distinguished as himself. He traded it in for a black Packard roadster in which he whizzed around town. With Norman behind the wheel, his ever-present pipe trailing smoke in the wind, this massive midnight-hued car with its huge headlights and gleaming chrome front looked like a small locomotive blasting down the roadways. Everybody knew the car—and Norman Rockwell.

When he returned home each evening, after nine or ten hours at the easel, more likely than not the Rockwells would either be scheduled to go out somewhere or to have guests come in. Not only was theirs a very busy social life, but a swinging one as well. Quite a bit of heavy drinking was involved everywhere they went. In their set, a family bootlegger was considered more important than a family doctor—or maybe he just came first. Along with the serious drinking, a considerable amount of hanky-panky was accepted as part of the game. That wasn't supposed to be serious, though, just casual fun not allowed to continue too long with one partner.

Talking with me about the state of the world today, Norman reflected, "Things aren't much wilder now, I don't think, than

they were then. Of course, I just *read* about the goings on now. Ha, ha."

For an artist turning out about a picture a week for the most critical clients of the day, this was a wearing life. So busy was the social calendar that Norman became accustomed to scheduling his painting around the more demanding party dates. If he and Irene expected to be out very late (which meant until early in the morning), he'd plan a light painting schedule the next day. It was no use trying to start a major canvas on one of those purple mornings when his head was aching and his eyeballs could use a bit of draining.

His best means of release from social and business pressures seemed to be (and still is) travel. In those years, he didn't go away very often, but he stayed for a long while when he did catch the boat. Irene never accompanied him. She didn't care for traveling, and she found much to interest her in New Rochelle.

In a *Saturday Evening Post* article in 1926, his friend Clyde Forsythe commented on Rockwell's love of travel. "When his work calls too heavily upon the artist's energy and knocks him flat, he will all of a sudden leap from his easel to a far-off land— Venezuela, Europe, California—and is astonished to find upon his return that his clients still remember him. Concerning the foregoing, one charming aggravation in Norman Rockwell's character is his inferiority complex. The painting just finished is unsatisfactory—almost always. He speaks of only two or three with merely a slight degree of satisfaction. The fine thing is always yet to be done. Rockwell will spare neither time nor expense in finding the right model or object to fit into the subject he is painting; he never fakes. All the dogs in town know him. Along the street he is greeted by schoolboys and their granddads and grandmothers. They all love him; they are his models first, then his friends."

Although it was Rockwell's technique in those days to paint his pictures from models, he produced one cover illustration for the May, 1921, issue of *American* magazine that was an interesting departure from his usual custom. It probably is the first major example of his use of the camera in painting, a method he was to adopt regularly in the 1940s. *American* ran a brief article in its

Making a first sketch for a cover illustration for the Saturday Evening Post *in 1925. The young lady looking at the cameraman is supposed to have her head snuggled on the young man's shoulder, as shown in Rockwell's pencil drawing.*

May, 1921, magazine about its cover and the famous young artist, Norman Rockwell, who had produced it. The article showed a small sketch of the cover, which pictured a bored schoolboy yawning at his desk, and also a photograph of Rockwell in a similar pose. The article explained, "Since he could not ask any boy to hold a yawn long enough for him to draw it, Mr. Rockwell went himself to a photographer and registered before the camera. In other words, Mr. Rockwell is his own model, so far as the yawn goes."

In 1927, Norman went to Europe with two of his friends: Dean Parmelee, the architect who had designed his studio, and a wealthy young man named Bill Backer. They sailed on the *Aquitania* to Le Havre. From there they toured the southern coast

Rockwell has always loved airplanes. His first flight was in an open biplane, shown here, piloted by Dean Cornwell. He was about twenty-five years old at the time. Several years later, he flew across the English Channel, a daring adventure then.

of England in a rented Rolls-Royce, before going on to London. After a few days there, they decided it was time to hop over to France.

They flew across the Channel in a small plane, a daring adventure in those days. Norman had flown once before, in an open biplane, with his friend Dean Cornwell. Parmelee and Backer had never been off the ground before and got more of a thrill than they had bargained for during the rough hour's flight across the water to Le Bourget airport. Paris, as always, fascinated Norman and provided material for many pages in the sketch book he carried with him everywhere on the trip.

The trio went on to Germany next. They sailed down the Rhine

on a small steamer, witnessed a duel in Heidelberg, enjoyed a beer festival in Munich, took a walking trip over the mountains. Heading south, they spent some time in Spain and in Tangiers before catching a boat home from Gibraltar. Altogether, it was a grand trip. Even though it lasted several weeks, it was too short for Norman.

As soon as he returned to New Rochelle and Lord Kitchener Road, it was back on the merry-go-round again. There were so many parties that he and Irene sometimes went to separate parties on the same night. No need to go together if they didn't wish to; their circle of friends was a broad-minded crowd, and the only dictum was to have as much fun as possible.

The late hours sometimes slowed Norman down in the mornings in his studio, but he'd just work that much longer in the day to finish his painting chores—right up until party time again. In this way, he managed to keep up with his busy schedule of commissions. The long hours also accomplished something else; they kept him from thinking about things he didn't want to face. They also meant that there was less time with Irene, time when the two of them might have had to find things to talk about. Work was an excellent anaesthetic until the evening came and liquor could take its place.

In those days when the married-too-young couple found themselves drifting apart, Norman's closest companion was his ever-faithful dog, Rollie Rockwell. A beautiful collie with a beautiful disposition, Rollie followed his master everywhere. He accompanied him on the morning walk Norman relied on to clear away the cobwebs from his mind before starting work. And all day long, Rollie would be in the studio.

Norman's brother-in-law, Howard O'Connor, recollected for me that Rollie's favorite attitude was to sit right up against his master's chair with his muzzle resting on Rockwell's knee. He'd stay in that position for hours while the artist painted and talked to him. The dog missed his master terribly when Rockwell was away on a trip—refused to eat and wasted away to skin and bones before Rockwell returned home.

About a year after his long trip with Dean and Bill, Norman headed for Europe again, once more without Irene. He traveled

this time with three couples from the wealthiest group in New Rochelle. It was high society all the way, staying at the most expensive hotels, meeting titled people, touring the fanciest places in London and Paris. At last, little Norman Rockwell had become the kind of international playboy that the common people stared at as he sailed by in his evening clothes with his partying friends.

When he returned home this time, though, everything was not as before. Irene had decided they finally must sit down and talk. About a divorce.

Learning that she had fallen in love with someone else was not too surprising, not even very upsetting. It bothered Norman more to hear her say she wanted to leave. His strict upbringing surfaced, giving him the feeling that it just wasn't right for two married people to part. That would really expose the status of things, which otherwise could be hidden or ignored. Out of some distant sense of propriety, he asked his wife to stay with him, not really meaning it.

Irene was not about to change her mind. She packed and headed for Reno. It was the year of the crash—1929.

"The twenties ended in an era of extravagance, sort of like the one we're in now. There was a big crash, but then the country picked itself up again, and we had some great years. Those were the days when America believed in itself. I was happy and proud to be painting it."

Starting Over Again

When Irene walked out after thirteen years of marriage, Norman finally had to face the fact that his life had come unraveled. Together, they had been involved in a frantically busy pattern of activities that he had often found full of irritations. But alone, there was nothing, and that seemed worse.

During the day, he could keep his thoughts fenced in pretty well by the details of work. During the evenings, it was difficult to avoid thinking—and simmering in self-pity.

He didn't feel like going to any parties. Word had gotten around instantly of the Rockwells' separation, and he didn't want to talk to anyone about it. His shiny roadster sat in the driveway, for anywhere he went in New Rochelle, he'd run into mutual friends of his and Irene's. As a consequence, he just sat alone most of the time in the empty house with the radio turned up loud. Looking

around at the fine furniture and costly decorations, of which they had been so proud, he reflected that all he had accumulated from his labors was a lot of expensive bric-a-brac.

He didn't feel bitter toward Irene. He had to admit to himself that they really hadn't known much about each other—not the important things anyway—when he persuaded her to marry him. They still didn't! They didn't enjoy the same things; Irene hadn't cared for art and travel, which meant so much to Norman. They had never even learned to like each other a lot—or to dislike each other either.

Norman reflected that if Irene thought she could be happier with someone else, maybe she was right. He might be happier with someone different, too, though just the thought of a new liaison was distasteful at this time. It would be better to be alone, with no ties to anyone, he thought.

After several days of floating about in the warm, comfortable depths of self-commiseration, Norman realized he simply had to surface and face the cold world again. He didn't find any of the former satisfactions when he made contact once more with the old gang around town. They seemed like strangers now. Another solution to his situation was needed, and he thought he knew what it was. New York City. Plenty of action there. Handier to business contacts than New Rochelle. And he knew many people in the big city who were strictly *his* friends.

This time, he'd go in style. No little room at the Salmagundi, such as he'd had during his brief separation from Irene a year previously. This was to be a permanent setup, so he wanted both a first-class studio and stylish living quarters appropriate for a famous, prospering artist. There was one place made to order for that, and he headed straight there.

The Hotel des Artistes was built with successful, and rich, artists in mind. Still standing in massive elegance at the corner of Central Park West and Sixty-seventh, the rococo ironwork of its outer gates and lobby doors is carefully guarded. Back in the early decades of the century, its spacious, two-story apartments attracted a scattering of celebrities from the theater. Rudolph Valentino stayed there when he traveled East. Ethel Barrymore lived there for a time. Most of the residents, though, wanted the

big studio rooms with their twenty-foot-tall windows for their original purpose.

In Norman's apartment, you walked from the entry hall into a small library which opened onto the double-story main room, the artist's studio. This was practically all glass at the far side. When you were in the center of the studio, you could look up at a balcony over the library where there were two bedrooms. They were reached via a circular iron stairway. There were also a dining room and kitchen downstairs, and a very important storage room for canvases and art supplies.

The kitchen came complete with dumbwaiter and chef's service. You merely had to telephone down to the hotel's main kitchen if you wanted a meal prepared. The chefs there would cook whatever you wished, to order, and send it up with the wines you requested. They asked a day's advance notice for exotic dishes that might entail shopping for special supplies.

This was going to be the life, Norman decided. All the luxuries he had become accustomed to, and more, with no emotional entanglements whatever to interfere with his beloved work. Having signed the lease, he hurried back to his house in New Rochelle to select the items of furniture he wanted for the apartment and to arrange for moving them and the studio contents. While they were being packed and delivered, he engaged an interior decorator to paint the new place and fit it out with the most tasteful carpeting and draperies money could buy.

Norman should have remembered from his first bachelor stint in New York—but he didn't—that the city could be a lonesome place. If he wasn't too busy painting, he might call someone to have lunch with him. For dinner, though, his artist friends always seemed to go home or out with other couples. Norman threw a big dinner party to which everyone came to see the new apartment, but that took care of only one night.

He took up horseback riding in Central Park to fill up some time during the day. Even though he outfitted himself in all the latest equestrian finery from Abercrombie's, that didn't cancel out the fact that he was one of the awkwardest horsemen east of Laramie. He became the Ichabod Crane of Central Park. Finally a recalcitrant mount convinced him he'd better give up before he ended

up with a cracked skull—or, worse yet, a fractured brush hand.

With each succeeding month, time seemed to drag a bit more, and his poor frame of mind began to make it harder to maintain the enthusiasm he needed to turn out outstanding work. Just when he felt he couldn't stand up under the situation much longer, a change was forced on him.

It all came about because Norman hates to hit people with a strong, definite no, even when he means no. Many times, he'll soften a refusal by stating, "Not now, I'm too busy, but maybe sometime later." He had been giving this type of brushoff for quite a while to the persistent art editor of *Good Housekeeping.* The man had approached him several times about illustrating the life of Christ for his magazine. This was to require a long series of pictures which would run for many months.

In no way was Norman willing to undertake such a task. In the first place, he hates to do a series of anything. Besides he had promised Mr. Lorimer at the *Post* that he wouldn't work for any other magazines. And finally, Biblical pictures simply aren't Rockwell's thing. He had tried to convey some of this to the editor, but not enough to turn him off entirely. As a result, that gentleman tried to pin him down again at the big party Rockwell threw in the apartment. Once more Norman had difficulty in cooling him off. To get away from him so he could attend to his other guests, Norman finally said, "Sure, I'll do it," thinking the man had had so much to drink that he probably wouldn't even remember the promise in the morning.

That was definitely not so. The next week, the man from *Good Housekeeping* showed up to discuss getting the series of pictures started right away. When Norman told him he really hadn't meant to make the promise, the editor became very much upset about the whole matter. So upset, in fact, that he threatened to sue Rockwell for breach of a promise made in front of witnesses. Norman, he claimed, had put him on the spot with his boss and had upset important plans at the magazine. Perhaps he wouldn't have followed through with his threat of a lawsuit, but Norman decided not to chance it. The *Post* didn't like the idea that he might have another magazine's assignment forced on him, so its

lawyers advised him to get out of town for a while, just in case a process server came looking for him.

California was the place to go, he was told by his old friend Clyde Forsythe, who happened to be visiting Norman at the time with his wife. It was a stroke of fate in more ways than one. Norman packed his bags and the three of them boarded the train, heading westward.

The trip to Los Angeles with the Forsythes was to be a brief vacation, but Norman found many things in California to keep him there. He was always the happy traveler, pleased by exotic surroundings, and his painter's eyes opened in fascination at first sight of the Golden State. He knew he must stay at least a little while to capture some of the new feeling that must be there in a land so different from the East Coast.

So far as is known, he never did paint any of the scenery—the open hills that terraced down from the bowl of the mountains, the woolly citrus groves that surrounded the city then, two generations ago, or the lines of royal palms that towered haughtily over many of the avenues. He never was a landscapist. But he did begin right away to paint some of the marvelously interesting people who seemed to be all over the place.

As Clyde had promised him, this land of sunshine and the open sport shirt was also the place where the finest artists' models in the world were clustered, like bees in a clover patch. The honey that had attracted them was Hollywood, the big jackpot in the golden sunset. They had swarmed to the studio area, just a few miles from where the Forsythes lived, not to pose for artists, but to become movie actors and actresses. Not one in a thousand of them ever landed more than a bit part in a mob scene; the others seemed to spend most of their time wandering around Hollywood and Vine, where an artist with a sharp eye could spot just the model he wanted in no time at all.

There were beautiful young girls and spectacularly handsome young men everywhere. Artists like Flagg and Christy back East would have dropped their eyeballs at the sight of such a concentration of perfect models for their perfect pictures. All were happy to earn eating money by posing, rather than scrounging for jobs

*Gary Cooper, guns and all,
becomes the subject for a*
Saturday Evening Post *cover
in 1930. He and Rockwell,
with Norman's friend, Clyde
Forsythe, had so much fun
together that it was difficult
to get the painting finished.*

as clerks, dishwashers, waitresses, or laborers. Norman was more interested, though, in the character actor types. From kids to old men and women, many of whom were veterans of long years in the legitimate theater, they offered an infinite variety for Norman's selection.

During his stay in the Hollywood area, Norman painted just one *Post* cover that was based on a movie theme. He decided there would be some appealing humor in picturing a rough, tough, he-man sort of character sitting meekly while a studio makeup man applied lipstick to him. Clyde, still the never-failing admirer of Norman's ideas, thought this concept was absolutely great and

deserved to have a real "name" actor pose for it. "Come to the movie lot with me," he told Norman, "and I'll have one of my friends arrange it for you."

The publicity department at Paramount was more than happy to talk to Mr. Norman Rockwell, who wanted to put one of their actors on the cover of the *Saturday Evening Post*, where millions of people would see him. "Take your choice," they said. "Who do you want?"

It was finally agreed that the epitome of the he-man would probably be a cowboy, attired in his complete Wild West regalia. The studio told an incredulous Norman that he therefore ought to paint their number-one cowboy star, who happened to be Gary Cooper. "We'll send him over to your place tomorrow," they casually promised him.

Sure enough, the awe-struck artist had a visit bright and early the next day from a smiling giant of a man, all rigged out in range style from hat to spurs and with six-guns on his hips. Smiling shyly, he drawled, "I'm Gary Cooper," as if Norman didn't know.

"We had a wonderful time," Norman recollected to me. "He was as nice a guy as ever you'd meet. I didn't know what to expect from a famous movie star; maybe that he'd be sort of stuck-up, you know. But not Gary Cooper. He had fun, too. He horsed around so much in Clyde's studio, where I was working, that I had a hard time painting him. Clyde and I had a picnic that week, though we didn't get much work done."

The cover with Cooper on it was finished very early in 1930. It appeared on the *Post* issue of May 24 of that year.

Norman also got involved in California with one of his rare attempts to teach art. "I'm just no good at teaching," he states. Yet someone at the Los Angeles County Artists School who heard he was in their city got in touch with him and managed to persuade him to take on an advanced class in illustration.

In recalling this episode, he remembered that he had also tried something similar once in the Westchester area. "It was just a year or so before I came to California. A school in Mamaroneck. I taught there for only a few weeks, and then I gave it up. So I don't know why I tried again in Los Angeles, but I did."

Why hadn't he been able to teach others? Certainly he was

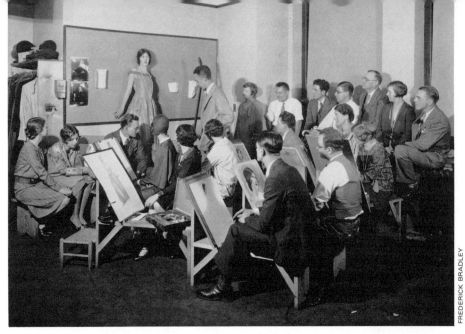

This scene at the Phoenix Art School in New York City in 1928 shows Rockwell lecturing to a class of would-be illustrators. He admits he was never very successful in teaching others the skills of painting.

always generous in sharing his knowledge. Couldn't he communicate his ideas? His explanation to me was, "Oh, I could tell the other people how I produced it . . . how I got the effect. But I would take the wrong approach for a teacher, I guess. I would tell a person, 'Do this or do like that.' And that wasn't enough. I didn't explain the reasons behind it. Maybe I didn't even know the reasons myself or think about them. But there was always someone in a class who would raise an objection to my way. They'd want to get into an argument with me. *And I was no good at arguing.* So I figured if that was what teaching was like, I better leave it to someone who knew how to maneuver an argument. I'd stick to what I knew—painting. So I didn't stay long at the Los Angeles County Artists School."

Although teaching wasn't for him, Norman did like teachers. In fact, one in particular. Her name was Mary Rhodes Barstow. Before the train even arrived in California, Clyde and his wife had

been telling Norman about *the* girl for him—Mary. She was pretty. She was intelligent. She was very much interested in art and was a great admirer of Rockwell's work. Just the girl for Norman, they insisted. He agreed the minute he met her.

Mary Barstow and Norman were introduced at a dinner larty the Forsythes held for the express purpose of playing matchmaker. Mary was everything Norman had been led to believe she would be—a vivacious young woman who made him feel at ease right away and delighted him with her knowledgeable conversation about artists and art. She was fairly tall—in her high heels, almost as tall as Norman—had wavy brown hair, sparkling brown eyes, and a pretty, heart-shaped face.

Almost too good to be true, Norman thought. She was so young and radiant to be interested in an old, divorced man like him. Mary told him she had just graduated from Stanford University the previous summer and was now teaching in an elementary school in San Gabriel. He learned that she was only twenty-two. He was thirty-six. That was just too much of a difference for things to work out, he thought.

Everything did turn out to be hearts and flowers though. The pair became engaged just a few days after they had met. They'd have scheduled the wedding right away, too, but Mary's father had some doubts about a quick marriage between two people of such differing ages and backgrounds. They waited three months to satisfy him and were married on April 17, 1930.

The bride and groom returned to Norman's apartment in the Hotel des Artistes, but living in noisy, dirty New York City didn't suit Mary any more than it did Norman. When she saw the house Norman still owned in New Rochelle, she knew that it was the kind of place where they could live happily and raise a family. They closed up the apartment and moved everything back to Lord Kitchener Road.

Even though she was fourteen years his junior, Mary was the stabilizing gyroscope in their marriage right from the start. She took one fast look at the free-and-easy social style of Westchester County and decided that the new Mr. and Mrs. Rockwell would have none of that. Norman resigned from the country club and the yacht club. He put his opera cape, top hat, and silver-headed

cane into the rack in his costume wardrobe to serve as future props for pictures.

Instead of tearing around town, Norman stayed in his early-American studio and put in a solid day's work, every day, with no juggling of the schedule to allow for big parties or hangovers. He was never happier. Mary took a genuine interest in his work and was always pleased to discuss what he was doing. More important, she tried to help him worry his way through the problems that inevitably arose as he worked on paintings.

One day, after he had mentioned how fondly he remembered listening to his father read stories from Dickens to the family, Mary asked if he'd like her to read something aloud while he painted. She did this—and really started something. Norman enjoyed listening, and his painting seemed to go easier and faster. Certainly the day moved along quickly with Mary in the studio. Norman asked her to read to him again when she could. It became a frequent pleasure of Norman's.

Through the years, he estimates that Mary read to him most of the best-selling novels and biographies that had been published, along with many of the classics. "She went through the complete works of some of them," he observes, "the complete Dickens, for one. I've always loved Dickens. And Henry James, Tolstoy, Dostoevski. Jane Austen, too—that was a favorite of hers." Maybe Norman wasn't able to finish high school, but how many of us have the advantage of our own private tutor in literature?

Mary's unfailing good humor was also much appreciated by Norman. She needed it, for Norman always has a few misgivings as a painting progresses. He needs some cheerful assurances from others at such points. Sometimes, when he really gets disgusted with a picture and starts to wipe out big sections of it with the turpentine rag, he stews himself into a black mood that's hard to penetrate. On such occasions, Mary had to work hard with her sympathetic hugs and infectious laughter to get him halfway smiling again.

Unfortunately, a lot of cheering up was needed in the next year or so. Norman entered a troublesome period in his work when he often just couldn't seem to get things right. The quality of his work didn't satisfy him. The number of paintings he was able to

produce declined too, because he would make change after change in them and often discard a canvas altogether. He tried just about everything, including producing a *Post* cover based on a new theory of painting called dynamic symmetry.

This was an involved theory which required the artist to tailor his design to fit some intricate mathematical formulas of proportion and balance. Unfortunately, the calculations didn't suit the proportions of the magazine, nor did they mix with Rockwell's long-established way of doing things. The dynamic cover ran on the March 28, 1931, issue of the *Post*, but fortunately it was Norman's last brush with the newfangled theory so many of his artist friends were excited about.

In 1932, a son was born to the Rockwells. He was named Jarvis, after his uncle and his grandfather. Norman was delighted with the baby. Playing with him in the evenings provided a happy relief from the troubles of the day. But those troubles were mounting.

In the spring of 1932, Norman announced to Mary that they were all going away, to Paris. He needed to study, he said. His painting wasn't going right at all. Dynamic symmetry hadn't been the solution, but there were other new approaches being developed by the artistic innovators in Europe. Picasso and Braque and their friends had started a whole new thing. Now there were futurists and expressionists and surrealists trying all sorts of wild and wonderfully imaginative approaches to painting. The main thrust seemed to be in the direction of abstraction. Unless he took the necessary time to find out the secrets of that style, Norman thought, his whole career might go down the drain. It seemed headed in that direction now.

Dutifully, his helpmate Mary packed up Jarvis and locked up the house. They took off for an indefinite stay abroad. Norman plunged into his search for the magic solution as soon as they got to Paris. He tried several schools there. At each one he was told something different. At each he was also asked by some of the advanced students and professors if he thought that they might learn to be successful illustrators. His instructors were at a loss as to what they might teach a man who earned more money in a week that they did in a year.

Rockwell stayed in Paris for about seven months. During that time, he painted two covers in an abstract style, and both were turned down by the *Post*. During 1932, only three of his cover paintings appeared on that magazine, the fewest in any year from the time he sold his first efforts. One of those 1932 covers appeared on the January 30, 1932, issue, so it had to have been painted in the preceding fall months during Norman's turbulent mental period, when he was thinking about going abroad. It pictured a young lady tourist with a bilingual dictionary asking directions of an animated French gendarme.

At the end of the seven months in Paris, Norman had learned very little, except that the answer to his problems lay within himself. Maybe that wisdom made the trip worthwhile. He later told a writer for the *New Yorker* magazine, Rufus Jarman, "My best efforts were some modern things that looked like very lousy Matisses. Thank God I had the sense to realize they were lousy and leave Paris."

Returned to the States, he resolved that he must buckle down and really plug away until he got his painting straightened out again, no matter how long that might take. This was going to be no quick turnaround, he felt in his bones, and he was right. It was a long struggle, a complete rebuilding of his confidence, that was to go on for two or three more years before whatever had been bothering him went away.

One of the things that helped greatly during this period of frustration and uncertainty in his work was a decision to concentrate more on illustrations, rather than magazine covers. In a sense, this was a starting over, since the earliest days of his career had centered on making illustrations for stories in magazines and books. He had always found it much more difficult to paint covers because they required that he start from scratch, or rather from a brand-new idea which he had to think up himself. In illustrating a story, the idea was already there, created by the author; Norman needed merely to visualize the author's dream and paint it.

A second son, Thomas, was born to the Rockwells in 1933. Jarvis was nearly two—at the toddling and into-everything stage. Mary and Norman were happy in their marriage, despite the

strain they both were undergoing because of his continuing struggle with his work. He did enjoy getting immersed in the good stories the magazines sent him to illustrate. They allowed him to draw on the imaginations of some of the finest writers and to gain creative strength himself as he put on his canvases what they described in words.

In 1935, he accepted an assignment to illustrate two books which marked a turning point in his troubles. From a financial standpoint, painting for the book publishers was a lot less desirable than turning out magazine covers or illustrations for advertisers, who paid many times as much for a picture. From an emotional standpoint, though, this particular commission was exactly what Norman needed at the time.

"I was so excited," he told me. "I was asked to illustrate the classics of Mark Twain. He's one of my very favorite authors. I felt so honored that they had come to me to illustrate his books. He's great! It was to be *Tom Sawyer* and *Huckleberry Finn* both—eight color paintings for each book."

Like a teenager at a hamburger stand, Norman plunged happily and hungrily into this enticing new project of illustrating the Mark Twain books, which were to be published by the Heritage Press and issued as Limited Editions Club offerings. Right away, he began rereading *Tom Sawyer* and *Huckleberry Finn* so he could figure out what scenes he would use for his sixteen paintings. He made small rough sketches of many different happenings from the books as he visualized them.

Of course, the Twain classics had been printed many times before. Norman studied the illustrations in as many of those previous editions as he could find. He wanted to choose different scenes, where he could, and make his pictures as different as possible from earlier ones. Also, he vowed, his creations must be far better than anything that had been done before.

As he studied the works of other Twain illustrators, he sensed that there was something missing from all of them—something very important. When artists talk among themselves, Norman told me, they sometimes call it "the *smell* of the place." By that they mean that when you look at a truly great realistic picture, all

your senses tell you that everything in it is precisely right. It's so real you can *smell* it! And the reason you can is that the artist did. He had actually been there, soaking up all the atmosphere he could.

Somehow, Norman's sensitive instincts told him that none of the illustrators before him had actually gone to Hannibal, Missouri, where the two stories were based. They had sat in their studios somewhere thousands of miles from the Mississippi and just guessed at what the places and the people really looked like. That was a mistake, he thought, one he didn't intend to make.

Off to Missouri he went, by train to Saint Louis, and then by car upriver. To his delight, Norman discovered that the little town of Hannibal showed almost no sign of change since Mark Twain's time. Many of the buildings talked about in Twain's stories still stood, just as he had described them. The townspeople were happy to point them out to visitors and to provide any other information they could about the era when steamboats were kings of the river.

With the guidance of the local residents, Norman was able to follow exactly in the footsteps of Tom and Huck, as detailed by Twain when he wrote of their adventures. He climbed over the fences, walked down the same streets, strolled into the same stores and houses, found their secret cave (now a well-known landmark). Equally as important to the artist, he studied the faces and the idiosyncrasies of the people. Everywhere he went, he took his sketchbook, which rapidly became filled with backgrounds he might use.

As always, he wanted some authentic costumes of the place, so he'd be able to dress his models correctly when he returned home. In this case, the costumes would not be the colonial dresses and dragoons' uniforms with which his closets in New Rochelle were already amply stuffed. Instead, his models would require well-worn farm clothes. There seemed to be plenty of these in Hannibal, but they were still in use—on the backs of the residents.

After some hesitation, Norman decided he simply had to have an assortment of old pants, shoes, hats, and etceteras, showing the stains and tears of long, hard usage. He likes to tell and retell the story of how he began to buy a supply of old garments. The

people he approached thought he was crazy when he told them he wanted the clothes they were wearing, but when they saw the money in his hand, most of them agreed to sell. In fact, they even told their friends to hurry down to town to get some of the greenbacks from that nut from the East before his supply of cash ran out. Norman finally had to run away from the eager sellers who saw an opportunity to get rich quick on the proceeds from old sunbonnets, sole-flapping boots, and bedraggled coats. He did head back home, though, with a beautiful (to him) supply of just-right clothing for dressing the likes of a raggedy Huck Finn and his buddies.

The pictures Norman painted for the two Twain classics were a triumph of illustration. They were also a euphoric stimulant to his psyche. After such a long time of seemingly endless trouble with his work, he had finally created something that was absolutely, undeniably, beautifully, gloriously right! His whole world, which revolved around painting, was okay again. The sun was shining.

A model for a Coca-Cola calendar enjoys a pause that refreshes. In the 1930s when he created this illustration, Rockwell had more assignments offered him for advertising illustrations than he could handle.

In the May, 1936, issue of *American* magazine, Rockwell wrote: "Right now I am engaged in the most delightful task of illustrating an edition of Mark Twain's *Tom Sawyer*—recording the trivial events in the lives of two ordinary American boys. While literary men of fifty years ago were imitating European novelists, Mark Twain was immortalizing the prosaic environment of Hannibal, Missouri. His books . . . have enabled the rest of the world to understand and appreciate us . . . and us to better understand ourselves.

"When I go to the farms or little towns, I am always surprised at the discontent I find. The farm family so often looks with envious eyes upon the town, the town upon the cities, and the cities upon New York. And New York, too often, has looked across the sea toward Europe. And all of us who turn our eyes away from what we have are missing life."

In the years immediately following, Rockwell turned out some superb paintings. He created many other fine illustrations. One series of pictures was ordered by the *Woman's Home Companion* to go in a biography of Louisa May Alcott. For this, as for the Mark Twain pictures, he journeyed to the original locale to get the right flavor for his illustrations. Again, the results justified the pains he took.

Another of the excellent pictures he painted during this period was something new to him—a mural. The only true mural he has ever created, it was a challenge that came to him quite by surprise. He was approached by an architect from Princeton, New Jersey, who was designing several buildings there. The architect had seen an illustration of Rockwell's showing a colonial sign painter working on a sign for a tavern. This gave him the idea that Rockwell might do some colonial-day figures for a tavern that was to be part of the new Princeton complex. He wasn't thinking of a sign, of course, but a mural to go inside the building. The novelty of the request intrigued Rockwell; he said he'd have a try at it.

Since Princeton had been the scene of much fighting during the Revolution, the architect and Norman agreed that they wanted a picture with soldiers in it. And they decided that the character from the song of the early days, "Yankee Doodle," might provide

a good theme. In keeping with his passion for complete accuracy of historical detail, Norman had a tailor make him several authentic Hessian uniforms and other costumes for his models to wear. He can't recall how many exactly, but since there are twenty people shown fully or partially in this scene, the tailoring bill must have taken a huge bite out of a commission that couldn't have been too lucrative to start with.

The finished mural was thirteen feet long. Norman worked on it, off and on, for nine months, when not involved with other urgent jobs of higher priority. It was put over the bar in the Yankee Doodle Tap Room of the Nassau Tavern. I journeyed to Princeton especially to see the mural, which is still there, and it was well worth the trip. Probably the finest barroom decoration in the world, it is a superb painting that has everything: a rare, anecdotal quality; historically perfect detailing; striking realism; beautiful caricatures; strong humor; and great design.

Everything seemed to turn out well for Norman now. He was back in the swing with some fine *Post* covers. People from other magazines and books and advertising agencies were all after him with more commissions than he could handle. The family was coming along well, too. In 1936, a third son was born. He was christened Peter.

This period of smooth and happy sailing ran into a few surprise squalls late in 1936 which caused Norman to do some readjusting of his course. The first shock was delivered by George Horace Lorimer, of whom Norman has often said, "He *was* the *Saturday Evening Post* all through the years I knew him." Mr. Lorimer, as Rockwell always addressed him, called the artist to his office and broke the news that the magazine wanted a new editor. With tears in his eyes, he haltingly admitted that after thirty-seven years as the power at Curtis, he was being forced into retirement to make way for a younger man and some new ideas.

To Norman, this was like saying the North Star was being abolished. Mr. Lorimer was the one constant he always looked to in his career. If he had trouble with his work, he could always talk to the all-knowing editor and get his course straightened out. When he had become engaged to Mary, Lorimer had sent his assistant all the way to the West Coast to have a look at the young

woman and report on her suitability as a match for their most popular cover artist. (If Lorimer had disapproved of the match, I've wondered whether Norman would have broken the engagement.) Lorimer was more than a father figure to Rockwell—he had been the law and the prophets. And now, suddenly, he was but a tired old man, hunched over a bare desk top and wondering what to do.

This last meeting with Lorimer shook Norman up considerably. So did the news a year later that the former great editor had died. And so did the change in Rockwell's relations with the staff at the magazine in the ensuing years. He didn't like Wesley Stout, who took over the editorship and remained in that job for the next five years. Instead of the strong reassurance he always needed that a new cover idea was on target, what Norman got from Stout was more doubt to add to his own. Rockwell tartly observed to me that there was always something Stout wanted changed in a cover when it was started, and something he didn't quite like about it when it was finished.

Norman began to lose confidence in his cover paintings. He sought more assignments from other clients. He also began to get restless about living in New Rochelle. He had lived in that town for more than twenty years, and the memories were not all happy ones. He was getting tired of the place, and he kept feeling that he needed constant changes of scenery to maintain his drive. He and his family would take the train back to California every once in a while to see Mary's folks and to give Norman a brief change of atmosphere.

One of his models provided an idea that led the Rockwells in a new direction. This was Fred Hildebrand, the man who posed for Yankee Doodle in the Princeton tavern mural and for many other pictures of Rockwell's. He was one of the most sought-after models in New Rochelle and an enthusiastic outdoorsman and fisherman. One day, while he was posing and Norman was painting away, the two began talking about vacations. Fred became ecstatic about a place up in New England where he thought Norman ought to take his family if they'd like to get away on a little trip.

The place to go, he said, was Arlington, Vermont. The big

appeal to Fred, the avid fisherman, was the Batten Kill River there, which he believed to be one of the finest trout streams in America, if not the very best. Norman doesn't care much for fish; he doesn't even like to paint them. After all, a fish has little expression on its face and can't lift its eyebrows to show emotion, which is Norman's criterion for a good model. Fred did mention, though, that besides the absolutely marvelous fishing, Arlington was one of the most scenic places you could find anywhere.

A vacation in Vermont sounded good. Norman loved trips to Europe, but they took a lot of time—and money. Earlier that year, in 1938, they had spent several months in England with the three children and a nurse. That had proved extravagant, even by Rockwell standards. For that kind of money, they could probably buy some old farm out in the hills where they could go anytime they wished. Might be a good idea. It would help Norman to kick the cobwebs out of his brain from time to time and be great for the kids, too—wholesome country atmosphere and a place for them to run.

In the fall of 1938, Mary and Norman decided to have a look at some rural spots. They headed north from New Rochelle until they hit Highway 7 into Vermont. They browsed around in Bennington and Dorset, with some advice from local residents and realtors, who kept assuring them that these were swinging communities where they could find a lively party to go to most any night. That just about drove the Rockwells posthaste back to New York, but Mary said, "No, let's at least go a little farther and see that beautiful, quiet spot that Fred Hildebrand had been telling you so much about."

When they reached Arlington, Norman almost drove through the town before he realized it was there. The community had only about a thousand residents at that time, and most of those were off on the side roads in adjoining rural areas. Not much likelihood here of the big-city shenanigans that the Rockwells were trying to get away from. As they pulled up to the Colonial Inn, with its sedate, white, "Southern-mansion" pillars, and entered the quiet entrance hall with its crystal chandelier and graceful circular stairway, they began to relax a bit.

After a delicious dinner, Norman stepped out to amble down

the main street and see what was doing in town. He soon discovered that nothing much was happening, which suited him fine. He also determined quickly that the place was filled with people who all seemed to look like the folks in a Rockwell painting should—flinty old farmers with noses as hard as the granite they broke their plowshares on; real, honest-to-God women who knew how to bake bread and sew a quilt. You could see in their faces that they had ideals and strong convictions which they were not about to change for anybody or anything. And you could paint that.

It took Norman about two puffs on his pipe in the general store, where he had stopped to buy a packet of tobacco and some wooden matches, to get acquainted with a couple of the fellows lounging there. He didn't quite have the twang, but he talked their language. They told him a little about the history of the region and about their ancestors, the Green Mountain Boys, who had fought under Ethan Allen to chase the damned redcoats right back where they came from.

Norman was fascinated. The more he listened, the more he became convinced that he needed the stimulation of a place like this. He and Mary talked to the local realtor, Bert Immen, in the morning.

Bert knew just the place for a summer vacation spot for an artist. It was sixty acres of meadow and apple orchard just a couple of miles west on Route 313. The farmhouse wasn't much to look at, but it perched just across the bank of the Batten Kill. An artist sitting on his front porch there could watch that crystal-clear stream splashing along the rocks. In season, he'd see the fishermen wading along it with their fly rods. Why, if the artist were a fisherman himself (which Norman wasn't), he could almost cast a fly into the waters of the Kill from his front porch.

There was a mountain in back of the farm, heavily wooded. Another mountain right across the highway. An island in the stream practically in front of the house where the only soldier killed in Arlington during the Revolutionary War was shot. Just down the road another mile or so was the field where Ethan Allen drilled his troops. The place reeked of charm and history. The Rockwells couldn't resist buying it.

They spent a few days there that fall and made arrangements with a local contractor to do some work on the buildings during the winter. Mainly, he was to renovate a small barn into suitable quarters for Norman to set up a studio. If the family was to come here for any extended periods, Daddy had to keep churning out those pictures. The house would require some fixing up, too, but it didn't have to be fancy for a summer home. For example, the fact that it had no central heating was not considered too bad, since there were several fireplaces and stoves which could be used on chilly spring or autumn days.

Norman was ecstatic about being a landowner in Vermont. The brand-new farmer (after all, he did have an apple orchard and some uncut hay) told all his friends in New Rochelle about the rural utopia where he and his brood were going to spend their summers.

The most interested of all the listeners was Mead Schaeffer, one of the country's finest illustrators, whose eardrums chimed when he heard the magic name Batten Kill. Mead, or Schaef, as he was often called, would travel across the country at the drop of a blue-speckled, double-tied fly to fish in a stream like the Kill. He had heard of it often from Hildebrand, the model whom he and Norman both used. Actually, Schaef's main contact with Norman at that time was an occasional talk on the phone about Hildebrand's schedule, since they both used him often and sometimes wanted him to model at about the same time. Now when they talked, Schaef always asked Rockwell, "Hey, Norm, you going to invite some of us up to your place to fish in the spring?"

Under the prodding of Hildebrand and Schaeffer, nonfisherman Rockwell organized a fishing party as soon as the weather broke. It was just for a small group of fellows the two avid trout chasers considered worthy of trying the famed Batten Kill. Norman phoned up to Arlington and arranged to have his builder open up the house for their arrival.

The little stag party was a huge success. The fishermen found the stream all they had been led to expect. Norman had fun playing host. The rest of the crowd even got him into some waders and down into the river, although, as Schaeffer told me recently, "Norman is no fisherman. I believe he did catch one fish that day,

but I think someone must have put it on his hook as a gag. We'd get all excited about the trout. But Norman's mind was back at his easel, thinking about revising the composition he was currently working on. He was *always* working."

Schaeffer also said: "I fell in love with Arlington, I hoped I could find a place like Norman's on the river. I found one just a couple of miles away on a feeder stream of the Batten Kill, the Green River. I bought the place right away; it had a half-mile of trout stream on it."

Mary, Norman, and the three little Rockwells thoroughly enjoyed their first summer in Vermont, in 1939. Plenty of room there—not like New Rochelle, which was becoming increasingly hemmed in by the spread of New York City. The boys, who were three, six, and eight at that time, loved the open fields and took to the shallow river like tadpoles.

Norman's work, always a prime consideration with him, was also thriving in the new environment. His acquaintance, Mead Schaeffer, had become a close friend now that the two of them were residents of Arlington, and they began to visit each other often to discuss picture ideas and help each other with advice when either one developed uncertainties about a composition. As the cold months approached, they hated to think about going back to Westchester County.

Schaeffer recalls that he had the inspiration first. One day he hit Norman with it. "I'm not going back to New York," he said. "Elizabeth and our girls agree with me. We're going to fix up the house some more, get central heat put into it, and we'll live here in Vermont all year round."

Norman thought for a moment, but only a moment, about the problems of leaving the New York area, where all his business contacts and his models were concentrated. Then he told Schaef, "If you can stay here, I will too. I'm going to talk to Mary about it right now."

Both families did stay in Arlington, and they formed the nucleus of what was to become one of the most unusual colonies of artists, writers, and visiting celebrities in the country.

7

"Guess I never really belonged in Westchester. I was never really happy there. But the hard-dirt farmers in Vermont–when I got with them it was like coming home."

Life in Vermont

Their first winter in Vermont, in 1939, gave the Rockwells a generous taste of the differences between life in a plush suburb of New York and life in a simple farm community in the granite mountains.

Although Mead Schaeffer had moved quickly to get his house winterized and heated, Norman had delayed a while before getting a heating contractor started on his place. As a result, the Rockwells had no central heat that first winter in the cold, cold country. Sometimes the temperature dropped to twenty and thirty degrees below zero. They burned a small mountain of birch logs in their fireplaces and in the several Franklin stoves kept roaring during the snow-filled months. They also learned to rely on the old Vermont secret weapons for keeping warm on blizzardy days and icy nights—long underwear and flannel nighties.

Always a hayseed at heart, Norman luxuriated in the rugged rural life like a cat in shag carpeting. He loved to walk through *his* orchard, across *his* fields, to climb up one of the round-topped mountains that circled shoulder-to-shoulder around the valley. Eventually he bought practically the whole mountain directly behind the Rockwell house.

Country squire accompanied by canine pals walks the hilly fields of his land, sandwiched between the slopes of the Green Mountains. His home was near the banks of the Batten Kill, a famous trout stream.

One of the familiar sights of the valley to West Arlington was the lean figure of Mr. Rockwell, the famous artist, puffing his ever-present pipe while he loped for the hills with his trusty dog at his heels. He always had some kind of hound at his house. Initially, in Arlington, the family dog was a springer. He died and was succeeded by another spaniel, and then a basset, Norman recollected to me. There was always a passel of cats around the house, too, but Norman ignored those; he was a *dog* man.

If Norman took a deep liking to Vermont, the love affair was mutual. When he first decided to move to Arlington permanently,

he had some grave worries about getting the people there to pose for him. This could have been a serious problem. Good models were crucial to his work, and he would be moving away from an invaluable gathering of experienced professionals in suburban New York to plunge into an area where the natives might not warm up instantly to the idea of posing for some artist fellow. To try to assure a supply of modeling talent, both he and his friend Schaeffer arranged to give some lectures on art at Bennington College. That did introduce them, and they both were able to find many young models from among the students there. But they soon discovered that the townspeople of Arlington, naturally reserved though they might be, were only too happy to assist "The Artists" as models or in any other neighborly way.

Soon after Norman and Schaef got themselves established, they were joined by two other skilled artists—Jack Atherton and George Hughes. Those two gentlemen had heard about the wonders of Vermont and how much their pioneering friends were enjoying them. They wanted to participate, too. As a result, The Artists, as the townspeople proudly described their new celebrity friends, became a group of four.

Other well-known people were attracted to the area, too. Dorothy Canfield Fisher, the famous author and editor, bought a place there. An advantage of having her in the neighborhood was that she was on the editorial board of the Book-of-the-Month Club. This meant that she received rafts of new books to review every month as part of her assignment of picking candidates for forthcoming Book Club offerings. The Rockwells and Schaeffers, who were omnivorous readers, were invited to help themselves at any time from this inexhaustible stack of new literature.

Mrs. Fisher was grateful to have them read some of the many books she simply couldn't go through thoroughly herself. They'd tip her off if they found a story that seemed way above average, and she'd give it her expert perusal then. Since Mary was always looking for books to read to Norman while he worked, this free supply was welcome. And it was somewhat flattering to think that maybe one of your recommendations could start the ball rolling for some author to make the Book Club and hit the best-seller lists. In a small way, perhaps the Rockwells were an influ-

ence on the literary as well as the artistic fare of the nation.

Other celebrities frequently came to the area from Hollywood. They heard about the little utopia in Vermont from The Artists, who all traveled a great deal and met many famous people on their assignments. Norman particularly had many friends in Southern California; when he wanted a change of locale, it was often there he went so that Mary could visit her relatives at the same time. Norman was a good friend of Walt Disney, who was in the habit of stopping in Arlington during summer trips east. Bob Cummings was another; the Rockwells attended his wedding.

Linda Darnell stayed several times in Arlington, Rockwell told me. She had a dual purpose in going to that secluded spot. She had broken up with an admirer whose temperature was still high, while hers had dropped well down into the "let's-forget-it" stage. This persistent friend, a well-known sports announcer, kept chasing her from coast to coast, but except for frequent phone calls, he never caught up with her in Vermont.

Miss Darnell's other reason for liking the Arlington hideaway was that she was a serious student of painting. The Rockwells entertained her for a time. He and the other artists gave her some tips on drawing and painting. This is something Norman *never* does, but who wouldn't make an exception for the lovely Linda?

Even though the Rockwells lived in a tiny, rural community, it shouldn't be assumed that they passed up too many comforts. After the first cold winter, their farmhouse was expanded and fixed up in cozy if simple style. They had two servants: a maid of all work and a gardener/handyman. Norman was never one to take on any chores around the house; he concentrated too hard on his art and put in long hours. Mary was also busily involved with his career. She and the other painters' wives had to be prepared to drop their household duties at the snap of the master's fingers to run out and round up props for a picture. This might be anything from unusual clothing to a butter churn, an organ, an antique table or chair. When they went shopping, it was usually not for something *they* wanted, but for some new painting prop that might later become part of the house furnishings.

Besides helping her husband constantly in his work, Mary had to act as mother to three active young sons, aged three, six, and

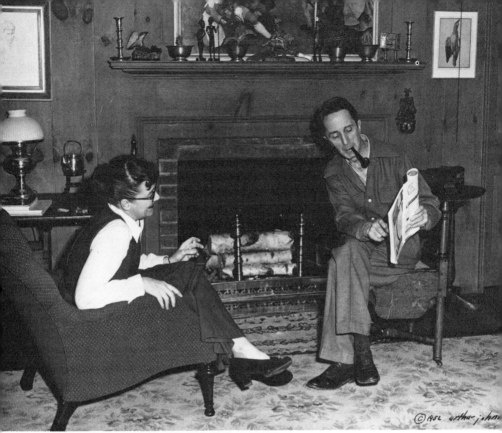

Mary, Rockwell's second wife, admires a magazine illustration pointed out by her husband. This 1952 photo was taken in the "sitting area" of his pine-paneled studio in Arlington, Vt. This small area for relaxing was part of the big, main room of the studio.

PHOTOS BY ARTHUR JOHNSON

At one of the busiest mailboxes in New England, where drawings for clients were constantly being sent out and stacks of letters from admirers were received daily. Butch, the Rockwell dog, is behind Norman with just his nose visible.

Three characters snapped at the funny photo booth at a California amusement park. From left, Norman Rockwell, Clyde Forsythe, Mead Schaeffer.

Mead Schaeffer gives gorgeous Norman Rockwell a sponge bath.

Movie fan on a Hollywood lot gets autographs from John Wayne and Oliver Hardy.

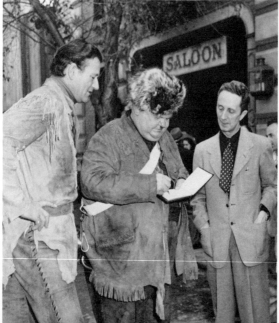

eight when they settled in Vermont. And not the least of her mothering involved her biggest boy—her spouse—when he ran into frustrations. The townspeople remember her telling them, "At least once a year, Norman has a real bad time with a picture." It is recalled that during one of those bad stretches, he did one magazine cover over five times before he was satisfied with it. And when the sky was falling in for Norman, it wasn't very bright for anyone around him.

In addition to having Mary always at his beck and call to fetch him supplies, round up props for his scenes, and act as all-round business manager, Rockwell felt he needed an assistant for his always-busy painting studio. Like the Italian masters of the Renaissance and before who delegated some of the routine, noncreative chores to apprentices and younger painters in their *bottegas*, Norman wanted some help. He particularly needed someone to aid him in taking photographs of models—a technique he was beginning to adopt in the late 1930s. And he frequently wished for a carpenter-handyman to build some of the props and backgrounds he was beginning to use at that time, as he started to move away from simple, outlined scenes into more elaborate magazine cover creations.

Quite by accident one day, he stumbled across a person who combined all of the several talents he was looking for in a studio helper. As he drove along the country road one morning heading west of town, he spotted a young man busily at work out on the lawn in front of a small house there. The man had carpenter's tools and lumber spread out on the grass and evidently was cutting and assembling some fairly elaborate construction. The cogs started whirring in Rockwell's brain; he slowed his automobile and made a U-turn as soon as he could find a wide enough place on the highway.

Parking his car behind the diligent carpenter, who was so engrossed in his pounding that he didn't even hear his visitor, Norman watched him for a while and then reached over and tapped him on the shoulder. When the young man turned around, they were both in for a surprise. In unison, both exclaimed, "What are *you* doing here?"

The man with the hammer was Gene Pelham, fresh from

Rockwell's former location of New Rochelle, New York. Norman had first encountered him a dozen years before when he was looking for "a fat little kid" to appear in one of his pictures. One of Rockwell's regular models recommended Gene for that part, and the boy had subsequently appeared in several of the artist's paintings. Rockwell developed a special rapport with the lad because he showed an exceptional talent for drawing, eventually winning some local art contests and attending art school. Rockwell knew that young Gene had, in fact, started a career of his own as a struggling professional illustrator.

During the years when they had lost track of each other, Pelham had acquired a pretty blonde wife and an awareness that it was difficult for an unknown artist to make ends meet in an expensive suburb of Manhattan. A relative in Vermont had persuaded the young couple to try their luck where the living was cheaper, in the Green Mountain area near him. They had borrowed enough money to put a down payment on a small cottage. Pelham, unaware that his old friend Norman Rockwell lived just down the road, was now in the process of trying to fix up his cottage. Since it was a warm, sunny day, he had decided to go out on the front lawn to do some sawing and hammering on the bookshelves he intended to install next to his living room fireplace.

As soon as the two old friends had brought themselves up to date on each other's activities, Rockwell inquired if Pelham might find a few hours occasionally to do some expert carpentry work or other jobs for him. He surmised instantly that Pelham, being an artist himself, would be a real find at the studio, understanding exactly what was needed in helping to set up a picture.

Pelham, who still lives in Arlington in the same house, told me: "I jumped at the chance to work for Mr. Rockwell. Any extra money was a godsend at that time, of course. I wasn't exactly deluged with assignments of my own; I knew it would be a long, hard haul before I could count on much of an income as an illustrator. But more than that, a chance to work in any way in Norman Rockwell's studio and see how he did things was like a dream. He had always been my idol in New Rochelle. He was the tops in the whole business."

What Pelham didn't know at the start was that his odd jobs for Rockwell were to become so frequent that they would take up the major part of his time for the next fourteen years—until the famous artist moved from Vermont. "I'd get a call most any time of the day or evening," Pelham recollected to me, "and the minute I recognized Norman's voice, I knew what would come right after the hello. It would be 'Gene, I need you.' Sometimes he'd want me to come over to his studio first thing the next morning. But just as likely, he'd want me to drop whatever I was doing and come right away. Norman could never rest or put anything off when he had a new project started."

"I built sets for him, stretched and sized canvases, got frames, shipped pictures—all sorts of work of that kind," Pelham explained. "And then he got me into photographing models for him too. There was no great expertise with the camera required, because he just wanted straight, clear shots. We finally figured that the best way was to shoot everything at F:8, so it was simple for me after he got his models posed the way he wanted them. I'd take bunches of pictures, and then after the shooting I'd generally work late that night in the darkroom he had in his studio, getting all the prints made so he could have them to go over first thing the next morning. That way he didn't lose any time."

"After a while, he let me do tracings, too," Pelham continued. "You know how he usually makes a complete, full-size drawing before he starts painting? Well, that has to be transferred to the canvas, of course. It takes time and has to be done very carefully, but it's just a pain in the neck. So I'd do that for Norman. Usually that had to be done at night, too, because when he finished the drawing, he'd want to get going on the painting the next day."

Pelham verified what Rockwell had said about his compulsion to work constantly, even in the years when his children were young. He corroborated that even Christmas time was no exception to this. Pelham recalled, "I remember one Christmas day, I got so mad at Norman. He had called me on the phone the day before, on Christmas Eve, to come over the next day and help with something—I can't remember what. I refused. I think at the time I half thought he was kidding. But damned if he didn't phone me again on Christmas morning saying he needed some help. I told

him, 'No, dammit! I'm going to spend today with my children. Now why don't you relax for a change and do the same?' And you know what? He wouldn't give up even then. In about an hour, Mary showed up at our door. He had sent her over to coax me to come; I know she didn't want to do that, but he must have insisted that she do it for him. I had to tell her too that I wasn't going to be in any studio that day. I never saw anyone work like Rockwell.''

If life was rough for Mary at times, it was generally good for the youngsters. Arlington was a wholesome place to grow up—great country and lots of it, populated by people who would do anything for you, if they liked you. And they liked the Rockwells: the father, who hobnobbed with some of the most famous people in the world, but who'd grab a broom like anyone else to help clean up the Grange Hall for a dance; the hard-working mother, who could be seen buzzing in and out of town myriad times a day to get art supplies, make business arrangements, or haul the kids around; the three children, who are still remembered in those parts as a fine bunch of boys, always welcomed back when they return to see old friends today.

Part of the boys' acceptance might have been due to the fact that they attended the local schools just like the rest of the farmers' children thereabouts. They were not off to some fancy private place, which their father certainly could have afforded if he had had a mind to. The boys participated wholeheartedly in every activity that came along, whether it was sports, blueberry picking at the edge of the mountain, maple-sugaring in the autumn, or dragging their beloved mongrel dogs and cats to the big annual pet show in town.

Up until the sixth grade, the Rockwell children went to a one-room schoolhouse, just like the ones you've seen in Norman's paintings. When they got home from school, the boys would run out in the back yard to Norman's studio to say hello and see how the paintings were coming. Sometimes he'd let them play with things from the treasure trove in the back room—that conglomeration of costumes and props from scores of pictures. Imagine playing Redcoats and Colonials with authentic military coats and hats to wear and real muskets to carry!

The boys took it for granted that they would see their father at

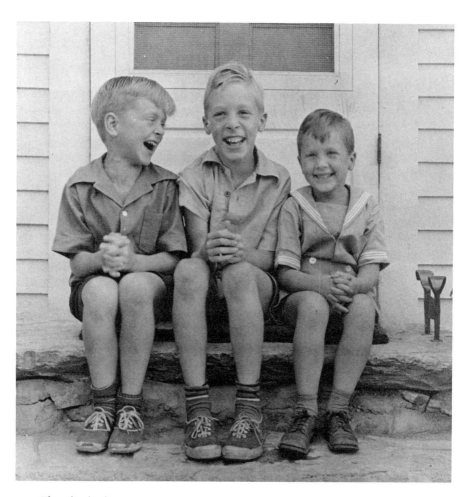

Three husky, happy Rockwell sons in Vermont in the very early 1940s. From left, they are Thomas (now a writer), Jarvis (an artist), and Peter (a sculptor).

work and spend some time with him, just as the neighboring farm boys saw their dads. Once in a while, Norman would knock off work for a spell to play baseball with his sons. They were also fond of getting out the .22 rifle and popping cans off the fence or walking back through the fields with Norman to hunt varmints.

Circuses were something Norman liked as much as the boys. There was one every year up in Rutland that they generally managed to see. Several times, when the big Ringling Brothers,

Barnum and Bailey show was in New York at Madison Square Garden, he took all the kids to see it. Because of his dealings with publishers, Norman frequently made trips to Manhattan, and he occasionally took his sons along so that they could have a holiday and remember what the big city looked like. On those outings, they'd not only visit such expected spots as the park or the zoo, but also offbeat places like the Bowery. His son Peter, in an article in *Ladies' Home Journal*, recalled that Norman once took them to Rockefeller Center at 7:00 in the morning so all of them, including dad, could run up the down escalators.

In the same article, Peter recalls that his father always made the decisions in the family—"whether it was deciding to have roasts for dinner, to finish his painting or to leave for California. When he became disgusted with work in New England, he'd just leave. Mother would wait for us kids to finish our school term and then we'd all go to meet him."

All of the boys had to pose for their father once in a while. That was no big deal for them. In fact, they weren't very keen on it because daddy didn't pay them as much as he did other people. The usual modeling fee for youngsters was five dollars, but Norman didn't want to spoil his own sons, so he only gave them a single dollar.

He acknowledged to me that he also tried to interest them in art. To encourage them, they all were given easels, pads, and supplies. Jarvis, the eldest, took readily to drawing. In fact, he decided to make art his career and is a professional artist today, though of a type far different from his father.

The second son, Tom, enjoyed drawing, too. As he grew a bit older though, he tended more toward writing, particularly poetry. Today he is a writer, specializing mostly in imaginative books for children that have won him growing recognition.

Rockwell remembers that only Peter, the youngest, turned his back completely on his father's attempts to instill some knowledge of the craft of the artist. The more Norman coaxed him to join the others in informal sketching classes, the more steadfastly he refused. Ironically, when he reached his twenties, Peter came to a sudden realization that creating art was what he wanted to do more than anything. He began sculpturing. He now maintains

his sculpture studio in Rome, though he sells much of his work in the United States. When I visited him and his family in their apartment in Italy, Peter proudly pointed out to me a painting by his father displayed in a place of honor. He told me then: "It's the only one by him that I have. I got it recently. I'm sure he'd have given me a picture before, but until I asked him for this one, it never occurred to him that I might want one of his paintings. He still doesn't think of them as anything so special, once he has finished the work."

As Rockwell and his other artist friends—Schaeffer, Atherton, and Hughes—became established as a fundamental part of the little town of Arlington, its reputation as an artistic center began to spread. That had some unfortunate byproducts. For people taking a vacation in Vermont, or those who lived in some town near Arlington and wanted to take a Sunday drive, it became a popular pastime to try to find the artists' studios along the Batten Kill. And nothing is more irritating to an artist than to have some gawker barge in on him and try to look over his shoulder while he's painting.

A story is told of Jack Atherton, whose consummate skill as a painter was exceeded only by the speed with which he could become angry and the sharpness of his tongue when he did. One day Atherton, who lived along the river near Rockwell's place, made the mistake of trying to paint out in his yard on a gorgeous weekend in that season when all the hills in Vermont are trying to outdo each other in the vividness of their color. He was making marvelous headway in capturing the vibrant colors of the autumn foliage, when he became aware that he was not alone. Turning, he coldly surveyed a pair of tourists who had parked their car along the roadside nearby and sauntered over to watch him work on his canvas. Undaunted by looks alone, one of them chirped in ecstasy at the sight of his nearly finished painting, "How did you ever do that?"

Atherton snarled back, "With a brush, Goddammit! Now get the hell out of here!"

If Atherton and Rockwell's other friends were caught occasionally by curious visitors from out of town, Rockwell was the prime target. To protect him, all his artist buddies had an agreement,

instigated by him, that they would give wrong directions to any tourists who asked the whereabouts of his house. Because it was hard to find—located on the far side of the Batten Kill—many people driving through with the intention of dropping in to give him the benefit of their company would stop at some house along the river to inquire where Rockwell lived. If they asked one of his artist friends—or even many of the other residents of the area— they would be told, "He lives a couple of miles down that way," while the director pointed his finger out of town.

Yet if anyone did manage to locate his whereabouts and traverse the narrow bridge across the river, Rockwell was too softhearted to chase them off. Pelham recounted to me an incident when this led to Norman's being cornered by a tipsy and amorous female admirer.

One afternoon when Rockwell was engrossed in his work at the easel, there was a banging at the screen door of the studio. Instead of swearing, as Atherton would have done, and scaring the intruder away, Rockwell absent-mindedly called out, "Who's there?" He didn't bother to look up. The lady on the other side of the screen took this as an invitation to enter. The next thing Norman knew, she was inside the studio, weaving decidedly as she walked, but bearing down unmistakably on him at alarming speed. Worst of all, she was calling out, "Oh, you darling. Oh, you darling. I have to give you a hug and a kiss!"

Always lithe and quick, Rockwell managed to drop his brush on the spotless floor and whip up out of his chair just before the lady hit, blasting the area with a cloud of potent alcoholic vapors. Norman let out a yell to his friend Pelham, who was in the darkroom at the time developing photo negatives. When Gene burst out of the darkness to find out what in the world was going on, he found a strange ballet taking place in the main room. The amorous female, a determined figure of formidable size, was charging at Norman like a lovesick bull (or cow?). At each lumbering pass, Norman would pirouette deftly and duck under her outstretched arms, never ceasing his frantic yelling for help.

Pelham says he managed somehow to maneuver the uninvited admirer out of the studio and out to her car. How he did it, he still doesn't know, but the presence of another person might have

spoiled the ardency of her emotions. Be that as it may, he suc-
ceeded. When he came back in, laughing at the episode, he found
Norman in no mood to join the hilarity. "He was more terrified
than I've ever seen him," Pelham remembers. "He was still shak-
ing, and he grabbed me and said, 'Gene, for God's sake, don't
leave me!' I'll never forget that woman, and I'll bet neither will
Norman."

In addition to Gene Pelham, Rockwell acquired a still younger
assistant for a few summers at the end of the decade of the
thirties. His chief recommendation was that he was even more
bashful than Norman—so how could Norman turn him away?

Orlando Cullinan, who used to own the general store in Ar-
lington and who with his good wife, Dorothy, now operates the
Maples Motel, remembers how a skinny, intense young man
named Freddy Manfredi showed up out of the blue one day. He
didn't talk much to anyone, and he seemed to have no money, but
at the general store he gradually confided to Orlando that he was
an art student who had come to town to try to see the great Mr.
Rockwell. He came from a poor family in Brooklyn. His one
ambition in life was to be a famous illustrator. He had concluded
somehow that if a poor boy from New York (Norman Rockwell)
had made it in the art world, maybe he, Freddy Manfredi, could
catch some of the magic if his hero would bestow a benediction.

Always a soft touch, Mrs. Cullinan advised the young man that
he could sleep on the porch of their house for a couple of days,
instead of in the small, unsuitable tent he proposed to live in
while waiting for his big moment. After a couple of days had
passed, he still had not screwed up enough courage to find his
way to Rockwell's studio, so Mr. Cullinan asked him if he
wouldn't like an introduction. The very thought of that set him off
like a bag of firecrackers someone had dropped a match into.

A phone call to Rockwell established the facts that "no, Mr.
Rockwell did not have any possible use for a young, ambitious art
student around his place," but "yes, he certainly would be happy
to talk with him for a few moments." Cullinan bundled young
Manfredi into his auto and headed west out the highway.

When they pulled into the Rockwell driveway and stopped next
to the studio, Norman was waiting in the yard under a shady

maple tree. Cullinan shoved the boggle-eyed young man out the door of the car and started him toward the famous illustrator. When they got to the appropriate closeness, Cullinan called out, "Norman, I want you to meet Freddy Manfredi, who is an ardent admirer of yours."

Freddy stuck out his hand to reach the outstretched one of the smiling Norman Rockwell—*the real Norman Rockwell.* But he was so totally overwhelmed by the magnitude of the occasion that he couldn't keep track of where his feet were going. Just as their fingers were about to touch, Cullinan told me, Freddy stumbled on a tiny grassy hillock and fell flat on his face in front of Norman. When he lifted his face from the tricky Vermont turf, it was clear from the look of him that he wished he were buried under that grass.

Sad as the mishap was, it was Freddy's salvation. Norman couldn't let him go away with his whole world shattered. So he offered him a job.

That summer and a couple of summers thereafter young Freddy spent in heaven. He followed Norman Rockwell around every day and made himself useful in any way he could at the studio. Besides handling various apprentice chores, he was especially adept at lettering, which Rockwell hates to do. In view of this, on those rare occasions when Norman painted a picture with a sign or a newspaper in it, he would allow ecstatic young Freddy to letter in the words that showed in the painting.

Then the war came along and swept Freddy away with it for a while. After it was over, he headed right back to Arlington and tried to make a living there in the small artist's studio of his own he set up. He found, however, that one who is not well known by art buyers gets very few commissions for illustrations if he lives in the hinterlands. Freddy had to go back to New York rather than stay where his heart was, in the maple forests of Vermont, but he did achieve his dream of becoming a professional illustrator.

The whole Rockwell clan had also grown to love the beautiful valley west of Arlington, nestled in the rough-hewn mountains so thick with game that the deer clogged the highway there when they came down their ancient crossings to warmer grazing areas before the snows hit. The Rockwells could not imagine living

anywhere else. But they were travelers. The family would often go into Manhattan with father when business took him there. Trips out to Los Angeles to visit Grandmother and Grandfather Barstow were common. And, on occasion, they went east to the New England shore.

On the shore it was Provincetown they headed for. It was a place that suited them all. Jerry, Tommy, and Peter loved the ocean, as you'd expect, and the dune country, which was so different from their home territory along the Batten Kill. Mary was an enthusiastic sailor. They'd rent a boat, frequently a Portuguese sloop, and Mary was never happier than when at the tiller with a leg hooked over the handle and her brown curls blowing in the wind.

Norman enjoyed going to the little fishing town, mainly because it was so picturesque, but also because he's a wanderer who can't stay in one location very long without taking some kind of trip. There were pleasant memories in Provincetown of his first visit there as a young art student, in 1912, about thirty years earlier.

The tip of the Cape was still relatively uncrowded and unspoiled in the early 1940s and therefore still looked like the town Norman had known as a struggling young artist. It attracted many artists and writers during the vacation months. The Rockwells' good friends Mead Schaeffer and his wife and two daughters often stayed the whole summer. John Dos Passos summered there. Eugene O'Neill was a frequent vacationer. The Rockwells would see these last two gentlemen on rare occasions, but there was no closeness between artists and authors. Norman knew only that Dos Passos and O'Neill lived in New York, wrote books and plays for a living, and were pleasant fellows to say hello to if you bumped into them on the street.

Despite the pleasantness of the Cape, Norman was always glad to get back to Vermont. The seashore was no place to work. It provided none of the conveniences of his beloved, quiet, spacious studio in Arlington, and he couldn't relax for very long away from his easel. After a refreshing few weeks at the shore, Norman was always rarin' to go with his brushes when he got back home.

He always had a stack of assignments piled up after a vacation,

and that meant starting an immediate search for models for each picture. He would scour the countryside to find just the right ones to fit the image he had built up in his mind for each illustration. When he spotted someone who fit his mental picture, shy Norman Rockwell always managed to screw up enough courage to approach the person, no matter who he might be. This often proved to be a surprise to strangers on the street who were accosted by a lean, intense man asking them to please come and pose for a painting. It sometimes proved surprising to Norman's friends as well.

Mead Schaeffer retold for me the story of a birthday party that took place in the early 1940s. It was a party for Mary, held on Sixty-seventh Street in New York City, where Schaeffer had a second studio. Along with the birthday girl, a guest of honor was the president of the Dodd, Mead Publishing Company, with whom both artists had business dealings. From the time the dinner started, Norman kept staring at the publishing tycoon. Finally he tapped him on the shoulder and asked, "Would you mind leaving the party with me for a little while? You're just the person I need for a painting of a fireman that I want do do."

Rockwell, Schaeffer, and the bewildered businessman excused themselves and caught a cab to the home of a photographer they knew in that part of town. The photographer had some company at his apartment that night, but they persuaded him to open his studio, which happened to be right next to his living quarters. Norman posed the man from Dodd, Mead. He had him screw up his face as if he were smelling smoke. The photographer banged away with his camera and got a few fast shots. His visitors thanked him and left.

"We were gone about three hours," Schaef recalls, "before we got back to the party. The girls were really burned up about our running out on them that way. But Norman was all happy and relaxed; he had some pictures of a model he'd been searching for for a long time. I don't know to this day what Norman saw in him so special. He looked like a lot of other men to me, but he was precisely what Norman had in mind for that one particular painting."

The painting that resulted from the episode was a magazine

cover. It had started when Norman found an old picture frame that had evidently been owned by a fireman. The frame, which he bought for a dollar at a junk store, had fire hats, hose nozzles, etc., carved into it. Norman immediately visualized a portrait of an old-time fireman, complete with helmet, rubber coat, and big mustache, inside the frame. He conceived the idea of a smoldering cigar butt on the mantel near this framed portrait. Naturally, the smoke from the cigar would waft up past the fireman's face in the picture, and Norman thought it would be funny to have the old fireman scowling and sniffing at the smoke. The finished cover appeared on the *Post* of May 27, 1944.

Norman would go to just as many pains to acquire the correct props for a picture. One of many examples of this single-mindedness occurred when he painted a Christmas cover for the *Post* in 1941. His idea then involved an outdoor newsstand of the type you see along the streets of a big city. He wanted to show the newsstand in a wintry scene. There'd be snow on the roof and on the magazines and newspapers outside on the shelf. Smoke would be coming out of a stovepipe on the stand. Inside, behind its glass windows, you'd be able to see the proprietor cozily sitting away from the snow and cold. There'd be a Christmas wreath and a string of colored lights on the stand.

It would have been easy for Norman to go to Boston or New York and make some sketches of a newsstand to which he could then have added his snow and decorations. He could simply have gotten photographs of stands. Or he might even have had one of the local handymen to help him slap up a few boards to simulate the front and the counter; then he could visualize the rest of the structure and come reasonably close. But close is not good enough for Norman.

He wanted the whole thing built, so he could pose his model inside, hang decorations and magazines outside, get all the reflections and shadows precisely where they belonged. To accomplish this, he instructed Pelham to build a complete and exact copy of the entire stand in his studio. It was then painted, fitted with a stove and smokestack, decorated, stocked with papers and magazines. As soon as the painting was completed, the whole contraption was dismantled. That was one expensive prop

that left no future benefit at all—nothing for Mary to put in her parlor and nothing that could be added to the costume closet.

This willingness to go to any length in order to achieve accuracy and authenticity is a holdover from the golden age of illustration, the source of Norman's training. Artists like Howard Pyle, Abbott, and N. C. Wyeth wanted all the realism they could possibly get in their models and backgrounds. Only when the real thing was impossible to obtain would they consider using other pictures for reference.

Because they did spend a fortune on costumes and props, the illustrators who still followed the old, precise way of doing things plowed a large part of their income back into their work. Today they'd be considered poor businessmen, and they were. They didn't have, and didn't want, an orientation toward business. What they created was what counted. Norman never dared to tote up the money he poured into colonial costumes, uniforms, his extensive gun collection. And if he had to take an expensive trip to get a feel of the locale for a few book illustrations which would bring him very little income, that was all part of the profession. He had enough money left after expenses to live comfortably and travel often, and that's all he really wanted.

There was also another payoff—one that all artists like, whether they admit it or not. Increasingly, Norman won awards and honors for the excellence of his work. In 1938, *Judge* magazine gave its High Hat Award to "Norman Rockwell, artist, illustrator, raconteur . . . for having become, while still a young man, a tradition in art . . . for his encouragement to aspiring young artists . . . for his youthful enthusiasm and curiosity about all things."

The *Ladies' Home Journal* honored him in 1939 for "standing head and shoulders above almost all others in depicting scenes from his country's Colonial days." In 1941, the Milwaukee Art Institute gave him his first one-man showing in a major museum. That pleased him greatly—to be recognized in the marble halls of the art palaces where paintings by Raphael, Rembrandt, Renoir, and Rubens looked haughtily down on the whispering viewers. And now some Rockwells had been allowed in, too.

Despite his ever-increasing fame, Rockwell still did not put a

high value on his popular magazine covers. Gene Pelham explained to me that once the famous artist received his paintings back from the magazine, if he ever got them back, he figured they had served their purpose and were worth nothing. He routinely used to take the canvases out of their frames and just throw them aside. Pelham recounts that Rockwell once gave him a stack of these old paintings, telling him to take them home and give them a coat of white paint; they would save Gene the cost of buying new canvas for his pictures, and Rockwell knew this was a big expense to a young artist. Fortunately, Pelham kept a few of those canvases, though he never availed himself of Rockwell's offer to help himself to any of the old cover paintings around the studio any time he wanted. Conditioned by Rockwell, Pelham at that time shared the master's view that a great big cover picture was a totally inappropriate wall decoration for a house.

In this regard, Pelham recalled to me how surprised Rockwell was the first time anyone offered to buy his paintings for decorative purposes. The two were at the studio one morning when Rockwell said, "Hey, Gene, look here. I just got a letter from some crazy woman in Chicago. She has a big recreation room in her house, and she wants some of my original *Post* covers to put on the walls. She wants several of them, and she wants to pay me a hundred dollars apiece. Can you imagine that?" Rockwell was delighted to pack up the several paintings he had in his studio at that moment and ship them off to the nutty woman in Chicago. He regarded this as an unexpected windfall for work he had already been paid for producing. For her $700, the woman in the Midwest received an art collection that might now be worth a quarter of a million or more.

Pelham remembers another occasion a year or so later which also demonstrates the cavalier attitude Rockwell had toward his work in those days. It was at the time of the local art show held in Arlington each year—the Spring Art Fair. Everyone who could paint was invited to put something on the wall at that exhibition. With his customary humility, Rockwell figured that it was perfectly logical for him, then the most famous illustrator in the world, to hang his work next to that of students and the amateur Sunday painters of the area. His only problem was that most of

his canvases were so big that he did not feel they were appropriate for a show where visitors would be browsing for a picture to put over the mantel at home.

Rockwell finally concluded that the only appropriate painting he had for the exhibit was a small one—his first April Fool *Post* cover—which at least was the right size for home use. The rub was that he was very fond of this particular painting, which had just come back from the magazine. He didn't want anyone to buy it. But he figured he could take care of that by putting a high price on it. As Pelham was leaving the studio that day to take one of his own paintings to the fair, Rockwell stopped him and took the April Fool canvas off the wall where it had been hanging. As he gave him the little gem of a painting—only slightly larger than an actual magazine page in size—he told Pelham, "I wish you'd take this small picture with you for the show. *But I don't want to sell it*, so I'm going to price it *high*. Tell 'em I want $500 for it, will you?"

Pelham recalls that he wondered if that would be enough to discourage any prospective purchasers. Just to make certain no one would buy, he decided to double Rockwell's price. He put a tag of $1,000 on the painting and gave it to the exhibit committee along with his own entries.

To his consternation, the next time he went to the Art Fair building, Rockwell's painting was gone. He learned that the picture had been sold at that outrageous price to Gracie Lambert, heiress to a pharmaceutical company fortune, who didn't care what the price tag was as long as she liked the painting. Pelham knew this would be hard to explain to Rockwell.

When he got back to the studio, he told Norman, "Jeez, what do you know—your picture sold." Rockwell was furious. He said, "I didn't want to sell that picture; I told you to put a $500 price on it!"

Pelham then explained, "I know you didn't want it to go. So I even upped the price. I put a $1,000 tag on it, but it still sold."

This upset Rockwell because he really didn't need the money, and he wanted to keep the picture. This particular painting, showing a multitude of errors in a scene where a man and a woman sat at a table playing checkers, had received a tremendous response from *Post* readers and had inspired Norman to

paint a whole series of annual April Fool covers thereafter. When he learned who had purchased it, he immediately got in touch with Miss Lambert and offered to buy it back from her, even at a profit. He was infuriated when she adamantly refused. The painting had a special meaning to him, but he was incapable of understanding how anyone else, even someone with piles of money, could pay so much for an insignificant little cover illustration.

The early 1940s were years of change, even for a quiet community in the hills like Arlington, Vermont. More and more of the young men of the town began to join the armed forces. Then World War II started in earnest. On leave, the boys would show up at the Grange Hall dances, proud but self-conscious in their army khakis or navy blues and whites. In portraying life in America, Norman naturally became interested in telling the story of the boys next door who had become the boys in uniform.

In those early days of the war, he didn't think of them as heroic fighting men, but as the kids he knew—farm boys and clerks—suddenly shipped away to a strange and lonesome new environment. One evening, at a square dance at the Grange Hall, Norman spotted a young man whom he could imagine as a bewildered young soldier, caught in the maelstrom of war. This lad, Bob Buck, was not in the military at that time, but he was destined to become one of the best-known "soldiers" in the world via Norman Rockwell's art—the archetypal rookie of World War II.

Young Bob Buck was "drafted" by Norman immediately for an October, 1941, cover painting. He was dumped into a pair of oversize army fatigues and shown surrounded by a bunch of bigger, older, very determined-looking soldiers who were concentrating their attention on the package from home the young draftee was carrying. The package was marked "FOOD." For the address label, Mary Rockwell invented a name for the new soldier. Inspired by the old children's book, *Wee Willie Winkie*, she suggested that young Bob Buck looked like a "Wee Willie" type, so he ought to be called Willie Gillis. That became his name for the duration.

Buck, as Willie Gillis, appeared on magazine covers with great regularity after that in a series of whimsical scenes. He was fussed over by USO hostesses, caught in a blackout with an attractive

*Willie Gillis, **one of the most famous characters ever created** by Rockwell, tries on his civies after returning home from World War II.*

young lady, shown a magic trick by an Indian fakir. His photograph was fought over by two young ladies who evidently both regarded him as their boyfriend. (The models for these two girls were Mead Schaeffer's two daughters, who often posed for Norman.)

Eventually, Buck ended this series of paintings by going into the service himself. Exempted from the draft because of physical disability, he enlisted as a naval aviator and flew away overseas. That put the kibosh on Norman's Willie Gillis soldier covers, except for one more picture. He finished the series with a family portrait gallery of six generations of Gillises, from Great-great-great-grandpa Gillis in a Revolutionary War hat to Little Willie in a GI helmet. That didn't require any posing. For years thereafter, letters poured in to Norman, asking how Willie was doing. (He came home from the war safe and sound.) After the war, in 1946, Norman painted Willie one final time. He was shown, older, seated on a window seat in a college dorm, studying his books; the old GI helmet and a bayonet hung from the window top.

As the war roared along, Norman became caught up in the national fervor over it and painted many other pictures related to it. During the war years, more than two out of every three magazine covers he created were based on some aspect of the great conflict. There were more than two dozen of these patriotic covers in all, ranging from references to victory gardens to Rosie the Riveter. He tried to contribute to the war effort in other ways, too. One example is a dramatic poster he gave to the ordnance department. It shows a machine-gunner, his uniform in shreds, firing the last cartridges from his gun; the caption below the picture reads, "Let's give him enough and on time."

Norman wanted to do more, though, to help the war effort. For weeks, he tried to come up with the "big idea" that would enable him to capsulize what we were really fighting for. Something that would get across an inspirational message in pictorial form, just as President Roosevelt and Winston Churchill had tried to do in verbal form with their proclamation of the Four Freedoms, which were our goal for the world.

That was it! In the middle of the night—at 3:00 A.M. on July 16, 1942—he sat bolt upright in bed with the answer. He'd paint the

Four Freedoms, translating those high-sounding intangibles into simple, everyday scenes of ordinary Americans enjoying them. It would be something everyone could grasp immediately.

Norman nudged Mary awake, or partially so. To the disgust of his usually understanding spouse, he proceeded to spout forth an excitement of ideas, gesticulating in the dark as he described four grandiose scenes that were going to wow the whole world. Mary told him to shut up and go back to sleep, which she promptly proceeded to do. But Norman couldn't calm down; his fuse had been lit.

At 5:00 A.M., three hours earlier than usual, he was out at his studio making charcoal sketches. As soon as he had some small thumbnail roughs sketched out, he jumped on his bicycle with them to catch Mead Schaeffer at breakfast and share his inspiration with his friend. Schaeffer, now retired on Long Island, where he goes fishing every morning, told me that he can still remember that day.

Mead sparked to the Four Freedoms idea immediately. He advised Norman to go ahead with the project just as fast as he could. What's more, Mead caught his friend's patriotic fervor and decided that he too should contribute some inspirational paintings to the war effort. He conceived the notion of a series of posters of our fighting men which would depict a broad range of military activities. That's what he'd do—paint the gunners, infantrymen, sailors, tank drivers, flyers, truck drivers—the men of all the units that needed the support of the folks back home. Like Norman, he'd donate his paintings without charge to the government.

Buzzing back and forth between each other's studios, the steamed-up pair devoted the next several days to developing their respective ideas. Norman worked out his four scenes in charcoal, and then made some medium-sized sketches in color. Schaef roughed out several posters of his men in uniform in full size. When they figured the two projects were visualized completely enough to be understood by nonartist types, they packed up their sketches and headed for Washington.

That's when the letdown occurred. They started off with Robert Patterson, undersecretary of war, and worked down from

there. Patterson was polite but unenthusiastic; he had more important things to worry about than printing posters and distributing them around the country. From that beginning, Norm and Schaef were passed down from generals to colonels to majors. Everyone said it was awfully nice of the two artists to want to contribute their pretty pictures free of charge to the War Department, but the War Department just wasn't set up to use them. One official ventured the opinion that by the time a special appropriation could be put through to pay for printing a large supply of these posters, the war would probably be over.

Each time the pair from Vermont went through their song and dance for a new official, their tempo slowed down a bit. They were really dragging by late afternoon when they reached one of the minor potentates in the Office of War Information. Once more, Schaeffer unrolled his big posters of the men in uniform, and Rockwell whipped out his four smaller color scenes that indicated what his full-scale paintings would be like. Their presentation was met mostly with silence until Norman finished explaining how he wanted to illustrate the great Four Freedoms concept of Roosevelt and Churchill.

"At that point," Schaeffer recollected to me, "this little publicity guy told Norman, 'We already beat you to that. See this folder we printed on the Four Freedoms?' And he showed us a small booklet with the text of the Four Freedoms, and in it were some tiny, poorly done, decorative pictures in pen and ink. Norman and I just looked at each other when we saw them. Neither of us said a word for a minute or so. Then he said, 'Schaef, let's get the hell out of here.' Norman picked up his beautiful color sketches. My posters were big and bulky, and I was tired of carrying them, so I just tossed them in the corner of that fellow's office. We walked out the door and headed for home."

There was little conversation between the disheartened pair when they boarded the train back to Vermont. Neither one of the artists wanted to say anything about the grand, idealistic plans that had gone sour, and that's the only thing they could think about. As the train whizzed northward, however, and the conductor came through their car announcing that the Philadelphia stop was just ahead, the two looked at each other with some new

stirrings of hope. Why not stop at the *Post*? There was a new editor there, Ben Hibbs, whom they both liked very much. He seemed to be open to new ideas. Maybe he'd have some interest in their patriotic paintings. Anyway, they ought to stop in to pay a brief call and see what new projects he might have in mind for them. Might as well get some good from their long trip. They grabbed their bags and scooted off the train when it pulled in to the Philadelphia station.

Editor Hibbs not only showed interest in the ideas of the two Vermonters, he hopped up and down. Schaeffer's pictures of fighting men from various armed forces units sounded great, even though Mead had to describe them without the aid of the big sketches he had dumped in Washington. They would make fine cover pictures, Hibbs decided. Schaef should get started on them right away. (He did produce a series of several such covers which appeared periodically throughout the war.)

Hibbs was even more ecstatic about Norman's desire to interpret the Four Freedoms via pictures of his Vermont neighbors exercising those rights in their homes, churches, and town meetings. These should not be cover pictures though, Hibbs decided. They'd be featured as full-page illustrations inside the magazine, along with an article commenting on the particular freedom pictured. And he wanted them right away. "Forget your cover assignments," he told Norman, "and get the Four Freedoms paintings finished just as quickly as you can."

Rockwell promised to have the four king-size paintings (each one forty-four by forty-eight inches) delivered in two months. Actually he didn't come close to meeting that deadline. "It took me two and a half months before I even got started," he says. "The scope of the job was just so big it scared the daylights out of me. Not just the size I planned for the paintings, but I knew this would be the most important thing I'd ever done. These would have to be pictures not just to amuse someone, or to entertain. They must *inspire*! That's a job for a Michelangelo, I thought, and that's not me."

When he did get started on the first picture, *Freedom of Speech*, nothing he put on the canvas seemed good enough. He painted that picture four times before he thought he had it right and

shipped it off to Philadelphia. *Freedom from Want* and *Freedom from Fear* went much faster and easier. Then he tackled the one that had really been scaring him—*Freedom of Worship*. Religion is such a touchy subject with many people, and he knew this one must be just right. After painting a complete picture on this subject, he concluded it had missed the mark, and so he scrapped it. Twice more he started sketches, neither of which pleased him. Finally, he got going on a fourth version, but he seemed to have almost as much difficulty with that conception.

"A face in the picture would bother me," he explained to me, "so I'd rub it out with the turpentine and do it over. I scrubbed so much on that painting—did parts of it over so many times—that I was afraid I'd go right through the canvas before I finished. But, you know," Norman confided, "those two pictures I had all the trouble with—*Freedom of Speech*, and *Worship*—are the ones I like best. Far better than the others, I think."

Publication of the pictures was accompanied by a great deal of fanfare. The magazine people were able to do what Schaeffer and Rockwell had struck out on; they enlisted the support of the government in taking the paintings to the American public. The Treasury Department agreed to participate in a series of Four Freedoms shows to sell war bonds. These were to feature personal appearances by film and theater stars, as well as other celebrities, along with a display of the four original oils.

War bond shows were held in sixteen cities, where Rockwell's paintings were viewed by 1,222,000 people, who bought a total of $132,992,539 worth of bonds. Each purchaser received a set of prints of the Four Freedoms as a keepsake. Other government agencies, and private organizations too, distributed additional millions of reprints. The Office of War Information alone printed four million sets. Portfolios of the prints were presented to President Roosevelt and his cabinet, all the members of Congress, members of parliaments and governments of many nations, and over forty thousand civic leaders throughout the United States. No other pictures in history have ever been so widely printed and distributed.

The shows were all spectacular affairs. Over four hundred entertainers, public officials, and miscellaneous celebrities par-

ticipated in the war bond rallies. Besides a host of movie and theatrical stars, these celebrities included such diverse notables as Edgar Guest, Viscount Halifax, and Henry Wallace, as well as distinguished ambassadors, senators, congressmen, generals, and admirals beyond count. Norman was an honored guest at many of the rallies. Eleanor Roosevelt reviewed the Four Freedoms concept and the paintings over a national radio network.

Norman lost ten pounds during the several months he struggled with these creations. Since there were only 135 pounds on his six-foot frame to start with, that was a sizable contribution to the war effort. But the results were worth all the strain. This group of paintings of his became the best-known pictures ever to come from an artist's brush. Probably more people saw them than have seen Van Gogh's sunflowers and Monet's waterlilies combined. And they loved them! So much so that more than seventy thousand people wrote to Rockwell to tell him so.

The spring of 1943, when he finished the last of his Four Freedoms paintings, was an unforgettable time for Norman. No sooner had he delivered the final canvas than he was sent to Washington to illustrate an article entitled "So You Want to See the President." This required that he spend four days at the White House observing and sketching what went on in the president's anteroom. When he returned to Vermont, all these sketches were destroyed, and he again had to travel to the White House to do them over. On that occasion, he was treated very kindly by President Roosevelt and invited to lunch with him.

Norman lost his first batch of sketches of the White House in a calamity that occurred at his home in Arlington. At one-thirty in the morning, Tommy Rockwell awakened the rest of the family by yelling, "Hey, look, the studio's on fire!"

To this day, no one knows how the fire started. Norman has speculated that when he switched off the light in the studio late that night, after having spent some time there talking with two friends, he might have dropped some ashes from the pipe in his hand on a cushion below the light switch. Others point out that Norman had a bad habit of tapping out his pipe and throwing matches into a big copper kettle where he also put turpentine

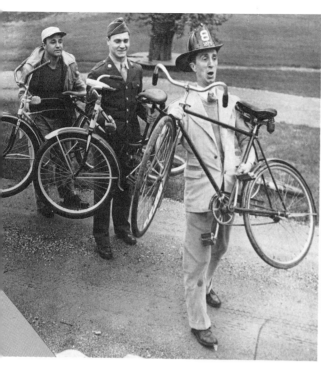

Clowning to keep from crying, Rockwell salvages the kids' bicycles the morning after his studio in Arlington burned to the ground.

Famous artist without a studio gets a ride from the scene of the catastrophe. He lost all his reference files, models' costumes, irreplaceable brushes, antique gun collection, thirty paintings, and a multitude of treasured mementos.

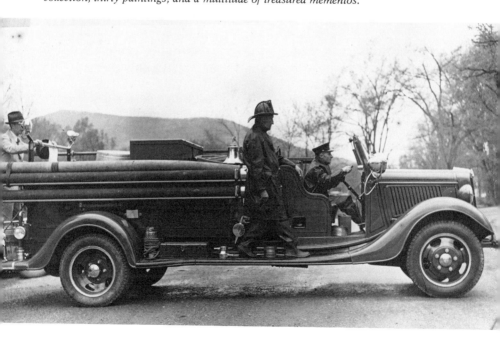

rags; they think some smoldering cinders there might have eventually burst into flame.

Whatever the cause, it was a wingdinger of a fire that gave Arlington a sleepless night and a grand spectacle to watch. To get the festivities going, the flames got to a supply of .22 rifle bullets and some shotgun shells which Norman had hidden in a drawer in the studio. When they went off, a good many of the neighbors were sure that this was going to be an exciting night. Then the volunteers roared out of town in the fire truck, sirens shrieking, drawing a crowd after them.

Soon the Rockwell front lawn looked like the bleachers at the ballpark. Snuggled in the warmest coats they could find, the pajamaed spectators cheered the firemen on, though they were losing the battle from the outset. They saved the nearby barn, but the studio went completely, crashing down in a shower of sparks that was scarier than the rockets on the Fourth of July. After that, Mary and Mrs. Wheaton, the Rockwells' maid at the time, brewed a big pot of coffee and served some doughnuts. Norman broke open a couple of bottles of whiskey for those who needed a stronger jolt. This included him.

After the fire had died down, he was heard to make only one comment—"There goes my life's work."

It has been estimated by Norman that the studio contained about thirty original paintings and countless sketches at the time it burned. More important to him, it also represented a loss of twenty-eight years' accumulation of all the useful aids to painting that he had painstakingly gathered in many countries. His wardrobe held about two hundred costumes, many tailored to order or purchased on distant trips. He had a library of prints of practically every painter and illustrator of note. File box after file box of reference pictures. Stacks of fine brushes he had bought in Germany before the war—the kind you couldn't get anymore. An extensive collection of antique guns. All sorts of memorabilia, from pewter mugs to gold medals and awards to stacks of personal photographs. Correspondence. Records. His easel. Even his pipes.

After the fire had quieted down to a smolder, the spectators and firemen had all left, and the peaceful pinkness of dawn was

filtering down on the valley, Norman sat a long while in the apple orchard, trying to get over the shock. As he was poking about in the ashes to see if anything at all had survived, some of the men from town came by. Typical Vermonters, they didn't attempt to offer sympathy with strained words, but they brought him a few new pipes, realizing how many of his old favorites had gone up in the flames.

As he sat pondering the rest of the morning away, Norman thanked the Lord that he had shipped his massive masterpiece, *Freedom of Worship*, to Philadelphia just a few days previously. Trying to do that over again, after the original four different approaches he had changed so many times, would have been more than he could have faced, he confided to me.

One thing that did bother him greatly was the loss of his sketches from the White House—the ones for the magazine article on visiting the president. He'd have to ask for permission to go into the presidential offices again, and he hated to do that. When he did call the next day, the secretary at the White House told him they'd heard about his fire and everyone would welcome him there again whenever he decided to come back.

After that assignment was finished, Norman had to do something about setting up a new studio. He couldn't bring himself even to think about putting up a new one over the ashes of the old. In fact, he had an idea that it might be better if they sold the whole place, house and all, and moved somewhere else. Either closer in to town or farther out westward along the river, where there were a few more houses clustered. They were a bit too isolated at their present location, right in the middle, he thought.

He and Mary agreed that there were advantages in moving. The boys would have more friends to play with if they were closer to the center of things. She'd like it, too, if there were a few more neighbors nearby. If they were going to a new location, though, they'd better do it promptly because Norman couldn't keep working in the corner of the living room. The very next day after their decision to make a move, they located a place they liked on the edge of the village green in the little settlement of West Arlington, just a couple of miles away. They closed the deal that same afternoon.

"Until the fire, we were regarded as outlanders by some in Arlington. But when we were in trouble, they took us to their hearts. They represent what I admire most in the American character. Not that they're the only ones. You find honest, warmhearted, hardworking people much like them in all parts of the country. But nowhere better. Here in New England the character is strong and unshakable."

The Middle Years

If you travel to Vermont, you can still see the house the Rockwells moved into in 1943. To find it, turn west in Arlington from Route 7 onto 313. You wind along for about five miles, with the river on your left and a mountain on your right, until you come to an old, red, weather-beaten, covered bridge. Take the bridge across the Batten Kill, and you're just about there.

The open field you come onto as you leave the bridge is the village green of West Arlington. It was here that soldier and frontiersman Col. Ethan Allen gathered together his hard-fighting, devil-be-damned militiamen. Known as the Green Mountain Boys, they drilled on this green and went forth from here to fight against the British and skirmish constantly with the hated Yorkers to the west who wanted to absorb little Vermont into their bigger state. Many of them fell at the Battle of Bennington and in the great victory when Fort Ticonderoga was captured.

The village green of West Arlington, where the Rockwells moved after his studio burned. Their house is hidden in the trees, just back of this open field where Ethan Allen drilled his Green Mountain Boys.

At your left as you leave the bridge and the popular swimming hole below it is the tiny schoolhouse the Rockwell boys attended. At your right is a white church with the Grange Hall attached to it. Beyond that is a wooden pavilion, its open sides screened against insects, where the Grange held its summer social events. These included the frequent square dances Norman loved. Straight ahead of you, overlooking the green, is a pair of similar farmhouses, now almost hidden by a row of trees grown huge over the years. The house on the right is the one the Rockwells lived in. Don't look for any village—West Arlington is merely a scattering of houses along the country road.

The Rockwell house, built in 1792, is of spacious colonial design. Besides the main, two-story section, there are a porch and a couple of rooms at the side. To fit out this roomy house, Mary

needed all the early-American furniture she had been accumulating over the years.

Norman immediately started construction of a studio in the back. It was patterned very much after the one that had burned. Covered with red barn-siding outside, it had three rooms inside—the main studio, a workroom, and a darkroom. The studio, measuring twenty-three by twenty-five feet, offered all the comforts Norman was accustomed to. It was paneled in knotty pine, had a fireplace, a balcony, lounge chairs, and a chandelier.

The new studio was also equipped with several fire extinguishers and a fireman's hat and axe. The house had a sprinkler system installed. If any blaze broke out anywhere, Norman intended to be prepared to handle it.

In West Arlington, the Rockwells became closer to the native-born Vermonters than they ever had before. Any barriers that still existed had melted away in the flames of the studio fire. A misfortune that wiped away years of a man's work was the kind of catastrophe these good farm people could understand, and it called for all the sympathetic help a neighbor could give.

There was not very much the good people of Arlington could do to aid the Rockwells. It wasn't a matter of building a new barn, as they might have done if fire had struck at some farmer's place in the area. They did learn that what bothered Norman more than anything was the loss of his tremendous collection of old costumes, which had been invaluable in outfitting models for his historical paintings. The word went out throughout the township that he was hampered in his work for lack of hats, coats, shoes, pants, dresses, etc., to put on his models. That did it. A steady parade developed of sympathetic people showing up at the Rockwell doorstep with all the old clothes they could find in their attics. Gene Pelham, who was helping Mary and Norman get settled in their new quarters at the time, maintains that he never saw so much clothing. "It just kept coming in," he says, "and we kept packing it into the garage until that was full to the rafters. There must have been enough stuff there to clothe half of Arlington."

As a gesture of concern, it was wonderful. Mary or Norman

thanked each and every person who showed up with a contribution, and they meant the thanks sincerely. But no matter how diligently people rummage in their attics, even in an historic area like Vermont, they don't come up with items like Hessian soldiers' uniforms, authentic colonial coats and knee-trousers, wigs appropriate for an English judge, shoes with big pewter buckles.

The old collection really had been a rare one. Norman told me of the time he sent an eighteenth-century waistcoat to the Metropolitan Museum of Art, asking if one of the curators could authenticate this very old item, which he believed might have considerable historical value. He received a letter back from the museum verifying that he was right—it really was a genuine antique of extreme rarity—and they thanked him for contributing it to their collection. "I guess it must still be in the Metropolitan someplace," Norman speculates. "I never intended to give it to them, but I'd have been too embarrassed to ask for it back."

Since there was no practical way of replacing the priceless wardrobe of antique costumes which he had accumulated over a period of several decades, Rockwell decided that the best thing was to forget about them. There was no use in crying over the loss. If he no longer had the requisite old English and colonial·American trappings, he'd simply stop painting pictures of a bygone era. No more Dickensian Christmas scenes or Yankee Doodles or Pilgrims. There was plenty to paint in the here and now.

The more he thought about the many new approaches his paintings could take, the higher his spirits rose. He even began to see a bright side to the fire; it had forced him to forget about old costume pictures and give his work a new look. His good friend and fellow artist Mead Schaeffer was the sounding board for much of Norman's enthusiastic talk about the great new things he was going to do. Mead commented to me, "He finally got himself talked around to the belief that the fire was a good thing. In fact, he was so damned convincing about it that he almost got me to the point where I was ready to burn my own studio down."

Whatever the validity of the logic involved, the important thing was that Rockwell managed to get over his depression from the shock of the fire and to build up that reservoir of optimism and confidence in his future ventures that was so vital to his creative

success. In looking back at the situation now, Norman believes, "The fire cleaned out a lot of cobwebs. I had gotten too much in a rut. I needed to make some changes."

Life at the new location farther out in the country presented many changes. Even though a gentleman farmer like Rockwell really didn't qualify, he was invited to join the Grange. Later he was even elected an officer of that organization—the master at arms—though he admitted, "It was really the job of being the doorman."

Mead Schaeffer remembers that Norman never missed a meeting of the local Grange unit: "Norman had an enormous curiosity about the farm people of Vermont. The Grange brought him in closer contact with them. He was absolutely fascinated about getting to really understand these people. And he loved the square-dancing. He was good at it too, no fooling about that. You should see him capering around with those loose-jointed legs of his swinging wide. He could go all night and never puff a bit. There was a big husky gal he especially liked to dance with. I think she was the hefty one he used for that Rosie the Riveter cover, among others. Remember that? Well, when she got hold of Norman, who weighed about half what she did, his feet didn't even touch the ground while she spun him. And Norman just loved that. He went into square-dancing very heavy."

Norman told me, "Yes, I sure did enjoy square-dancing. That was great fun. Great exercise, too. Harder than chopping wood, I think. You get a good caller and he'll run the legs off you. I could keep up with most of them then. But that's not my speed anymore."

It was a healthy life. There were Fourth of July picnics and hayrides and corn roasts in the fall. The kids had the best swimming hole in the area, just down the road at the foot of the covered bridge. They lived on the edge of an open field—the village green—ideal for casual baseball and football games. There was fishing and hunting all around. Schaeffer built a small ski lodge up the mountain in back of his place, mostly for the convenience of his two daughters and their friends, which included the Rockwell boys.

Norman decided that tennis would also be a good sport for the

whole family. The boys joined enthusiastically in his plans to put a court in their new back yard. They would have to help build it, father told them, because this was going to be a family project and not just an asphalt court they'd have someone lay down. A gray crushed-slate court was better anyway, he decided, sort of like a clay court and not as fast as asphalt. They would get an expert to supervise, but Norman and the boys would do all the laboring of preparing the tennis court.

Rockwell had heard that Orlando Cullinan, who then ran the general store in Arlington, had built a couple of gray slate courts, so he seemed to be the appropriate expert. Orlando agreed to come out and show the Rockwell clan what they needed to do. He directed as Norman and his three husky helpers slaved away with pick and shovel and rake. He remembers: "Norman wouldn't let me do any of the digging and rolling. I think he wanted to be able to say they had done it all themselves. Did a good job, too. Only trouble was that they left for California to see Mary's relatives and do some work out there right after the court was finished. They stayed most of the summer. Of course, you can't just go away and leave a slate court like that with no maintenance. You have to treat it with a good weedkiller regularly or they'll grow up right through it. I told that to Norman, and he left a note to the gardener about what to do. But they left in a hurry for California—some special job Norman had to start—and the gardener never got the note about the weedkiller. By the time the Rockwells returned home, that beautiful tennis court had greens sprouting up all through it. So Norman had to have it asphalted anyway. That burned him up. But it was still a good court and he and the kids enjoyed playing."

Possibly the California assignment that took the Rockwells away that summer was Norman's idea for a movie star mystery cover painting which he had developed some time in the early forties. This was a proposed *Post* cover which he never completed, though he worked on it for quite a long time. I first learned about it when I accidentally came across a strange assortment of snapshots of the top movie stars of the 1940s. When questioned about them, Rockwell explained why they were in his files.

At some time during that era, he couldn't recall just when, he

Lean and lithe tennis player returns a hard shot. Rockwell liked to play so much that he and his sons built their own court in West Arlington.

was inspired with an idea for a magazine cover that struck him as absolutely sensational. It would be built around the leading movie stars of the day. As he visualized it, his painting would show a cast of these famous actors and actresses being questioned about a murder that had been committed. The clues to the crime would all be in his painting, so the magazine reader could supposedly figure out which of their favorite Hollywood stars had perpetrated the crime and how he or she had done it. It would be the "whodunit" to end them all!

Rockwell got in touch with someone he knew at Twentieth

Century-Fox, and the studio agreed it would be a marvelous idea to have their stars featured on the cover of a national magazine. Norman was at the peak of his popularity as a cover artist at this period—it must have been sometime in the mid-1940s—and the publicity for the studio would have been tremendous.

Twentieth Century-Fox went all-out to line up a spectacular all-star cast for Norman's picture idea. The great Ethel Barrymore was to be in this mystery painting. So were Linda Darnell and Loretta Young, two of the most popular movie actresses of that day, and Richard Widmark and Clifton Webb. Of course, Boris Karloff, one of the big stars of the horror movies of that time, had to be included. Lassie, Twentieth Century's animal box-office star, was in the painting also, though I don't know if she was to be suspected of foul play. The victim was to be Van Johnson.

It was truly a sensational cast. All of the actresses and actors

Ethel Barrymore was one of eight top movie stars of the 1940s who posed for a proposed Post *cover picture.*

Van Johnson, here getting instructions from the artist, was to be the victim of a murder in the painting.

This sketch was the result of Rockwell's efforts to construct an intriguing cover painting which would depict the victim and the suspects in a murder. The idea proved too complex for the viewer to figure out, and the painting was never made. See the following pages for more photos of the movie stars involved.

Loretta Young, who was to be the maid in the murder mystery picture, enjoys her coaching by Rockwell.

Sinister Boris Karloff explains some of the fine points of looking mean.

Lovely Linda Darnell amiably strikes a pose.

Patient Lassie really needs no coaching from a director who thinks a dog should lie in such an awkward position.

were as bubbling with enthusiasm over the idea as Rockwell. They had a marvelous time meeting the famous painter and posing for his mystery composition. It was during these posing sessions in Hollywood that all the snapshots shown here were taken.

Rockwell spent a great deal of time on the preliminaries. He posed all the actors and actresses—and, naturally, he had to get into the act himself. He made detailed sketches, since lost, of all of his famous models. Then he completed a detailed black-and-white underpainting of the whole complex scene.

That was the end of the project, however. Once he had the detailed preliminary painting worked out, it became apparent that the crux of the whole thing—the solution to the crime—just didn't come off. Just from studying the clues in the picture, the

Richard Widmark seems doubtful as he watches the director demonstrate the kind of fierce snarl he wants in the picture. Clifton Webb dutifully mimics the instructions given him for the magazine cover painting conceived by Rockwell.

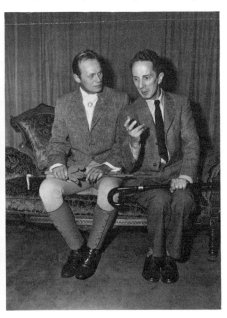

viewer would have an impossible time figuring out what had happened and who did it. What had seemed to everyone to be a super idea for a magazine cover just sort of fell apart at that point.

It isn't clear today whether someone at the *Post* squelched this project or whether the artist himself reluctantly decided that the idea wouldn't work. Anyway, it was shelved and forgotten until we came across the sheaf of snapshots of all those famous movie stars of yesteryear and a print of the discarded preliminary underpainting.

Although Rockwell had no difficulty in getting stars in Hollywood to pose for him, there were beginning to be some problems at home as World War II came along. This helped to bring about a change in the way he and many other illustrators worked on their paintings. The basis was economic. During the war years and afterward, it was no longer possible to get all the models you needed to pose day after day at an affordable rate. In a labor-short world, people were just too busy working on the farm or in the war plants at high wages. Some professional model rates escalated to thirty, forty, or even fifty dollars per hour.

Even in rural Arlington, where models were considerably easier to come by, Norman felt the pinch. He began regularly to supplement his sketching with photographs, which he could then use for reference for as many hours as he needed. No extra charge. No arguing with a model about the need to show up again the next day, and the next.

As he utilized the camera in capturing many different poses and expressions of his models, Norman also found that it opened up new vistas in the painting of backgrounds. For example, if you wanted to paint a scene in a physician's office, you couldn't ask the doctor to stop his practice for a week or so while you made sketches in his examining room. But with a cameraman, you could take photos of the room and everything in it in a few hours. You could shoot your models there, in a completely authentic setting, and then take them back to the studio for any additional posing needed.

This greater freedom led Norman to expand his scenes. No longer did they tend to concentrate on one or two figures, either silhouetted or with a minimal background, as had been the case

Posing for Norman Rockwell can be precarious work. Here the artist and a helper hold the young models suspended in mid-air to simulate a fast sprint, while the photographer snaps a picture which will form the basis for a painting. Before he turned to the assistance of the camera, Rockwell could never get such action poses.

with so many of his early cover pictures. Now he began to work in many of the architectural details he had previously shied away from. For example, one of his cover paintings in 1944 showed an entire railroad station. Another, in 1945, pictured a soldier returning home to a back-yard scene complete with the backs of two tenement buildings and all the families in them. He could now also easily get unusual perspectives, such as looking up at a man adjusting a clock on a building, or looking down on a sailor in a hammock. No longer did most of his pictures reflect the straight-on perspective of the artist looking at the model right in front of him in his studio.

Some of the most popular pictures Norman ever produced are his three April Fool covers, which exemplify the use of an extreme amount of detail in the backgrounds. In fact, it's the backgrounds that are the most important points of interest in these particular paintings. They were all published in the 1940s—around the first of April in 1943, 1945, and 1948.

Norman got the inspiration for these one day when he received a letter—one of many he receives—pointing out an error in a painting. He says, "I've never done a cover for any magazine that someone didn't find something wrong with it and write me about it. So it came to me, why not do a picture just loaded with mistakes? Give 'em a field day finding errors! Run it on April Fool's Day. I put forty-five errors in that cover, the first one, or at least I thought I had. But people wrote in from all over finding even more things wrong. One man claimed I made 185 mistakes."

The initial April Fool cover brought forth an absolute deluge of mail. More than 140,000 letters came in regarding it, all of them addressed to or forwarded to Rockwell. Mary, the family secretary, and Norman were swamped with them for weeks. But he loved it.

In the mid-1940s, the artists in the Arlington area welcomed a new member to their coterie. This was Grandma Moses, a native of Bennington, who had lived for some years in Eagle Bridge, a few miles from West Arlington just across the state line in New York. Mrs. Moses was a bit older than her new-found painter friends. She was eighty-five when Norman first met her.

Unlike the precocious Rockwell, she hadn't made a single

painting until a rather mature age—seventy-seven. Some of the local people began to buy her pictures for a few dollars apiece, so Thomas's Drug Store in Hoosick Falls got in the habit of keeping a few of them on display there. In that modest setting, she was discovered by a New York art dealer who happened to stop by during a vacation trip. That started a meteoric rise to fame. A load of her delightfully naive "memories in paint" were carted off to New York City for a big, one-woman gallery show, and Grandma soon became famous.

Grandma took her fame casually. She continued to paint on pieces of plyboard with dime-store brushes and ordinary house paint. Her paintings were all of days long gone by—memories of her childhood three-quarters of a century earlier. Those scenes of horses and buggies and children in quaint, mid-nineteenth-century clothing were as fresh as yesterday when she painted them. They sold like hotcakes, at very substantial prices, to rich city folks who sometimes wished they could be whisked back for a while to a simpler day and place.

The boys back in Arlington were very proud of the success of their fellow artist. They made a point of visiting Grandma from time to time to share professional confidences, to enjoy a cup of coffee and a piece of cake, and to admire her latest efforts. They never ceased to be intrigued by the unsophisticated charm of her pictures. As Norman appraised it, "Grandma was never spoiled by any formal art training. One lesson in perspective would have ruined her."

The little old lady was as curious as a five-year-old. Whenever she visited Norman's studio, he says, she poked into everything—studio, back room, and balcony. She wanted to know what he was painting, where he bought his brushes, how much he paid for them (what incredible extravagance!), and how he worked. Evidently her conclusions were that it was no use trying to adapt any techniques from nice Mr. Rockwell, even if he was a very fine artist whose work she admired. Her own methods required a lot less fussing than his.

Dorothy Canfield Fisher was another admirer of Grandma's. She arranged a birthday party for the spry little old lady, which was broadcast over a national radio network. Many of Grandma's

Grandma Moses, who lived near the Rockwells, painted her famous primitive pictures on a table top, using pieces of plyboard, dime-store brushes and paints, and coffee-can accessories. Norman attended several of her birthday parties. Grandma lived to celebrate her hundredth birthday.

friends got together afterwards for a big lobster dinner at a restaurant just outside Arlington. Everyone had a grand time, especially Grandma. She could hardly wait until her next birthday to do it again. And she managed to have quite a few more birthdays and parties. She passed the one-hundred mark in 1960 with spirit undimmed, but died the following year.

During the 1940s, the Rockwells, Schaeffers, and Athertons became inseparable friends. Whenever one of the three artists started a major new painting, he would bounce his ideas off the other two. "How do you think this would work out?" the instigator of the get-together would ask his friends. "Suppose I put this into it?" Of course, since they visited each other's studios frequently, they'd also get the benefit of expert advice, or just confirmation they were on the right track, as the painting progressed.

Because this trio was made up of the finest artists in the country, they thoroughly respected each other's recommendations. They understood each other completely. And there existed a wonderfully simpatico feeling among them, without a twinge of the common professional jealousy. All of them were on top of the world in those days.

Rockwell collaborated with John Atherton on a big painting—the only picture, I believe, on which he ever worked with anyone else. It was occasioned by the terrible flood in Kansas City in the late spring of 1951, and is a prime example of the concern Rockwell has for people who are in distress.

As soon as he heard that the Missouri River had flooded over its banks and washed out a large part of Kansas City, he wanted to do something, if he could, to help his friends there. For many years, he had painted Christmas card designs for the Hallmark company there, so he immediately called his old friend Joyce Hall to ask if there was any way he might aid in the tremendous rebuilding efforts that would have to be undertaken after this great disaster. At first Mr. Hall had no answer, but then it occurred to him than an inspirational painting by Norman Rockwell could be used as the basis for a poster to rally all of the city into an effort to rebuild their town into a better one than before. If Norman would

paint such a picture, Hallmark would print and distribute the poster.

The artist said he would be on the next airplane, and he was. He toured the devastated city and formulated his ideas for a large painting which he would call *The Spirit of Kansas City*. He envisioned a dramatic figure in the foreground of the painting—a man rolling up his sleeves in preparation for tackling the gargantuan task ahead. He needed a cityscape behind that heroic figure to symbolize the new Kansas City to come. Since he was never much good at such scenes, he asked his friend Atherton to supply the background, which he did. The large painting which resulted from this collaboration was reprinted by the thousands and served as a focal point for the townspeople's determination to rebuild.

John Atherton, generally known as Jack, was an exceptionally versatile artist, noted for his fine abstract paintings as well as for his many magazine cover pictures and illustrations for advertisements. Big and powerfully built, he was very much an outdoorsman, like Schaef. Atherton died of a heart attack while on a fishing trip in 1952.

Mead Schaeffer, lean and wiry like Norman, was probably his best friend. Schaef posed for Norman as a tattooist in a cover painting in 1944. His two daughters were among Rockwell's favorite models. (An ardent sportsman, Schaeffer still fishes every day at Sea Cliff, Long Island, where he now lives in a house overlooking the water, or in Puerto Rico, where he often vacations in winter. Just four years younger than Rockwell, he's still in his studio almost every day, too, but he now paints only what he wants and usually just for his own pleasure.)

Mary Rockwell, Maxine Atherton, and Elizabeth Schaeffer not only socialized but worked together. All three took on frequent assignments from their husbands to round up props for paintings. Usually the artist had in mind *precisely* the unusual article he wanted—something like a brass lamp with a white globe and a rose on the side of it, or a chess table that had to have an irregularly shaped top and curved legs with decorations on them. All the girls had to do was find it, *quickly*, so the painting could get

The Spirit of Kansas City *is the only painting in which Rockwell collaborated with another artist. After the devastating flood in 1951, he and John Atherton produced it for a poster which helped to inspire the citizens of Kansas City to rebuild their community.*

started right away. The three would plunge into the task of scouting the territory for miles around.

By this time, all of the artists were accepted in Arlington as an integral part of the town—its most glamorous industry. More important, they were respected as "regular folks" who worked hard at their jobs and never put on any fancy airs with their farmer neighbors.

Jim Edgerton, farmer and state representative, who still lives in the house next to the Rockwell place on the West Arlington green, is one of many who remember the artists and their families with fondness. "A man couldn't have better neighbors than the Rockwells," he assured me. "The boys were always very popular around here. They took part in all the local activities. So did Mary and Norman. When we got the Grange Hall ready for a party or dance, you'd see them with a broom just like anyone else, helping to clean up the place.

"And Norman was always thoughtful of everyone else. I remember when he sold the timbering rights on some property—about three hundred or four hundred acres—he owned on the mountain across the road there. He knew I liked to sit on my porch and look across at the white birches on the mountain. So he told the timbering man, 'You can cut some trees, but only on condition that you don't take down any of those birches that Jim can see from his porch.' That's the way he was.

"It was the same way when he painted his house. He was ready to have it painted . . . I knew because he mentioned it. But then he didn't go ahead. When I asked him why, he said, 'I decided it could wait a while. We both ought to get our houses painted together. If I go ahead now, it'll make yours look bad. And I know you're a bit strapped for cash now in these tough times and it would be a hardship on you. So I can wait a bit. You tell me when you're ready to paint, and we'll do it together.' "

Jim Edgerton also confided to me that Rockwell took great delight in driving Edgerton's large farm truck. Whenever he needed to go anywhere and Mary was away with their station wagon on one of her many errands, he'd come over to his neighbors, the Edgertons, to borrow some transportation. But he'd never ask for their car—only the truck. Jim said that Norman

The Common Cold *was the title of two pages of drawings which appeared in the* Post *in January, 1945. In preparation for these drawings, dozens of photographs were made. Rockwell outdid himself in coaxing the difficult expressions he wanted from his models, using his own facial contortions as the example.*

Rockwell used himself as the male model in this photo, but he didn't tower over the lady as much as he wished to. That was remedied by his standing on a stack of books. The drawings in his Common Cold *series are still well remembered by many people after more than thirty years.*

PHOTOS BY SCOVILL

told him once, "I never get tired of driving your truck. Sitting there so high up behind the wheel—*it makes me feel big!*"

If Rockwell was popular with his neighbors, he was even more so with the increasing numbers of visitors to that part of Vermont. In fact, that popularity led him to buy a cottage a mile or so down the narrow back road. He fixed up the little, out-of-the-way cottage as a hideaway studio for use during the peak tourist months. It provided a means of escape when the traffic got too heavy and the Rockwell yard became inundated with tourists who had no concept of privacy and no idea that an artist ever has work to do.

"I'd be painting sometimes," Norman explains, "and get the strangest feeling I was being watched. I'd look up and see faces pressed against the window or door screens. Then, when I noticed them, the people would want to come in and talk to me. Got very upset, too, when I told them I was too busy. One time I remember a man drove his car clear across our lawn and parked it right in the middle of the grass. It was wild. There were tour buses that stopped right in front of our place for a while, but I threatened them with court action and they finally kept their distance. Yes, that little house hidden back in the bushes really came in handy in the midsummer days. Couldn't have gotten a lick of work done without it sometimes."

Rockwell was also of considerable interest to his fellow illustrators, who respected him as the foremost magazine cover artist in the world and a serious craftsman with the highest ideals. Once a year, he was invited to the New York Society of Illustrators to talk at one of their luncheons. There was always a packed house on that day, for Rockwell was one of the group's most popular speakers, noted for his dry humor and interesting observations.

On one of these occasions (according to Rufus Jarman in the *New Yorker* magazine of March, 1945), some person in the audience observed that illustration was "just a way to make a living—you do your job, get your check, and no one thinks it's art." Rockwell was horrified at this viewpoint. "No, no," he protested. "How can you say that? No man with a conscience can just bat out illustrations. He's got to put all his talent and feeling into them!"

There was always plenty of painting to do. In 1944 Ken Stuart became art director for the *Saturday Evening Post*. That was one of the best things that ever happened to Rockwell, who had not gotten along well at all with the man who held that post for a short while before Stuart. When he and Norman met, Stuart told me, they hit if off from the first moment. Unlike his predecessor, Stuart realized that the world's premier magazine cover artist didn't need to be "directed" as other artists might. He merely needed to be encouraged and stimulated to do his own thing. With that kind of handling, Norman outdid himself on assignment after assignment. And Stuart always managed to find new things for him to tackle.

Even for someone like Rockwell, however, every job is not a cinch. One of the most discouraging he ever ran into was a grandiose project intended to represent a scene symbolic of the United Nations. It was to be a huge painting; Norman conceived it as having many faces in it—an entire background of nothing but the faces of people of diverse racial backgrounds, with a view of the chief delegates to the UN in the foreground.

Doing the multitude of faces proved to be the easier part of the chore. Working with people around Arlington, Rockwell managed to find the variety of models he needed and got so far as to make a full-scale charcoal drawing with fifty of them in it. But in addition to this vast background of faces, he needed four specific people in the foreground—the delegates representing the United States of America, the United Kingdom, the Union of Soviet Socialist Republics, and Chile. With these gentlemen, as sometimes happens in the UN, he was to have trouble.

Rockwell started his sketching with the Britisher, who was affable and paintable. With the American delegate, Henry Cabot Lodge, Rockwell encountered a bit of difficulty. Delegate Lodge seemed to have only one expression he could assume when he posed for his painting. It was a solemn, unsmiling stare, perhaps not to be unexpected at the head table of the UN, where the weightiest affairs in the world were supposedly being discussed, but not what Rockwell wanted in his picture. He felt it made the U.S. delegate look pompous and unfriendly. But no matter how he tried, Rockwell could coax Cabot to display no other aspect.

Rockwell gets to try a seat at the head table of the United Nations. His visit was in preparation for a painting with which he had a great deal of trouble. He never finished it, but did use some of the sketches years later for his great painting The Golden Rule.

But if Norman thought he had had trouble with Lodge, the Russian delegate, Andrei Vishinsky, was yet to come. He was supposed to contact Rockwell when it was convenient for him to sit for the picture, which the UN was anxious to have painted. No word came from him as the weeks went by. Finally Rockwell, who knew Vishinsky was in town, notified the UN that he and his photographer, Gene Pelham, would be coming to New York the following Monday to meet with the Soviet delegate.

Pelham related to me that he and Rockwell checked into the Plaza Hotel as planned and waited to hear from Vishinsky. There was still no word from the Russian delegate. All the UN could

promise was that they were trying to coax him to sit for the artist so the painting could proceed, but that he was still playing hide-and-seek. Presumably he was out on Long Island, where the Russians had a diplomatic mansion, awaiting word from Moscow before he made a move.

After a couple of days of waiting at the Plaza, Rockwell became thoroughly tired of the game. Pelham said that it was pleasant enough at the hotel, where he and Norman passed the time by drinking whiskey sours all day long, but that they couldn't keep that up indefinitely. When they phoned Mary back home in Vermont and told her about the situation, she wasn't thrilled with the way things were going either, and she took the next train to Manhattan to try to get some action—or at least get Norman back to his usual beverage, Coca-Cola.

It was Mary who did finally lasso the Russian for them. The three Vermonters had all gone over to the UN building on the day when the session was to start and they knew Vishinsky would have to show up. Norman and Pelham were on one of the upper balconies of the great entrance hall when they heard a stir below and realized that one of the major delegates must be arriving. Looking over the railing, they saw that it was Vishinsky. They were surprised to see him stop and a woman appear next to him. Even from their aerial view, Pelham said, they could identify the woman as Mary Rockwell. Blocking Vishinsky's path, she was proceeding to tell him something he was obviously not too anxious to hear. They were astounded to see her waving her finger under the Soviet diplomat's nose as she told him off. The next day he appeared at Rockwell's Plaza suite to sit meekly for his portrait.

That wasn't the end of Rockwell's difficulties, though. Before he could even get started on the final oil version of his picture, he received word that Vishinsky had summarily been recalled to Moscow. A new UN delegate would be taking his place. No one knew just when he'd be arriving. When he did, Rockwell would have to start over with that gentleman's portrait.

Norman thought about this new obstacle to an assignment he was already thoroughly sick of; he also thought about Cabot Lodge's portrait, which irritated him every time he looked at it;

and finally he said, "To hell with the whole project." The big charcoal cartoon with the fifty heads in it was filed away in the bin in the back room of the studio. It stayed there for a long time, until parts of it were resurrected for Rockwell's *Golden Rule* painting in 1961.

In 1948, Rockwell became involved in a new correspondence school for would-be artists. This was the Famous Artists School in Westport, Connecticut. Rockwell and several other noted artists were recruited to help put together a series of lessons which explained how each one went about his work. As the most famous of the Famous Artists, Rockwell was featured most often in its ads. For a time, the school enjoyed considerable success and contributed substantially to Norman's income.

In its first dozen years, the Famous Artists School signed up more than 140,000 students in its art course, at a fee of $500 each: that totals $70 million. The school continued to grow in the sixties, adding courses in writing and photography. Its stock price zoomed—to the delight of substantial stockholder Norman Rockwell. Then, in the early seventies, the concept soured and the stock plummeted much faster than it had gone up.

At that time, Rockwell, who is not ordinarily a reader of stock market news, was reading the daily financial page regularly. One day when I entered his studio, he showed me what he had been looking at—the latest abysmal quotation on Famous Artists. "I had a couple of million dollars worth of that stock once," he observed. "And now it's not worth much more than wallpaper." He laughed then—not a very hearty or long laugh, to be sure, but it was a laugh. "I guess I just wasn't born to be rich."*

Besides getting involved in art instruction via the correspondence school, Norman found other promising new fields in the late forties. It was then that he began his Four Seasons calendar series for Brown and Bigelow. He also continued to paint a calendar picture every year with a Boy Scout theme—a project on which the calendar company and the Scout organization collabo-

*In 1970, Rockwell told Phil Casey of the *Washington Post* that he had once owned 42,000 shares of Famous Artist School stock which reached a high of $62 a share. That would figure out to more than $2,600,000.

rated. His friend Jack Atherton used to razz him about painting so many scenes for calendars, but Norman has always wanted his art to be published in a way that will enable as many people as possible to see it and enjoy it. Calendars accomplish that. Countless millions of people saw his Four Seasons and his Scout designs every day. The Scout calendar has been the largest-selling calendar in the world.

These calendar assignments were lucrative ones, too. Amazingly enough, though, Norman got into this activity on a strictly philanthropic basis. When friends at Scout headquarters asked him for a picture for a calendar, way back in 1920, he painted one and just gave it to them free of charge! This was repeated for three years, until neighbors commented to Norman that someone must be making an awful lot of money on those Scout calendars, which could be seen everywhere you looked in stores and homes all over America. Norman said it certainly wasn't he who was profiting. At that point, he made it known to the Scouts and Brown and Bigelow that if he was going to create a sure-fire big money-maker for them each year, he thought he was entitled to at least a little share of the take.

The Hallmark Company approached him in 1948 about designing a Christmas card for them. He obliged with a picture of Santa Claus asleep in a chair while his little elves crawled around him, busily making toys. As one might guess, this scene was one of the top sellers of the year, and it was the first of more than twenty designs he created for the card company.

He visited the Kansas City firm many times in subsequent years, often stopping midway in his frequent trips between California and New York. He was evidently fascinated by a graphics publishing company which employed literally hundreds of illustrators and designers in its creative department—probably the largest assemblage of art talent in one spot anywhere. Jeanette Lee, who headed the Hallmark art department then, told me that Rockwell always delighted in wandering through the maze of artists' offices there to discover what new ideas and designs each person had on his or her drawing board. And he would always let himself be persuaded to stay for a while to chat with a group of the card creators who would gather

together quickly when they learned that Norman Rockwell was available to tell them about some of the newest happenings in the world of illustration.

There weren't enough hours in the day for Norman to complete all the commissions thrust upon him. He worked from 8:00 A.M. until 6:00 P.M. every weekday, in addition to regular stints on Saturdays or Sundays, and an extra hour or two or three on many evenings. Yet he still got behind when he had promised more work than he should have. This was frequently the case, and it sometimes led to embarrassing efforts to wriggle out of jobs he had rashly promised to do.

Sometimes, when a deadline caught up to him and he hadn't even been able to start a job that some client was expecting, Norman hid himself away from all contact with the outside world. It was up to Mary to take the irate telephone calls and try to soothe anxious customers with some excuse or other. On more than one occasion, when things became too hot to handle and a client threatened to come up to Vermont to find out what the score really was, Norman left town. He'd take off for a few days, about the time when his angry callers were due, going to some friend's house for a visit. He'd leave word that he had suddenly been taken ill and had been ordered by his doctor to go away for a rest.

This excuse worked a few times, but eventually it backfired on him. One client in New York, assured that Norman could not paint a picture because he was deathly ill, was completely taken in by the excuse. This particular man happened to know Walter Winchell, and he passed on the news of Norman Rockwell's critical illness to the popular radio commentator.

That night, when Winchell gave the latest scoop to Mr. and Mrs. America and all the ships at sea, he painted a gloomy picture of the prospects of poor Norman Rockwell, suffering horribly in a hospital bed with some probably fatal but unnamed illness. Actually, Norman happened to be in California at the time, hoping to enjoy a few days in the sunshine. When he heard the broadcast, however, it shattered his plans for a holiday. He was forced to hide indoors for the rest of his stay, for fear he'd be spotted on the street and unmasked as a fraud.

Along with Norman's frequent gallivanting around the country and the steady stream of visitors who came from all over to talk business with him, life for the Rockwells was kept lively by the three teen-agers in the house. Like their father, they were all hard-working boys. During the summer months, Jerry (Jarvis) worked as a porter at the Arlington Inn, where he developed his muscles and picked up some fair tips as he hustled luggage for the hordes of summer visitors. Tom got his exercise and spending money by mowing lawns. Peter, the youngest, was a busboy at the Arlington Diner.

Although all three were industrious, the Rockwell boys had distinctly different personalities. As the 1940s drew to a close, Jerry already knew he wanted to be an artist. When he graduated from Arlington High, Norman persuaded him, with a little arm-twisting, that he should get a good grounding in the fundamentals of drawing and painting. He enrolled first at the Art Students League and then at the National Academy of Design, trying both of his dad's alma maters in New York City.

Tom, two years younger than Jerry, was the liked-by-everyone, personality boy of the family. A quiet, shy lad, very much a bookworm, he was also a fine athlete. He starred at basketball at Arlington High, yet also managed to be valedictorian. He was elected president of his graduating class.

Peter, the youngest, was somewhat the rebel in this artistic family. He wanted no part of an art career and got his back up every time Norman tried to cajole him into practicing a bit at the drawing board. He was always a very serious little boy. Speculating about what he might grow up to be, Mary and Norman imagined that he would become the businessman of the family—or maybe a doctor or a professor. Unlike his two older brothers, he decided to go to a private school when he reached high-school age.

As the 1950s got underway, the house in West Arlington became a quieter place. Jerry was away at art school in Manhattan. Tom went to Princeton and then to Bard College. Even young Peter was gone to his boarding school.

Norman looks back on this period as one of those times of uncertainty when he had more than the usual share of problems

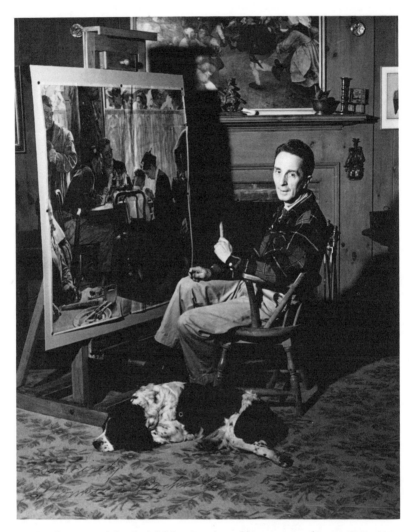

Rockwell poses with his faithful dog, Butch, and his most popular cover painting. This picture, voted the best-liked of his covers in a poll taken by the Post, *is titled* Saying Grace. *Shown here is a full-size charcoal preliminary of the type he often makes before starting his finished oil.*

with his work. He would become very much dissatisfied with everything he painted. Yet he did produce some exceptionally fine work. In November of 1951, millions admired the most popular magazine cover he ever produced: it was the scene in a restaurant in which the other diners all stopped to watch an old lady and a young boy saying grace. At about the same time, he started a series of fine illustrations for the Massachusetts Mutual Insurance Company. In the summer of 1952, he flew to Denver to paint his first picture of Dwight D. Eisenhower (he later made another portrait of Eisenhower in 1961).

The first meeting with Eisenhower was at the Brown Palace Hotel in Denver, where the artist caught up with the general in the midst of his campaign tour. It was to be a quick session, about

Dwight D. Eisenhower was one of Rockwell's favorite people. He painted the president twice—in 1952 and again in 1961. An amateur painter, Eisenhower used these occasions as opportunities to get a few painting tips from the expert.

two hours of sketching in a hotel room, so the two wasted no time in getting down to work.

Rockwell recalls, "Eisenhower had about the most expressive face I ever painted, I guess. Just like an actor's. Very mobile. When he talked, he used all the facial muscles. And he had a great, wide mouth that I liked. When he smiled, it was just like the sun came out."

To get that smile, Norman asked the general, as he often asks his models, to think of something he's especially fond of. Good family man Eisenhower said he'd think about his grandchildren, and that did bring out an immediate broad smile. He caught himself then and requested, "Please don't paint that gold filling in my mouth. Mamie doesn't like it when I show that in a picture."

While sketching went on, the general, who was an avid Sunday painter, availed himself of this golden opportunity to get some advice from the master who was doing his portrait. Rockwell remembers that he advised the amateur artist to throw away the tube of black he said he used and to mix his blacks from other colors on the palette.

"The second time I painted him," Rockwell says, "he took me up to his study, at Gettysburg, and showed me some of his pictures. They were terrible! His stuff was not quite as good as Churchill's, who was also an amateur artist, you know. But he was a wonderful man. I guess I liked painting him best of all the presidents. Yeah, Ike was as comfortable as an old shoe. Maybe that's why the two of us got along so well."

Although Norman was at the peak of his powers at the time, that period was an upsetting one for his wife, Mary. While her husband kept busy and happy with his work, she was undergoing middle-age emotional changes that she couldn't seem to cope with. Fortunately, some of the best psychiatric help in the country was available not too far away, at the Austin Riggs Center in Stockbridge, Massachusetts, about fifty miles to the south. Mary found that the experts there could give her the advice and reassurance she needed to handle her anxieties, and she began to visit them regularly.

At first, Mary would drive from Arlington to Stockbridge for

visits to the clinic. The trip, which takes a couple of hours, soon became too much for her, particularly as the New England weather entered its snowy season. Norman was greatly concerned over his wife's problems and wanted to do everything he could to help. That even included leaving his beloved studio, if need be. As a result, in November of 1953, they decided it would be best to move near the clinic, at least until spring. For temporary quarters, they moved into the Homestead Hotel.

Both Mary and Norman quickly grew to like the town of Stockbridge very much. It had the same sort of quiet charm as Arlington, but it was a bit larger and not quite so isolated. After fourteen years in one location, Norman had been thinking that he needed a change of scene. He suggested to Mary that perhaps they ought to leave the Vermont mountains permanently for the pleasant valley in the Berkshires. She agreed.

Norman already had a studio on Main Street he had been using the past winter. It was a unique location he had found—two rooms over a meat market, right in the center of town. The small apartment's windows faced the north, for the soft light he likes, but they were too small to suit him. So he had a great big hole cut out of the wall and had a super-sized window installed.

This not only let in a lot more light, but it also allowed him to look out. As the townspeople walked up the street, they were not aware that an eagle-eyed artist might be peering down on them from his second-floor vantage point. He could see everything that was happening. And see everyone who might have the right attributes to serve as a model for a painting. All of Stockbridge became his source of models.

Norman told me that there were some advantages in being able to see all the goings-on in the street below. "Just like a continuous peep show. Wonderful way to see a lot of interesting people. And I did locate some models that way. But it was *too* interesting, sitting there and watching the world go by. I could do it by the hour, I found. Too easy to waste time when I should be painting."

He began looking around for a house to rent, so that he and Mary could leave their hotel quarters. He was fortunate in locating a house which was immediately available. Like the studio over the meat market, it was also on Main Street, but a couple of

An artist tests his eyes, to the amusement of his handyman helper, Louie Lamone, who assembled this set for a painting. Photographed shortly after Rockwell moved to Stockbridge, Mass.

Artist doubles as model for a cover painting, After the Prom, *which appeared on the* Post *in May 1957.*

blocks removed from the business district, farther to the west. The Rockwells moved in quickly and began the adjustment of becoming permanent residents of Stockbridge.

Their new residence was the yellow house which you can still see in Stockbridge right next to the cemetery. Rockwell related to me that the breakfast room looked out onto the tombstones and that he always found that meal a restful one. "It was such a quiet and peaceful view. I always found it a good way to start the day."

Life in general seemed to quiet down for the Rockwells in their new environment. Mary was coming along well with her treatments at the Riggs clinic. Norman began to appreciate the wonders of psychiatry and figured perhaps he ought to sample some of it also. Sometimes when he took Mary to the clinic, he'd chat with Erik Erikson, head of the staff there, who was to become a good friend. He soon discovered that the understanding doctor was a wizard at calming nervous geniuses and bolstering their confidence. He decided that a bit of analysis would be of help to him, too.

The house and the studio did not provide the comfortable environment Mary and Norman had been accustomed to. In the spring of 1957, they found a larger home on South Street that seemed to fill the bill much better. One of the oldest houses in town, the central section having been built in the latter part of the eighteenth century, it had the genuine antique charm they wanted. Also, it had a large yard that would afford more privacy from the ever-present tourists. And it boasted an old carriage house which Norman immediately visualized as a roomy studio.

The Rockwells built an extension on the living room and a glassed-in porch next to it. That was about all the change they felt the house needed. Norman gutted the old carriage house and transformed it into a deluxe studio, with huge north windows, a balcony, and a couple of adjoining rooms. Mary and Norman settled down to a comfortable life in their new quarters.

For an artist who loves to paint Americana, there is no more appropriate place to live than Stockbridge. Hidden in the northwest corner of Massachusetts in a lush valley in the Berkshire Mountains, it still looks today like the ideal small town of a quiet and rosy yesteryear.

This is not accidental. During the Victorian era, when this first became a fashionable summer resort, factories and all suchlike disturbances of the picturesque charm were kept outside the village. Ever since then, the wise selectmen have maintained the same restrictions, and even excluded from the town limits any apartment buildings, fast-food drive-ins, or neon signs that would tend to spoil the old-world ambience.

It is quiet in Stockbridge, at least for much of the year. During those pleasant months when the throngs of summer visitors have roared back to the big cities and the nearby ski slopes have not yet called forth the parka-clad winter hordes, the "locals" here have this beautiful spot pretty much to themselves. In late fall or early spring they can sit back, breathe a sigh of contentment, and survey a landscape not too different from that of their parents' day.

At such a time, in fact, if you ignore the concrete pavement on Main Street, you might even imagine that the stagecoach from Albany to Boston is due to come clattering down the Post Road as it used to *before* the Revolution—before those firebrands at the east end of the road began their shooting at Bunker Hill. For those visitors who like to search out the vestiges of history, this is truly the place to come.

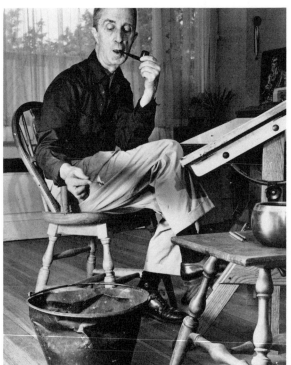

Fire-prone Rockwell said, "This big old brass bucket is the best ashtray in the world. Only time I have trouble is if I forget and toss my old paint rags into it. Then if a hot match gets on top of that turpentine, the whole thing goes 'whoosh'—up in blazes! But that really doesn't do any harm. I just pick the bucket up, go over to the door, and throw the whole thing out into the yard. That way, the rags just burn out on the lawn, and there's no harm done."

PAUL KRAUSE

Family portraits on the living room wall in the Rockwells' home in Stockbridge.
They depict Peter, Thomas, deceased wife Mary, Jarvis.

Way back, this was an important Indian village. In 1734, the Reverend John Sergeant, a young divinity graduate from Yale, and a teacher named Timothy Woodbridge came here to establish a mission. Five years later the town was incorporated and given the name of Stockbridge. In that same year, John Sergeant built his mission house on Prospect Hill, where it still stands, as do some other houses dating from Sergeant's time.

In the nineteenth century, Stockbridge became a center of literary and artistic activity. It evolved into a fashionable summer resort. Many of the large estates which dot the countryside around Stockbridge and Lenox were constructed at that time. Several of them, built by some of the richest families in the country, now house private schools and institutions.

The wide, scenic Main Street of Stockbridge, along which so many tourists stroll, was to be immortalized in two famous paintings by Norman Rockwell. The first of these, painted in 1967, was *Christmas in Stockbridge*, which appeared in the holiday issue of *McCall's* magazine in that year.

Medals, awards, mementos crowd the walls in the "office" area of Rockwell's studio. An ample store of painting supplies is kept on hand at all times. Paint tubes are arranged systematically by colors in a semicircular bin.

This large painting (it measures nearly six feet long) pictures the east section of Main Street. At the very extreme right edge, beyond the Red Lion Inn, it shows the junction with South Street, or Route 7. Down this highway a few hundred yards, Norman Rockwell's driveway is visible.

In the painting, the Red Lion Inn appears dark and deserted; it used to be closed during the winter in the 1960s. The classical building next to the inn is a bank. Then comes an old, churchlike structure, the former town hall, which now houses a photographic gallery and a flower shop. Next there is a tiny barbershop. Then Williams' Country Store (if by any chance there is anything you can't find in there, the odds are that it has never been made).

The large building beside the store is a grocery market. If you

Rockwell always emotes effusively when demonstrating the emotion he wants in a picture. He knows the model's expression will be less extreme.

Rockwell and model pose for a picture titled Saturday People *used in* McCall's *in 1966. Artist has been wiping his hands on sleeves of his painting jacket.*

D. WALTON

Rockwell's first studio in Stockbridge was on Main Street above a store. Here you can see the large window he had installed to give him more light. It also provided an interesting view of the street below and distracted him from his work.

get hungry when you're in Stockbridge and the excellent dining room and tavern of the Red Lion Inn are full, you can stop in the grocery for a quick hamburger at the lunch counter. Rockwell had his first studio in Stockbridge in this building, on the second floor, where you can see the Christmas tree in the big picture window in the painting.

The triple-windowed building next in line houses a real estate office and also Seven Arts Antiques. The last building in the block is the Stockbridge Library. Beyond it, across the corner of Elm

D. WALTON

The picturesque Main Street of Stockbridge, Massachusetts, was originally the old Post Road from Albany to Boston, traveled before the Revolutionary War. The Red Lion Inn (extreme right) had its beginnings as a stage stop providing food and rest.

Street and at the very end of the picture, you can see the Old Corner House, where tens of thousands come every year to see the finest display anywhere of Norman Rockwell's art.

While Mary and Norman tried to adjust to the pleasant town of Stockbridge and maintain a quiet life there, the Rockwell boys kept busily on the move. Jerry was in San Francisco going through the painful agonies of a young artist, trying to figure out what he wanted to say in his paintings and how he was going to say it. Peter, fortunately, was in good health again after a fencing

accident at Haverford College. He had been run through the lung with a foil after the protective tip had fallen off and nearly killed. After a long convalescence, he decided to take up sculpturing, as a less strenuous (and less risky) activity. Tom, still studying at Bard, had decided he wanted to be a poet.

In 1958, twenty-one-year-old Peter Rockwell married a girl he had met several years before at the Putney School in Vermont, which both attended. She was Cynthia ("Cinny") Ide, who had just graduated from Cornell. The wedding, just a few days before Norman's birthday in February, took place in New London, Connecticut, where her father was chief scientist at the U.S. Navy Underwater Sound Laboratory. It was a big wedding and a beautiful one in the chapel at Connecticut College.

During that same year, Norman, the man who loves traveling even more than his adored apple pie, received an offer he couldn't refuse. It was an opportunity to take a trip around the world with all expenses paid by Pan American Airways. Of course, there was to be some work involved. Along the way, Rockwell was to make some sketches that Pan-Am could use in its next advertising campaign. That wouldn't spoil Norman's fun, since he always sketches or paints anyway, wherever he travels.

Before the airline could change its mind, Norman hurried out to buy a fat new sketchbook and a huge box of charcoal pencils and then said, "Where are the tickets?" He and an executive from Pan-Am's advertising agency (Walter Elton, from J. Walter Thompson) soon boarded a clipper that was to take them from New York to London. From there, they were scheduled to make sixteen other stops before returning home the long way.

With his trusty sketch pad always ready, Norman sought out the most interesting-looking people and scenes he could. He drew some of the quaint streets and houses and inns near London. The boulevards of Paris and the myriad sights along them. Bulls and bullfighters, wine drinkers inhaling from wineskins, and priests on motor scooters in Barcelona. Fountains, statues, and sidewalk cafés in Rome. The bazaars and minarets of Istanbul. The men and women of Beirut, hooded against the heat in their burnooses. Everything from soothsayers to snake charmers in Karachi, Calcutta, and Benares. The dancers and temples of Rangoon and

Bangkok. The wild ricksha traffic in Hong Kong. Teahouses and geisha in Tokyo, where the camera-mad Japanese had a field day snapping photos of the strange American artist. Hula dancers and surfers in Honolulu. Then back home via San Francisco.

A few of these sketches were used in Pan American ads in the following months. Most were not, because after studying the sketches of the exotic scenes, the airline decided that they probably wouldn't attract as many travelers as would glamorous views of smartly dressed people in front of luxury hotels. Norman was a bit disappointed, but he had enjoyed the trip of a lifetime. And after the long trek, he was content for a while to stay quietly at home.

The quiet life received another little shake-up in February of 1959. At that time, the Rockwells agreed to open their house to Edward R. Murrow for his "Person to Person" television program. Naturally, they were excited about Norman's first television interview (the first of many), but they didn't know what they were letting themselves in for.

The excitement really started when the Columbia Broadcasting System's technical crew arrived in Stockbridge the day before the telecast. It consisted of twenty-five people—sixteen technicians, six production workers, two directors, and a producer. They brought along tons of equipment, including five cameras and a huge truck, which was parked in the Rockwell's yard to serve as a control booth during the show. Norman made his studio even more spick-and-span than usual for the occasion, and Mary thought she had everything just so in the house—until the two dozen people plus one started rearranging it.

Still everything went along reasonably smoothly, and the host and hostess kept their cool until 8:30 P.M.—about two hours before show time. Then things got hot. It was at that time that a fire was discovered in a chimney at the Rockwell home. The first thought Mary and Norman both had was "Ohmigod, not again!"*

*Rockwell seems to be haunted by fires. Besides this one and the major blaze which destroyed his studio in Arlington in 1943, he experienced a small one in his studio in New Rochelle in 1938—a minor fire which burned up a few costumes before it was discovered.

But the Stockbridge firemen took care of everything with fault-less efficiency.

They didn't dare blow the whistle at the firehouse or blast loose with the siren on the fire truck because that would have brought the whole town running to the scene. A crowd would have messed up all the carefully calculated preparations for the evening's telecast. As quietly as they could, the firemen whizzed over to the Rockwell's and shot some carbon dioxide up the chimney to extinguish the blaze.

By the time they had made all their inspections and left the house, there was only about an hour left until showtime, 10:45 P.M. That didn't faze Norman, the old trouper from the Metropolitan Opera. When the klieg lights came on, the show proceeded calmly and smoothly. At the end of the interview, Mr. Murrow commented to Mary and Norman that it couldn't have gone better. "The house looked just lovely. Everything came off perfectly."

That summer, a real catastrophe struck. In August Mary Rockwell suffered a heart attack. She died at home before any attempt could be made to get her to the hospital. She was fifty-one years old.

"The remarks about my reaching the age of Social Security and coming to the end of the road, they jolted me. And that was good. Because I sure as hell had no intention of just sitting around for the rest of my life. So I'd whip out the paints and really go to it."

Into the Sixties

The autumn of 1959 was a long one for Norman Rockwell. As he looked toward the glorious decade which the journalists were beginning to tout as the "Soaring Sixties," he didn't see much sunshine in the skies or experience any feeling of exhilaration over the prospects ahead. It seemed that his whole world was vermiculated with troubles that had done away with all the joys he prized.

His wife had just died. The kids were away most of the time, the house uncomfortably quiet and empty. An ineffable weariness seeped through him when he reflected on the fact that it was a full fifty years since he had started on a full-time art career by quitting public school and enrolling at Chase. Half a century as a serious artist; forty-eight of those years as a self-supporting professional.

What wearied him even more was the realization that he had reached that tenebrous time when modern society expected him to go into hibernation. He was sixty-five years old—"the age of Social Security," they called it.

"What a horrible thought that was," he observes. "I wouldn't have paid much attention to it myself, but whenever people found out my age, they'd say, 'Oh, you're sixty-five. You'll be quitting your work now, won't you?' They sort of took it for granted. And that would always shock me. I got a queer feeling in the pit of my stomach every time I thought about it. I guess that was good for me though, the silly questions about retirement. Because I felt very depressed at times, and I might have just slowed up and gotten completely off my stride if I'd been let alone."

If Rockwell had chosen to take up a life of leisure, finances would have been no problem. A man from the Social Security office showed up to hand over a check and get his photo taken with one of the most famous oldsters in the U.S. That seemed like a big fuss over a small matter, especially when Norman noted the size of the check. He was already receiving a much larger one every month from an insurance company from which he had purchased an annuity policy in the 1920s—way back then.

In the good old days, when you could buy not only a five-cent cigar, but also a five-cent loaf of bread or a gallon of gasoline for ten or fifteen cents with a free drinking glass thrown in for good measure, an insurance agent had persuaded Rockwell that it would be a good investment to put a few thousand a year into an annuity.

When the policy reached maturity, Rockwell didn't quite know what to make of it; in fact, he told the insurance company at first that he didn't want any payouts yet. Then, after a couple of years, he decided, as he told a friend in Vermont, "I guess I might as well start taking those payments now because I might not last but a few years more." Fortunately, this assessment of his longevity was off more than a bit, and to date he has gotten far more than his money's worth from the insurance firm. But he never could get around to the idea of living off those checks and going fishing every day. That's not his idea of fun. Painting is.

If Norman needed any confirmation of his feeling that the best way to keep going was to keep working, he had the example of his old friend Grandma Moses. In 1960 her hundredth birthday was approaching, and she was still keeping herself busy, turning out paintings of her girlhood. Norman took a day off to vist Grandma

as her century celebration approached, but it was one of only a few days when he didn't stick to his prescription for loneliness—work.

His longtime associates, the Boy Scouts, were having a big celebration in 1960—their Golden Jubilee—for which they required some Rockwell art. He painted an especially fine scouting scene for their calendar that year. He was also asked by the U.S. Post Office Department to design a stamp commemorating fifty years of scouting. Postmaster General Arthur Summerfield announced that Rockwell was the unanimous choice of the Citizen's Stamp Advisory Committee to design the Scout Jubilee stamp. He further stated that an initial print order would be placed for 120 million of these four-cent commemorative stamps.

Rockwell was pleased at the invitation and found this commission an interesting challenge. He brought fourteen-year-old Thornton Percival of Stockbridge into the studio in his uniform and made him the scout destined for immortality. A head-and-shoulders view of Thornton with his right hand raised in the three-finger salute appeared on the stamp, printed in the Scouts' khaki and blue colors.

Although this was the first postage stamp ever designed by Rockwell, it was not to be his last. A few years later, in 1963, the U.S. Post Office Department again asked him to create something for them. This time it was a commemorative for the hundredth anniversary of city mail delivery. The resulting centennial design was the first postage stamp in history to have a humorous motif. It depicted an 1863 postman, complete with umbrella, stoically trudging along his route while a grinning, Rockwell-type urchin and a typical mongrel Rockwell dog dashed past him in the rain. This was a five-cent stamp.

His next stamp went up to eight cents, reflecting the steady increase in postage rates. It was done in 1972 to commemorate Mark Twain's immortal book, *Tom Sawyer*. Norman's comment on the stamps: "At least the prices for my work are going up at the Post Office. Maybe eventually I'll get up to the *dime* category!" Little did he know then that stamps in the future would be way, way above the ten-cent level.

At about the time he was working on his first stamp, in the

summer of 1960, Rockwell received an assignment from the *Post* which he found most interesting. He was instructed to go visit John Kennedy, a young and not too well-known senator who had surprised everyone by rounding up most of the delegates for the upcoming Democratic Convention. Rockwell was to paint a cover featuring him, to appear in October of that year. This Kennedy cover painting was started in June, a month before his nomination, at the famous compound at Hyannisport.

Early-riser Rockwell arrived at the Kennedy home before the young senator had had time to get dressed; he was still in rumpled pajamas when the artist rang the doorbell, Rockwell recalled to me. This didn't fluster Kennedy, though. He simply called out to Norman to make himself at home while he finished breakfast.

When the sitting started, Kennedy had one request. He asked Rockwell to please make him look *at least* his age. Kennedy was only forty-three at the time—not very old for a presidential aspirant—and with his boyish face, he looked even younger. There was considerable talk at the time, before he had received the nomination, that his youth would be a handicap, so he was a bit sensitive about looking too youthful.

The senator was extremely. friendly, Norman recollects. The sitting was divided into two sessions. After Norman had sketched for about an hour, the pair knocked off long enough to take a little rest. John Kennedy then invited his guest to stroll down to the oceanside for a few minutes and gave him a tour of his boat, which was tied up at the dock there. "He was a marvelous host," Rockwell reminisced, "very considerate."

After the election, Rockwell painted John Kennedy again, in a Peace Corps picture which now hangs in the Old Corner House museum. He also painted a convention scene of Kennedy about four years later. It appeared on *Look* magazine's cover on July 14, 1964, after the president's assassination.

During the 1960s, Rockwell painted all the presidential and vice-presidential aspirants of that decade. His first meeting with Kennedy was followed soon thereafter by one with JFK's opponent that year—Richard Nixon. Afterward, he made other por-

traits of Nixon. In fact, Nixon was the president he painted the most—a total of six portraits.

"His looks haven't changed so much over the years," Rockwell observed. "Oh, he's older, sure. Aren't we all? But the features strike me as being pretty much the same. Maybe it's that Nixon nose. It's hell to paint and keep it from dominating too much," he confided to me.

Whenever he thinks about Nixon, Norman always seems to recall the incident of the maids, which occurred when the president came to the Plaza Hotel to pose for him. As Norman, Nixon, and an entourage of bodyguards came down the hall in a flying wedge, they encountered a couple of chambermaids who had been busy bundling linen out of the rooms. Nixon, the ever-smiling candidate, stopped to chat for a fraction of a minute with the two startled women. He asked them how they were being treated and invited them to come down to the White House to tell him about it personally if they were ever treated poorly by the hotel management.

Said Rockwell laconically, "If those two maids ever showed up at the White House, I'd like to have been there to paint a picture of them."

In 1964, of course, the candidates were Barry Goldwater and Lyndon B. Johnson. The picture Rockwell did of Johnson, for *Look*'s cover, was different from the usual single close-up portraits he had always done for the *Post*. Instead, he painted a trio of poses of Johnson. That was a memorable assignment.

Rockwell, Allen Hurlburt, then art director of *Look*, and a photographer were ushered into the president's office by an aide. They caught him at a busy time, as might be expected. The president looked up from a pile of papers he'd been scanning. Rockwell had approached nearest to the big desk. Johnson speared him with a cold stare. Norman remembers that the conversation went about as follows:

. "Who are you and what do you want?" the president demanded.

"I'm Norman Rockwell, Mr. President, and I've come to paint your portrait for *Look* magazine," the artist answered.

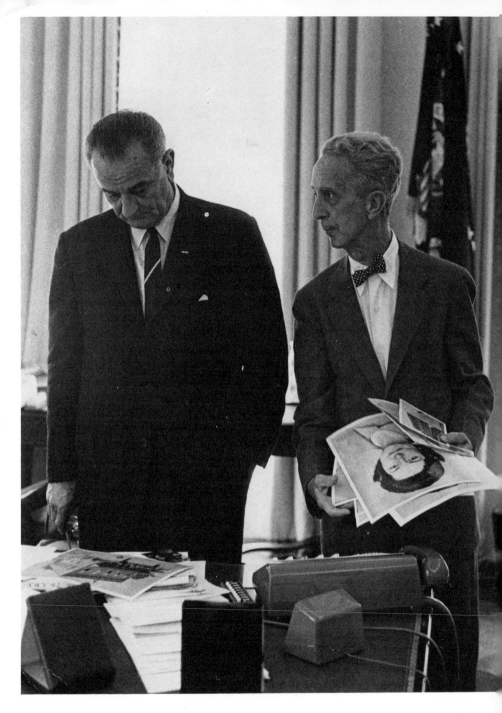

Lyndon B. Johnson was the most solemn of the many presidents and presidential candidates Rockwell painted. The artist had to coax a smile from him. He found Mrs. Johnson's Southern charm to be irresistible.

"How long will that take?"

"Not very long, sir. Our photographer here will snap a few pictures of you for reference, and I'll make some color sketches," said Norman, opening his paint case.

"Okay, start sketching then," the president snapped as he froze into a grim pose.

"Mr. President," said Rockwell quietly as he worked away a mile a minute, "I've just painted Senator Goldwater's portrait and he had a big smile on his face. Now, you wouldn't want his picture to look happier than yours, would you, sir? Couldn't you manage a little smile for me?"

In telling me about the outcome of this conversation, Rockwell chuckled a bit and pointed forward with his hand as if he could still see the former president in front of him. "Johnson turned straight toward me then," Norman recounted, "and he looked straight into me without twitching a muscle on his face. Lord, but those eyes of his could be *cold. I could feel 'em right through to the back of my head!* Then they seemed to twinkle just a bit, and he pulled up the corners of his mouth in a smile." Rockwell mimicked the look. "But it still wasn't a very happy smile."

"I guess we must have caught him on a real bad day. I never sketched so fast in my whole life and we got out of there in a HURRY!" He chuckled again. "You know, if you look at that picture for the 1964 election, you'll see I showed three different poses of Johnson—two of them smiling, but one of them grim, just like when we walked in that room."

Other political figures Rockwell painted were Ronald Reagan, when he was running for governor of California in 1968, Eugene McCarthy, Hubert Humphrey, and, again, Richard Nixon in the 1968 presidential race. After the election, he painted the vice-president, Spiro T. Agnew, for the cover of *TV Guide*. While that particular painting was in his studio, a visitor there commented that it didn't seem to be in Rockwell's style. Rockwell answered, "Neither is Mr. Agnew." His wife, he stated, almost stopped talking to him when he agreed to take on the Agnew assignment. And Molly verified that fact.

During the 1968 elections, there was another of Rockwell's nonfavorites whom he did want to paint. That was George Wal-

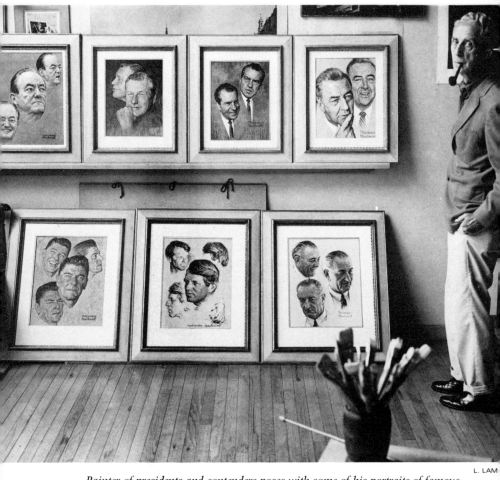

Painter of presidents and contenders poses with some of his portraits of famous political figures. These pictures appeared in Look *magazine.*

lace, a contender for the nomination, who fascinated Rockwell in a morbid way. Norman claimed that he had a great idea for a Wallace picture, but the magazine editors turned it down. Not surprising. In a television interview with Patsy McCann on Station WOR in 1968, he described his concept in the following way:

"I missed [painting] Wallace. But I had a wonderful idea for him. I'd paint him while he was talking loud, with that mouth of his which comes out almost the shape of a square, you know. He'd be talking, and behind him I'd put this black background . . . almost solid black with just the silhouettes of some black figures in it. But *Look* didn't go for it."

I reminded him (in 1975) that Wallace might just possibly be a presidential contender again. "What'll you do if he should be elected the next time?" I asked Rockwell.

"I'll move out of the country," he answered.

Along with the candidates for president and vice-president, Rockwell painted many of their wives. When questioned about his favorites among them, gentleman that he is, he maintains that they have all been very gracious and lovely ladies. But when pressed to indicate some who appealed to him maybe just a trifle more than the others, he singled out Mrs. Lyndon B. Johnson and Mrs. Barry Goldwater.

"Lady Bird Johnson had that extra special Southern charm that you just can't resist. Mrs. Goldwater was charming, too. And she was the smart one. She really didn't want to be the First Lady at all. And she got her wish."

Political portraits, whether of candidates or their ladies, were not the sort of work that occupied the major portion of Rockwell's time. They were special assignments that came up every four years and gave him an opportunity to meet some famous people, as well as to enjoy a brief change of pace from his usual routine. Norman worked quickly on these paintings and usually finished them off in a few days. Other pictures he did sometimes took months.

One ambitious undertaking he tackled in 1960 required five months of intensive work to finish. This painting was perhaps inspired by the noble sentiments John Kennedy was declaring at that time, as he began his plans for a new Camelot. At any rate,

Rockwell conceived an idea at about that time for a king-size painting with a grand and glorious theme. Known as the *Golden Rule* painting, it has lettered across it the admonition, "Do unto others as you would have them do unto you." It now hangs in the Old Corner House, and Rockwell ranks it alongside his Four Freedoms pictures as one of his most important works.

The idea for this painting came to Norman one day when he was reflecting on the fact that the golden rule had been a common denominator touching people of all races. It has cropped up again and again over the centuries in the religions of many different parts of the world. Norman decided that the best way to illustrate the timeless dictum would be simply to show the faces of many people of diverse nationalities in reverent attitudes.

He had started a huge picture of that general type several years previously. At that time he was trying to create something symbolic for the United Nations. He had gotten as far as making a full-scale charcoal drawing of fifty people from diverse lands, but as recorded earlier here, he had run into difficulties with two of his main models—the ambassadors from the United States and Russia. As a consequence, he had abandoned the project.

Now that he was becoming excited over the thought of a religious message that would apply to people everywhere, Norman remembered the enormous amount of work he had invested in his preliminary ten-foot-long charcoal drawing for the discarded UN painting. He pulled it out of hiding, dusted it off, and began selecting the heads he needed for the new project.

One point about the *Golden Rule* that particularly pleases Norman is that the models appearing in it, though they represent a cross section of the nations of the world, all came from his home area. They are all people he rounded up either around Stockbridge or from Arlington, Vermont, not far away. Many of the exotic costumes they wear came from his own studio wardrobe, especially clothes he bought during his Pan-Am trip around the world. But the people are all local.

"Guess it proves that America really is a melting pot," he noted to me as we looked at this painting one day at the Corner House. "Several of the models I used were students. There's a Japanese student I found on the campus at Bennington. A Korean girl, Joy,

who was studying at Ohio State but was visiting here. One young fellow from Brazil, I think, and that's a Jewish boy who was studying at the Indian Hill School just up the road a few miles from here. The others are New Englanders. The blonde woman with the braided hair and her baby and farmer husband are from Arlington. The little Chinese girl, Susie Lee, lives in Pittsfield. Abdulla, who runs the market on Elm Street in Stockbridge, rounded up a bunch of his friends so I could select some Middle East types. The little red-haired girl is Louie Lamone's daughter. Oh, and the rabbi, he's Mr. Lawless, our retired postmaster. I put whiskers on him and I think he fits the part quite well, even if he is a Catholic."

One face in the painting, located in the upper right corner, Norman painted from memory. It's Mary, his deceased wife, and the baby she is holding is their grandson.

After the *Golden Rule* appeared as a magazine cover in April of 1961, Norman was presented with the Interfaith Award of the National Conference of Christians and Jews. Generally, he tends to be unimpressed by the many honors conferred on him and turns down almost all of the frequent invitations he receives to attend banquets where he is to be given medals or other awards. But this is a citation he treasures, because it recognizes "his dedication to the highest ideals of amity, understanding and cooperation among men; and his artistic leadership in depicting with such exacting technique and unfailing humor the universal fact that all men, great and unknown, are members of the One Family of Man under God." That comes about as close as anything to describing Norman's philosophy of life.

At the end of May in 1961, Rockwell received another honor. He was invited to the University of Massachusetts to receive an honorary degree of Doctor of Fine Arts. At the ceremonies, he was flanked by two other distinguished residents of the state—the former president of MIT and the president of Boston College.

Norman laughed when he told me about the occasion: "I felt kind of strange sandwiched in between those two big brains, the heads of two famous colleges . . . me, a high-school dropout. I was worried before the ceremonies as to what I'd talk about with them if they started a conversation while we sat there. I didn't

want to sound stupid and I was afraid I would, but it turned out that there was no problem. All they both wanted to talk about was my pictures."

In the summer of 1961, the U.S. State Department became intrigued with the international-relations value of Rockwell's *Golden Rule* painting. By then, it had become much talked about throughout our country, and the State Department officials felt sure it would attract attention in other lands as an expression of universal goodwill by one of America's leading artists. They also liked the public-relations impact of being able to point out to people overseas, "See what a diverse group of people we have living in a largely rural area of the U.S. The models the artist used for this painting all came from within fifty miles of his home in New England. America really is a place where men and women of all races and religions live together in harmony."

The State Department's plans called for making a movie of Rockwell, his studio, some of the diverse models he used, and the finished *Golden Rule* painting. They also planned to show some of the area around Stockbridge. They said such a film would be a great hit overseas. They'd send prints of it to practically every country in the world where there was a movie projector.

As usual, Norman was happy to do whatever he could to cooperate. Once again he braced himself for an inundation of cameramen, lighting technicians, directors, gaffers, and tons of cables and photo equipment. Once again the red-barn studio, hidden away in a Stockbridge back yard in the center of the quiet Berkshires, would be put on film and shown to millions of people.

The resulting thirty-minute movie was a success. It won first prize in the documentary category at the Venice Film Festival. It was translated into seventy languages for showing abroad. Americans did not get a chance to see it, however, because of a law which prohibits such government agencies as the State Department from publicizing themselves to the electorate.

By this time, Norman had found a new interest in life. For a long while, he had been extremely lonesome. Then Dr. Erikson suggested he become involved in some sort of organized social or cultural activities that would get him out of that empty house and into contact with new people. He began attending a series of

Who says Rockwell couldn't paint in an ultramodern style if he wished to? Here he has a picnic trying the "dribble" method à la Jackson Pollock. The resulting spattered-up canvas was used as the background for a cover picture which showed a puzzled museum visitor looking at a modern painting. It appeared on the Saturday Evening Post in January 1962. Rockwell remembers this project as "a lot of fun," but not as something he'd like to pursue as a steady routine.

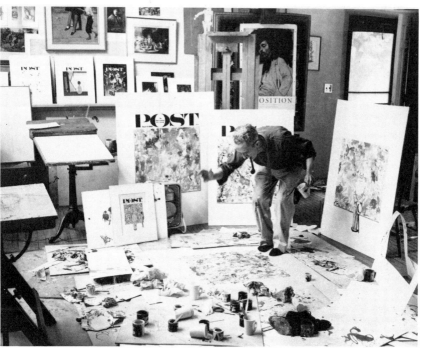

discussions on art and great books at the Berkshire Arts Center. Then he switched to a course on modern poetry. That was a fortuitous change, or perhaps merely proof that the artist's eye was still alert as ever, because the discussion leader was assisted by an able helper whom Norman began to describe as "that cute little Molly Punderson."

Miss Mary L. ("Molly") Punderson was a former schoolteacher, retired after thirty-nine years as an English instructor at the prestigious Milton Academy near Boston. She had returned to her home town, Stockbridge, where she had always maintained a summer cottage. Molly had many friends in town, but after having led an always busy, closely scheduled life, she too was a bit at loose ends. She and Norman hit it off right away.

Molly is as pert as a chickadee and sized to match. If you stretched her a little, she'd measure a bit more than five feet tall: "A full five-foot-two!" she'll tell you. But she packs a tremendous amount of vivacity and drive in that small frame. She's always sparkling-eyed and going a mile a minute. Like Norman she's a meticulous person who likes to follow an orderly daily routine, and she thrives on hard work. Besides books, which she and Norman both love, the two share an interest in many things— people, history, art, and travel.

Norman was not about to let this pretty little bird get away. They announced their engagement in September. On October 25, 1961, they were married at Saint Paul's Church in Stockbridge.

The new Mrs. Rockwell was to learn instantly that life as the wife of America's most famous artist would be subject to frequent interruptions. The newly married couple had planned to travel to California on their honeymoon. They did go there, but delayed the trip a day to zip down to New York City to the NBC "Today" show at Radio City, where Frank Blair interviewed Norman.

Molly also learned as soon as they returned home from the honeymoon that Norman's helpmeet could use as many arms as one of those Hindu goddesses. Fortunately she is a quick study at learning to handle new jobs and is also an efficient organizer. She became involved immediately in the various art-oriented civic projects of Stockbridge; eventually began to help with such daily chores as sorting the voluminous mail Norman receives; and

L. LAMONE

A new model appears on the scene in 1961. After retiring as a schoolteacher, Molly Punderson, spinster, married Norman Rockwell, widower, and began a new career as all-around helpmeet to one of America's busiest artists.

Senator Edward Kennedy visits a constituent and poses in front of The Peace Corps, *in which his brother John appears. Senator Ted is an excellent amateur artist.*

Another scene at the Old Corner House Museum. Just a block from Rockwell's home, it contains the finest collection of his original art. It is operated by the Stockbridge Historical Society, of which Molly is a former president.

learned very soon that the house and everything in it that needed attending was "hers."

Norman, who will cheerfully work like a beaver at anything related to his beloved art, can sometimes get too involved in his work to handle any of the ordinary chores of daily living. Most of those were immediately shunted onto his willing spouse.

Fortunately, too, Molly is not one to get flustered if required to pack the suitcases and take off with a minimum of advance notice. This happens all the time in the Rockwell household. Besides their usual short vacation trips, they took a long journey late in 1962. It carried them to India, with touchdowns at London, Frankfort, Munich, Beirut, Istanbul, and Tehran.

This exotic trip began with a telephone call from Robert Sherrod, then editor of the *Post*. He was planning to do a series of interviews with world leaders. The first chief of state whom he, Sherrod, had arranged to visit was Prime Minister Nehru in New Delhi. He'd be taking Mrs. Sherrod along and also the *Post*'s star photographer, Ollie Atkins (who would later become the official White House photographer). Norman was offered the assignment of coming along to paint a portrait of Nehru which would be used as a cover picture for the magazine.

It was decided that Molly could come too, but she'd have to work to justify her fare. She could go as a second photographer if she could quickly learn to shoot pictures of good enough quality to be used as a record of the trip. Molly was not about to stay home. She took a crash course in professional photography. It has served her in good stead, not only on that particular trip, but on all the others the Rockwells have taken since.

On November 18, the Rockwells and their companions boarded a plane headed east. About twenty-four hours later, they debarked in New Delhi. A few days thereafter, they got their first look at the prime minister at a small luncheon—an intimate affair where there were only about fifty guests.

Later, Rockwell was invited to come to Nehru's office, where he was given some time to make sketches. Most of the painting of the Indian statesman's portrait was done in a hotel room. In about two weeks, it was finished and shipped off to the United States.

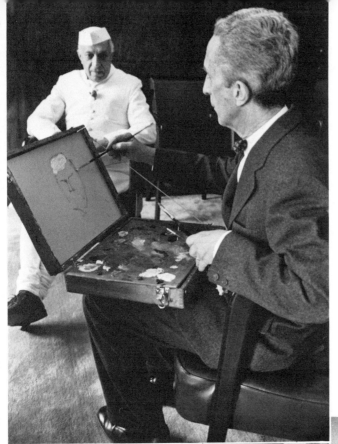

Prime Minister Nehru poses in New Delhi in his white suit. The artist uses his special portable paint box, the top of which serves as an easel and holder for a stack of precoated sketch paper.

PHOTOS BY OLLIE ATKINS

After the quick, preliminary sketches, come hours of concentrated work to develop larger full-scale drawings. These will be followed, back home, by the finished oil painting. Here the artist works while a hotel employee kibitzes and Molly reads up on points of interest to be visited on their Indian tour.

Then the Rockwells took a couple of days to enjoy a holiday in that distant part of the world.

While telling me about the trip to India, Rockwell rummaged in his file cabinets and uncovered a few photographs taken at that time. He laughed when he came to a print which showed the prime minister posing for him. "What's the joke?" I asked him.

"He's wearing his white suit," Rockwell answered. When I looked puzzled, he explained.

"I saw him first at Parliament. He was wearing a dark suit then. I went to his house to sketch him the next day, I guess it was. He had dark clothing on again. So I asked him if he wouldn't please put on a white outfit and cap. He wanted to know why; said he never wore white at that season of the year. I believe it was in the cooler months. I told him the American people who would see his picture in a magazine would imagine that he always wore white, tight suits, like a maharajah.

"He got a big chuckle out of that. But he told me, 'If that's what they expect, that's what we'll give them.' So he went out of the room and came back in a little while in that all-white outfit you see there. He certainly was most accommodating."

This accommodation was extended even though the Rockwells had arrived at an inopportune time. They landed in New Delhi the day after another great statesman of India had died. This was a severe shock to his good friend Nehru, but he kept his appointments with the American artist anyway.

When Rockwell first saw the prime minister at a session of the Indian Parliament, he was impressed both by his handsomeness and by his modesty. Nehru sat at a little desk in the great hall, just as the other members did. "I expected him to be up in front somewhere," Rockwell commented, "at some imposing seat more like a throne."

Rockwell also remembered being intrigued with Nehru's office when he talked with the great man there. He recalled particularly that there were busts of Dante and Abraham Lincoln on the bookcases. The artist came away with the strong impression that Nehru was truly "a man of peace."

Both Molly and Norman liked India very much. They were invited to Nehru's home. Molly recalls that it was a large house,

though not palatial, and that it had beautiful gardens around it. They also talked with Indira Gandhi (Nehru's daughter, later to become India's first woman prime minister). The Rockwells were amazed, and flattered, to find that Madame Gandhi had a room for her children lined with prints of Rockwell's paintings.

The Rockwells also had an opportunity to have tea at the home of one of the many small maharajahs of India. Besides being hereditary ruler of one of the smaller Indian states, near the Taj Mahal, this one really was small physically, too. He was called the Peter Pan of maharajahs because of his diminutive stature. Molly, who told me the story of that visit, rather enjoyed the fact that she towered over their host, a pleasure she seldom experiences. The little rajah was a most accommodating person. While entertaining the Rockwells at his palace, he drove them through the nearby wooded areas, his hunting preserve, bouncing them joyously over the rugged mud roads in an elegant, vintage Rolls-Royce. Fortunately they didn't run across any of the tigers he loved to hunt; the careening car was evidently enough to scare all game out of their path.

They visited some of the smaller villages as well as the big cities. As he usually does, Norman lugged his trusty paint box everywhere they went, so that he could make quick color sketches of interesting places and people along the way. He observed: "Everyone wanted to see what I painted of them, of course, like they always do. And I was surprised at the comments I got there. Usually people will comment on their eyes or their nose or their mouth. The mouth is always wrong on a portrait, you know. But in India, they all commented mostly on just one thing, their color. I had no idea that skin color was so important there. But everyone I painted in that country thought I made them look too dark.

"We went way up north, too, to see the mountains. And I mean *way* up. We got a good look at the Himalayas, which they tell me are about 28,000 feet high. I expected to be very impressed, but really, they didn't look any more picturesque to me than the Berkshires or the Green Mountains. Certainly not as pleasant-looking as the wooded mountains we have in New England. I'll leave those cold and barren slopes in Asia to the mountain climbers."

M. ROCKWELL

World traveler Rockwell always tries to keep in trim. If he can't bicycle, he might as well row a boat. In this dory, he ambitiously heads up one of the largest fjords in Norway, in August of 1972.

Later on the same trip, the Rockwells went to Egypt. The artist recounted that he had some difficulties in working with the Egyptian president. He was a very handsome man—and very conscious of that. "When I tried to paint him," Norman said, "he kept giving me that big 'hello, folks' smile. The straight-on view with all the teeth that you saw in posters on every shop window and wall in the whole town. I didn't want that. He understood perfectly what I wanted, he spoke beautiful English. But he was going to have things his way. I kept insisting on a profile. He kept insisting on the poster view. I guesss I must have been crazy; there were these big tough guards all over the place. Finally I took him by the shoulder and just moved him around the way I wanted

him to stand—the dictator of Egypt, mind you. But every time I started sketching and the photographer got ready to snap some reference pictures, Nasser would swing around and give out with that big toothpaste smile again. So I had to push him around again. Then he finally gave in and cooperated," Norman recollected with a grin. "He was a tough one though. Looked the part of a revolutionary. Quite a tall man, with a proud, straight bearing. I thought he looked like a handsome headwaiter."

Another stop on the journey that the Rockwells will never forget was their stay in Yugoslavia. Molly described it as a most beautiful country. They were able to drive down the coast to see some of the spectacular shoreline. Molly visited one of the churches, still very well attended in this Communist country, and was fascinated by the color and richness of the Byzantine architecture.

Norman was taken to visit Marshal Tito, long the undisputed ruler of that country, to paint his portrait. He found that this iron ruler, who had battled so fiercely against all invaders for his country's freedom, was just as sweet and cooperative as could be with the artist from America. "Not at all what I expected," Rockwell admitted to me.

"The people there love him. He's tough all right. But that's what they admire about him. He had to be strong to stand up to the Russians. And he took all those different races, six of them, with different languages and three different religions, and made them into one nation. He's a man of power, but they adore him."

There was one problem in painting the marshal. At seventy years of age, he still had golden hair, but it showed the unnaturally hard glisten of the dye bottle. The several "advisors" on the portrait kept pushing Norman to "make him look younger." They had to approve the picture before it could be taken out of the country.

"He was surely a magnificent man, though," Rockwell says. "Barrel-chested. Big. With lots of character in his face. And he did look pretty young at that."

It was also in 1962 that the Rockwells made their first trip to Russia. It was a brief one arranged by the State Department as part of an art exchange program with the USSR. "Norman was

one of three artists from our country who put on what they called a 'workshop' in one of the public buildings." Molly recounted. "There was a girl who was a very modern painter, a man from Yale who made etchings, and Norman. They would all work each day at their particular specialty in an exhibit area. And the crowds would come through the building and watch the artists. It was hard to see anything though, because there were such masses of people."

"Norman made quick paintings, portraits, of some of the people who walked through. He'd pull them out of the crowd when he saw a face he liked, and motion for the person to sit for him. Of course, they were thrilled to be selected by this American artist. But the officials there weren't so happy," Molly remembered. "They didn't like the fact that Norman chose the poorer types of people instead of the prettiest ones. I guess they don't really glorify the worker there, as they claim to do, unless he's a handsome man or woman. They created such a fuss about the peasants and older people Norman selected that he just gave up and let them determine who his models were to be. He was quite unhappy about the whole thing."

"We stayed there about a month," Molly continued. "We went to Russia again a couple of years later for *Look* magazine. On that second trip, we had hardly any time for sightseeing. We did get to the Hermitage one evening just before the museum was ready to close. I didn't have time to see hardly any of the fine paintings there—all those beautiful Rembrandts they have. Norman insisted on rushing me along up to the third floor of the Hermitage where there were some Rockwell Kent paintings on display. I guess he was interested in seeing what they had of Kent's because he's an American, one of the few shown there, and maybe because people confuse Rockwell Kent with Norman Rockwell. That used to happen all the time."

That Russian trip had its unusual aspects. Although the top cultural committee of the USSR had arranged it all with the information agency of our State Department, the Russian newspapers seemed out of sympathy with the whole idea. The hostile press took particular exception to the various abstract works of art which were part of the American exhibit that accompanied

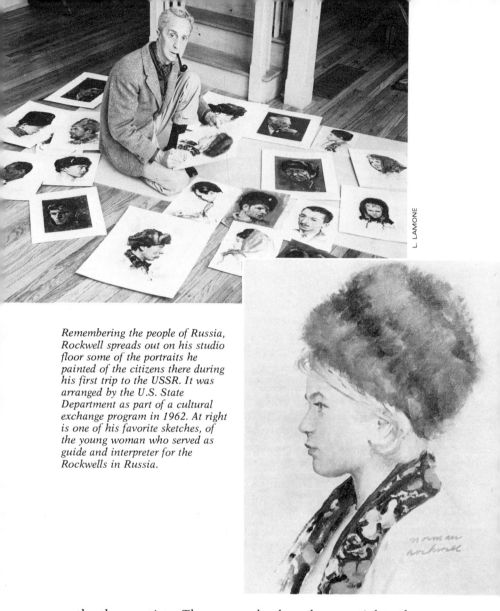

Remembering the people of Russia, Rockwell spreads out on his studio floor some of the portraits he painted of the citizens there during his first trip to the USSR. It was arranged by the U.S. State Department as part of a cultural exchange program in 1962. At right is one of his favorite sketches, of the young woman who served as guide and interpreter for the Rockwells in Russia.

the three artists. They were also less than partial to the young lady artist of the trio, whose work was very modern in nature.

There was still another sour note on that cultural visit. Among his big canvases displayed were the famous Four Freedoms. Although these had enjoyed universal popularity in the U.S., the

painting *Freedom from Want* evoked criticism in the Russian press. It was pointed out that this picture showed the affluent Americans gorging themselves on mountains of food, while much of the rest of the world went hungry. I don't know whether or not it is owing to the memory of this ideological hassle, but Norman likes this one the least of the four big pictures.

That public showing of the Four Freedoms illustrates a rare humility of Rockwell's which I have never encountered in any of the many other artists I've worked with. Unlike artists in general, he shows little protective feeling toward his creations once they are reproduced, even though he takes great pride in painting the very finest pictures he possibly can, and carefully frames them and has them hand-delivered to the publisher. An example of his casual attitude toward his masterpieces is the way he allowed the Four Freedoms canvases to be handled on the first Russian tour. Because it would be inconvenient to ship, exhibit and reship such big paintings with their heavy frames, *the canvases were taken out of the frames, off their stretchers, rolled, and stuffed into a metal tube. Then at the exhibit in Moscow, they were tacked on the walls for display.* Anyone familiar with oil paintings and what can happen to them if the canvas is flexed would have serious reservations about handling pictures of any value in such a cavalier manner. When Norman first told me this had been done to four of the most magnificent pictures he has ever painted, I was absolutely speechless with disbelief. But he simply commented, "It was a lot handier that way."*

*When Molly Rockwell read the last two chapters of this book, covering the period of her husband's life with which she was personally familiar, she took strong exception to these comments about Norman's lack of protectiveness toward his paintings once they have served their original purpose. She maintained that there was no choice but to roll them and carry them in a specially designed metal case, because the big framed paintings would not fit through the airplane door and could not be shipped safely in the freezing temperatures of the plane's baggage hold. There were no direct airlines to Russia at that time, so the paintings would also have had to go through customs unattended. I still believe that most artists would have insisted either that some better means of transportation be provided by the State Department or that they be permitted to exhibit a group of their smaller canvases in Russia.

Working conditions for the three Americans at the Russian exhibit were a far cry from what Rockwell was used to in his spacious, quiet studio back home. Working in a small space, the trio was surrounded by jostling crowds in an overheated auditorium. The models he selected were very patient, however, Rockwell reports. Though it was difficult to get any of them to smile, they obediently sat very still for him. At the end of each portrait session—which usually lasted only about half an hour—a Polaroid photo was made of the completed picture by one of the Russian guides and presented to the model for a keepsake.

Rockwell ran into a couple of disappointments in his painting. He wanted to paint a Russian soldier in uniform, since there were many around. Every time he asked one to pose for him, however, he received a polite but very firm refusal. He also wanted to do some sketching out on the street after his portrait sessions. But when he tried to make a drawing of a street scene, he was pounced upon by a policeman who threatened him with arrest. Fortunately, one of the guides assigned to the American party was not far away at the moment and rushed up to rescue the artist. He did not get to make his drawing though.

On this trip, Mrs. Rockwell, who enjoys new adventures in dining, had a great time sampling various Russian delicacies. Norman was not so keen on them because he likes his meat and potatoes—or, best of all, his favorite liver and bacon. Molly told me that after grumbling a bit about the exotic Russian cuisine, her husband stopped in one day at the American Embassy, which had arranged the trip. He returned to the hotel room that afternoon all aglow and smugly said to his wife, "I had lunch at the Embassy this noon—and you'll never guess what they served me!"

"I took one look at the happy grin on his face, and I knew right away," Molly recounted to me. "I said, 'That's easy to guess. You must have had liver and bacon.' That deflated him a little that I'd surmised so quickly. But I knew no other meal could have pleased him so much."

The Russian assignment was the end of Rockwell's obligation to the State Department. Free to do as they wished, Molly and

M. ROCKWELL

A visitor to Ethiopia examines local handcrafts and buys a string of beads at a fair. He painted a picture of Peace Corps members in that country which appeared in Look *magazine in 1966.*

Norman decided to make a few more stops before heading home. They flew to Ethiopia first so that Norman could make some sketches of the Peace Corps operations there for *Look* magazine. Then it was on to Athens for a brief vacation before flying to Rome for a short stay with Norman's sculptor son, Peter, and his family.

The stop at Ethiopia came about because of Norman's interest in a young man he knew—the son of a friend in Arlington, Vermont, who used to help Norman with his business affairs. This lad had joined the Peace Corps and had been sent to Ethiopia. The more he heard about the corps through a series of letters from his young friend, the more impressed Norman became with its aims.

He persuaded *Look* magazine to send him to Ethiopia to paint a picture of corps members working there.

The Rockwells landed at Addis Ababa, the capital city, in the central part of the country. After a short stay there, they flew out into the bush where the corps workers were located. They went in an old, open airplane of not very reassuring proportions or structural strength.

Molly, always ready for a new adventure, sat up front with the pilot while Norman sat in the back. The pilot was a polite and friendly aviator, so he offered to let Mrs. Rockwell take the controls for a while. In telling about this experience, Molly claimed that she wasn't really enjoying piloting the plane because she was fighting back a feeling of nausea all during the flight. Norman countered, though, that his stomach felt a lot uneasier than hers did until she relinquished those controls and turned the piloting duties back where they belonged.

Coming back home, Norman was to undergo some radical changes in the coming year in his main field of employment—that of magazine artist. For nearly half a century, he had been devoting a major share of his efforts to painting for the *Saturday Evening Post*, and he had always considered that his number-one job, despite the many other assignments he took on. In the early sixties, the *Post* was having trouble maintaining its circulation. Late in 1963, it underwent a change of management, and the new editors decided to switch to a sensational format. The transformation included photographic covers, and it ended the tradition of Norman Rockwell cover paintings, which had been one of the most popular features of the magazine.

On December 14, 1963, the very last Rockwell cover appeared on the *Post*. It was a picture of John F. Kennedy—a repeat use of a painting of the president that Rockwell had done earlier. This portrait was run in memoriam after the tragic shooting in Dallas.

Although its circulation continued downward after Rockwell left it, the magazine continued to publish until 1969, utilizing a "sophisticated muckraking" editorial approach which eventually got the management embroiled in over 500 million dollars' worth of libel suits. When the *Post* finally expired, Rockwell was quoted as saying, "I was glad the magazine died. It was sick for so

long that it was a relief when it finally went. Like when an old friend finally goes after a long, painful illness. I guess you could say the magazine actually died back in 1963, but it was unburied till now. I felt sad then, but not now."

After a hiatus of four years, the assets of the defunct magazine were purchased by a corporation in Indianapolis. The assets consisted chiefly of the *Saturday Evening Post* name and the unrestricted rights to reprint all of the covers and editorial art which Norman Rockwell and other artists had sold to the old magazine over the years. In 1971, the new owners began to produce a magazine on a quarterly basis, depending heavily on the nostalgic appeal of articles and pictures rerun from the old days. Norman, who always hates to say no, has permitted himself to be photographed several times for articles about himself in this "new" *Post*, but he has not painted any new pictures for it; the many paintings of his which appear in the magazine are reprints. It is a source of some irritation to him that the reprint rights for his old cover paintings can also be rented out to other companies for use in advertisements and a wide variety of products without his knowledge or permission.

The demise of the *Post* really disturbed Rockwell. In the year 1916, at the age of twenty, he had sold his first cover paintings, for $75 each, to the *Saturday Evening Post*. Over the next forty-seven years, he had produced cover illustrations for the magazine every year, usually painting six or seven annually. In all, 317 of his covers appeared on the *Post*. Although as his fame grew he helped to boost the circulation of the magazine enormously, he was never paid more than $5,000 for a picture. (He generally charged at least twice that much when doing a painting for other clients.) During this time he had also contributed many drawings and other illustrations to the magazine, including the immortal Four Freedoms paintings. Now, that part of his life was over.

The tribulations of the *Post* spelled opportunity for other publishers—and a new freedom for Norman. The editors of *Look* magazine approached him immediately with the offer of an assignment, illustrating important articles for them. What's more, they indicated that they'd like him to make some changes in his long-established style of picturing everyday folks in every-

day situations. They proposed that, at the rather mature age of sixty-nine, he try a new approach and become their on-the-spot eyewitness artist-reporter of the most exciting news events of the times.

That was a challenge too interesting for Norman to pass up. When you get to be nearly seventy, a little variety may be needed to shake up the juices. He plunged into the new and different assignments with his usual youthful curiosity and enthusiasm.

Instead of the happiness of kids at play, which the *Post* had encouraged, he now captured on his canvas the biting reality of black children walking the gantlet to a school where they were not welcome. Instead of timeless scenes on a village street, he painted for *Look* the immediacy of man taking his first step on the moon. He visited the Peace Corps in Ethiopia and became concerned with Lyndon Johnson's war on poverty. When the radio brought news of bloodshed in Mississippi, he went back to his studio that same night to paint the anguish he felt.

He began painting for *McCall's* as well. Unlike the news pictures for *Look*, these were scenes more reminiscent of his old style. The view of Main Street in Stockbridge at Christmas time.

In 1970, some of the leading citizens of Stockbridge dressed up in historical costumes to commemorate events in the early history of their town. After the ceremonies and some picture taking, a famous artist decided that a few informal photos would be nice, too. Here he poses as a wounded, screaming Indian.

Another in warmer weather, showing Rockwell and friends ped-aling their bikes down the road. The old pro had proved that he could paint news events with the best of the young crop of artists, but he hadn't lost his touch for nostalgia either.

Besides changing to new magazines and developing some de-cidedly different approaches in his painting, Norman also under-took his first involvement with sculpturing in 1965. A satisfying feature of this new project was that it was done in collaboration with one of his sons. Peter, who had studied sculpture at the Pennsylvania Academy of Fine Arts and then at the Scuola del Marmo in Carrara, had been commissioned to produce four bronze panels for a memorial bell tower. He persuaded his father, the history expert, to sketch four scenes celebrating American heroines from different periods of American history. Peter took these back to his studio in Rome, where he made sculptures based on Norman's pictures. The panels were cast and now can be seen high on the tower at the Cathedral of the Pines in Rindge, New Hampshire.

These were busy, happy days for Rockwell. The resurgence of his popularity increased steadily. This had its negative side as well as its good one. The tourists really began to beat a path to his door, and that proved an annoyance to the hard-working artist at times, much as he liked to have people like him.

Once while we were resting a bit at his studio, sipping Cokes, Norman told me of the time he invited a busload of tourists into the place. It seems that one day a large tour bus pulled up in front of his driveway and disgorged about fifty ladies who were all excited about seeing the famous man's abode as part of their tour of New England. This crowd spilled out of the bus like schoolkids at recess time. They soon edged up the driveway and were run-ning about on the Rockwell lawn snapping pictures. Their chat-tering became so loud that it interrupted Norman's concentra-tion, which isn't easy to do. He got up from his chair to peer out the big north window at the scene outside.

You or I might have been more than a bit annoyed if such a thing had happened in our yards (and Norman has since put a stop to such tour invasions). But on that day, he was intrigued with the ladies' obvious enthusiasm. He told me he thought,

"Gee, I'll bet they'd get a kick out of coming into the studio for a few minutes. I decided to stretch my back a bit, so I figured why not take a chance and invite 'em in. That was one helluva mistake!"

Norman continued his tale: "I stuck my head out the door and told the ladies they were welcome to step inside if they liked. But just for a few minutes, mind you, because I told 'em I had to get back to work soon. Well, gosh almighty, you should have seen what happened when they heard that. The nearest ones squealed and headed for the steps. The others maybe didn't know exactly what was happening, but they came running too. Wow! I thought they'd break the door down. I stepped back out of the way fast— just as fast as I could—so as not to get trampled. And they came pouring into the studio.

"Well, you never heard such a hubbub. They were sure having a good time, though. But, jimminy, after about a half-hour of this, I began to worry I'd never get them out of the place. I was reminding them, see, that they'd promised to stay just a few minutes. But nobody was making any move to go. I guess nobody wanted to be the first. Well, finally, I got the bus driver aside—he was inside, too—and I told him, 'Look, you have to shoo these women out of here now, you just have to.'

"Well, he tried. And I tried. And fortunately Louie [Norman's handyman-photographer] had shown up at the studio, and he tried, too. Would you believe that all three of us spent about a whole hour trying to move those women out the door? We'd manage to get a few of them outdoors, see. But then we'd go into the storeroom or up on the balcony—they were all over the place—to try to collar some more. And the first ones would move back in the door again!

"There was one lady in particular, I'll never forget her. She was just in ecstasies over some of the sketches she found in the back storeroom. She kept pulling sketches out of the racks—some of those old Russian ones. And she'd exclaim, 'Look at this! Look at this!' We'd get her moved as far as the main room, and the next thing you knew, damned if she wasn't right back. She was a nice enough lady, and having a wonderful time. But, gee whiz!

"Would you believe that finally when we got everybody else

Photographer and jack-of-all-chores at the studio, Louie Lamone seldom gets his own picture taken. Here he has rigged a long cable extension on his camera to take a picture of himself with his boss.

In 1965, Hollywood-fan Rockwell not only painted this huge publicity picture for the refilming of Stagecoach, *but also played a brief bit part in the movie.*

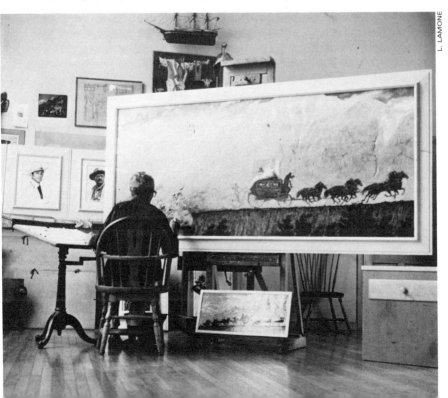

Bing Crosby wrote Walton, "Rockwell played a part in the saloon scene. He got a tremendous kick out of getting into makeup and looking as tough as possible."

chased out, Louie and the bus driver had to pick her up, one under each arm, and sort of lift her down the steps? And then lock the door? If they hadn't, I think she'd be here yet. Well, that was the last time I ever invited a bunch of people into the studio. No more!"

There were benefits in being popular, though. Rockwell's connections on the West Coast gave him an opportunity to indulge briefly in a field of endeavor that has always fascinated him—acting. It was in 1965 that this occurred. He fondly remembers the time when Twentieth Century-Fox studios actually gave him a bit part in *Stagecoach*, which they were remaking. This little adventure came about, as you might suspect, as the result of a painting commission from a movie-maker. This is how Rockwell described the chain of events in an article in the Chevrolet magazine, *Friends*.

"I got a phone call from a Twentieth Century-Fox producer, Martin Rackin, asking me to go to Hollywood to paint pictures of the stars in *Stagecoach*, which they were re-filming. I had seen the original film (in 1939) and thought it was a wonderful picture, and the whole thing sounded fascinating to me . . . too good to be true. I talked it over with my wife and we decided to accept.

"The commission was to paint portraits of nine stars—Ann-Margret, Bing Crosby, Robert Cummings, Van Heflin, Mike Connors, Alex Cord, Slim Pickens, Stefanie Powers, and Red Buttons. Then I met Keenan Wynn, who was also in the film, and decided to paint him as well, because I have admired him and his father for so long.

"I also agreed to paint a large canvas of one of the big scenes in the film—the stagecoach being pulled at top speed by a team of six horses, with a band of Indians in hot pursuit. I tried to sell the producer on the idea of having only one or two horses. Painting six of them is a lot of work. But I had to put them all in.

"The stars were very cooperative. I couldn't imagine Bing Crosby in the role of the drunken doctor, but I wish you could have seen him when we made his sketches and photos. He was wonderful . . . he even made his eyes look bleary. I am always amazed at how disciplined these performers are.

"I got a part in the film myself when Rackin [the producer] came to the hotel while Mike Connors was posing for me. Mike had a deck of cards, and I was showing him some card tricks. Rackin seemed to get inspired. He asked me if I'd take the role of a card-player in the film, and I said, 'Why not?' He ordered a costume for me, and that was it. I don't do much in the film. I'd

have been glad to do it just for the fun of it, but they had to pay me as an extra.

"I liked acting, even though I'm mostly in the background, and I liked Los Angeles. There are so many things to do there. We took drives in the mountains, and I had a show of my work at the Los Angeles Municipal Gallery. We had about forty of my pictures there. Best of all was getting to know the performers while I was sketching and working with them. I even had a good time while I was painting the horses."

Shortly after Norman's brief fling at being a movie actor, both the Rockwells took off on a long journey eastward. This time, in the late spring of 1965, it was again to Russia, where they had made their first visit three years previously. They went not at the behest of the State Department on this occasion, but as part of an assignment from *Look* magazine. Norman was to visit a typical Russian school in Moscow and paint the children there. This painting finally appeared in the magazine in October, 1967.

Former schoolteacher Molly, after nearly forty years in classrooms herself, was completely in her element on this assignment. She obviously enjoyed accompanying Norman and helping him on this educational excursion. Her eyes sparkled as she recounted the experience.

"We were supposed to present the idea of a typical Russian school. The Russian guides took us to a very nice school building. They were a little bit ashamed of the physical aspects of some of their schools. Naturally they wanted to look good in the American magazine, and they had been so busy building housing in their cities that they hadn't been able to do as much as they liked with their schools. But this was a very nice one they took us to one afternoon, and the children presented us with flowers and were very courteous.

"It was an English-speaking school they picked. It's quite common in foreign countries, I find, to have English, French, German schools and so on, and the teaching is all done as much as possible in those languages. This was an English one, in Moscow.

"When we went in with the guide, one little girl gave us a speech of welcome. They all brought us flowers, too. The people

Former schoolteacher Molly Rockwell enjoys visiting a school in Russia in 1965 on her second trip to that country with her famous husband. The children presented her with a bouquet of flowers. Norman painted a classroom scene to illustrate an article for Look *magazine.*

It gets cold in Moscow. But it's not so bad if you have a warm fur hat and a glowing pipe to warm your nose.

there love flowers. And we looked all around throughout the school on that first day's visit, so Norman could decide which of the classrooms he liked the best.

"The next day we went back again to that room, and the children were all seated, ready for us when we arrived. It was a typical Russian grade-school class. There was a statue of Lenin at the front of the room, I remember, and the children had brought some flowers to put with the statue, and they presented me with a small bouquet again, too.

"Norman got out his paints and made the sketches he had come to do. There was one boy—a dreamer—who just looked out the window all that time. He stood out from the others, and Norman made him the theme of the picture. When the sketches were finished, the children wanted to look at them, of course. And they all applauded and said, 'Thank you.' It was a happy, pleasant experience.

"As a treat then, after all the posing was over, Norman went to the blackboard and started to draw a picture of a dog in a special way he knows how to do. The children watched intently. As it gradually began to take shape all of a sudden and they realized it was going to be a dog, they broke out into applause. They were so excited. They were just as natural and delightful as they could be."

A couple of years later, in 1967, Norman collaborated with his wife on a project again, but this time it was of a different kind. For some time, Molly had been busy at her typewriter in her little hideaway house in the back yard. She ended up with the manuscript for a book—a whimsical tale about a bird. Norman was delighted with it and agreed to provide illustrations for the volume.

This story, *Willie Was Different*, is presumably a children's book, but it actually was written for gentlefolk of all ages. A parable of sorts, it has to do with a thrush named Willie, who is typical in many ways of youth today. A dropout from thrush society, Willie gets tired of always singing one song. He proceeds to do his own thing, and in the process achieves worldwide fame. The story is charmingly told. The illustrations, by an artist who had never painted birds before, are charming, too, in that they

manage to convey the human qualities which the author intended to give her thrush with his "people-type" problems.

Besides the excitement of getting the book ready for publishing, the Rockwells had the happy experience of a wedding in the family at about the same time. In September 1966, Jerry Rockwell decided to forsake his bachelor existence, at the age of thirty-five, and marry Miss Susan LeRoy Merrill.

Although the bride had attended college at Bennington, Vermont, only a few miles from where the Rockwell family used to live, the couple had met in Rome just the summer before the wedding. The bride was studying there on a scholarship at the Academia di Belle Arti, and Jerry was visiting at the home of his sculptor brother, Peter. The marriage ceremony was performed by the bride's father, the Reverend George Merrill. The young couple then went to live in Boston, where Jerry had his studio at that time.

As the decade of the sixties drew to a close, it became apparent to some people that the broad public appeal of America's best-known artist had not faded, even though the age of illustration was over. He had survived the demise of the *Post*. And no matter if the editors of other magazines were coming to believe that their readers preferred to look at photographs rather than paintings, the public didn't agree. They thought more highly of Rockwell's pictures than ever.

Bernard Dannenberg, the owner of the Dannenberg Galleries, was one of the few New York City experts smart enough to recognize that the pictures of Norman Rockwell were more in tune with the mood of the times than those of the "Now" painters. He decided that Norman Rockwell, the best-known painter ever to come out of Manhattan, ought to have his first one-man show there.

It was to prove to be an important event in Rockwell's life.

10

"The secret to so many artists living so long is that every painting is a new adventure. So, you see, they're always looking ahead to something new and exciting. The secret is not to look back."

Rockwell Rediscovered

Having passed his seventy-fifth birthday—and good riddance to it—Norman Rockwell found himself in pleasant circumstances. The goddess of good fortune smiled at him, and, being the alert gentleman he is, he winked back at her.

Things had been a bit dull at times as he made the transition from his decades of painting *Post* covers to working for other magazines. The illustration business was generally slow in the sixties; photographs had crowded most art off the periodical pages, and many periodicals had gone under as their revenues were gobbled away by television. This is not to say that Rockwell was hurting. He had his steady patrons, such as the Boy Scouts and various advertisers who coveted his paintings, and he could always keep busy with portrait assignments. But a man who wants to stay young at heart needs an occasional stimulus, a new direction, a new outlook.

In the period immediately following his "diamond" year, 1969, Rockwell entered one of the happiest times of his life. Buoyed by

the surge of his renewed popularity, he ventured into many new and different assignments. He and his wife managed also to take time off every few months to enjoy traveling to new and interesting places.

His first inklings of the ferment to come emerged when the people at Dannenberg Galleries contacted him for help in arranging a one-man show. Any artist would be pleased at the prospect of an exclusive show at a prestigious New York gallery, but Rockwell was as ecstatic as a kid just out of art school who sells his first painting. Incredible as it may seem, Rockwell, whose works could be identified at fifty paces by hundreds of millions of people around the world, had never had a show of his own in his hometown of Manhattan. Now the folks back home were finally ready to recognize that he existed.

He gladly cooperated with the gallery curators in their quest for key paintings of his, giving them what bits of information he could as to their possible locations. They searched diligently and the roundup was a success. Nearly fifty canvases, most of them done for magazine covers, were displayed at the gallery on Madison Avenue on the day of the big show in 1969.

Even the art columnists and other erudite critics came to the Rockwell retrospective exhibition. It's hard to guess why, because the show did nothing to change their lack of enthusiasm for his nostalgic scenes, gentle humor, and realistic technique. But their apathy was not echoed by the majority of the supposedly sophisticated New Yorkers who traveled up the avenue to crowd into the show throughout its run.

Even at the by-invitation-only preview party on the eve of the show's opening, it was obvious that quiet old Norman Rockwell, who had been tucked away in the woods for so long, was destined to join the ranks of the superstars in the upper-Manhattan gallery world. The majority of the paintings on the walls that night were snapped up by the insiders present, at prices averaging around $20,000 each. When the regular show opened the next day, nearly all the pictures in it carried little red "sold" tags. No longer would any Norman Rockwell art go for bargain prices. The rates were destined to go up and up.

To say that the gallery was happy to have sponsored a show

that rang up about a million dollars' worth of sales would be the understatement of that art season. They were no happier than Rockwell, though. He didn't own many of the paintings on sale, but he received something that night that meant far more to him than money. Like the rest of us, he is fond of approbation. As he once admitted, "I can take a lot of pats on the back. I love it when I get admiring letters from people. And, of course, I'd love it if the critics would notice me too."

That night he received many pats on the back. If the critics, for the most part, couldn't bring themselves to go that far, at least they had showed up for the party—a tacit admission that Norman Rockwell could not be totally ignored. There was no longer any doubt that he had attained a special niche—not alone as an illustrator, but as a fine painter with a rare ability to capture the essence of certain elements in the American character and American life.

After the show, Rockwell plunged into a busy schedule of assignments. One of special importance to him resulted from an idea he presented to the editors of *Look* magazine. They responded to it enthusiastically, and as a consequence he spent Christmas Eve of 1969 in Bethlehem, then as now a place of bitter tensions between nations.

Never a very religious man in the orthodox sense, Rockwell nevertheless has always been firm in his belief that all men should show reverence for their Creator and kindness toward each other. In Bethlehem during that holy season, he made many photos and some sketches of a scene that impressed him deeply. He felt that this view of pilgrims coming to worship in a procession guarded by armed warriors might also be a moving one to other thoughtful people who had a dream of universal brotherhood and peace.

On his return to the United States, he reconstructed his reference material into a full-size cartoon in pencil of the entire panorama he had witnessed in Bethlehem. Then he worked for many months to transform it into a painting. This creation, *Christmas in Bethlehem*, was reproduced in the December, 1970, issue of *Look*. The painting now hangs in the Old Corner House Museum in Stockbridge.

Thinking back on it, he commented, "Maybe we'll never see that dream—peace on earth. But we have to keep hoping . . . and trying."

While Rockwell was working on his Holy Land painting, a leading publisher of art books was busily preparing a comprehensive view of all of the artist's works. Recognizing the unique appeal of Rockwell, publisher Harry Abrams commissioned Thomas S. Buechner, then director of the Brooklyn Museum, to put together a book that would show and describe Rockwell's paintings. Published in 1970, this huge volume, which weighed almost ten pounds, sold like no coffee-table book ever had before. At a time when the publishing world was still convinced that "not many people are educated enough to buy art books" and that "super-sized books sell only in small quantities," this one shook up the whole bookselling establishment. It racked up dollar sales greater than the combined hard-cover and paperback editions of *Love Story*, then being acclaimed as the bestselling novel in a decade.

Mr. Rockwell had become a literary lion as well as the much sought-after painter of the people of America. He couldn't quite believe it. On some of the many television shows where he was eagerly welcomed as a guest, he often expressed his complete amazement over the fact that anyone would want to read "about an ordinary old codger like me."

In the decade of the seventies, the wave of admiration and affection for Rockwell surged higher than ever. Another big retrospective exhibition of his work was arranged. Featuring about eighty of his works, it opened at the Museum of the Arts in Fort Lauderdale, Florida. From there it traveled to the Brooklyn Museum, then to the prestigious Corcoran Gallery of Art in Washington, D.C., and on to the leading museums in San Antonio, San Francisco, Oklahoma City, Indianapolis, Omaha, Seattle, and Philadelphia. Everywhere, the crowds thronged in and went out smiling. During their walk through the show, they had lost themselves for a while in nostalgic views of the great days of America, painted with gentle humor and precise virtuosity—and in views of themselves, with all their hopes and dreams mirrored with compassionate understanding.

At about the same time came the first attempts to make Rockwell's paintings available in the form of high-quality lithographs. Those who could not see his originals at a museum would now be able to look at—or to own—the next best thing. Unlike the many cheap, poorly printed copies of his art which had been circulated over the years, these would be produced carefully in many colors on quality paper. Now published by Atelier Ettinger in New York and distributed through galleries, these limited-edition prints are all authorized by Rockwell, checked by him, and hand-signed by him. Some limited-edition collotypes are also authorized and signed by him.

Early in 1970, Rockwell was also introduced to another form of limited editions, for which he would create entirely new art. It was then that I, as fine arts director at the Franklin Mint, contacted him to find out if he'd be interested in working on a unique new product—an etched silver Christmas plate. His answer was, "I'm always willing to try something new—if I can do it."

That was the beginning of a long and pleasant relationship between America's favorite artist and the leading marketer of collectibles. That first silver Christmas plate proved to be so popular that it practically spawned a new industry. One marketer after another rushed to copy the idea of reproducing an artist's design on silver; none, however, ever came close to Rockwell's inimitable holiday scene.

The next summer, he experimented further in creating art in silver. This time he created the ideas and designs for a series of commemorative medals—the first time he had ever ventured into that field. The result was a series of twelve medals honoring his good friends of long standing—the Boy Scouts. Called the Spirit of Scouting, these medals pictured the twelve elements of Scout law and quoted those basic rules on their reverse sides. These first official Boy Scout medals were minted in February, 1972, nearly sixty years after the time Rockwell produced his first works of art for that organization.

Those first experiences in creating art for limited-edition collectibles encouraged him to try other fields as well. In the succeeding years he produced more than eighty pieces of art for the Franklin Mint, to be used not only in silver products, but also in

These loud singers are townspeople of Stockbridge posing for a carolers' scene which would be etched on a silver Christmas plate. The man with the hat sets the tone. Rockwell often likes to appear somewhere in his pictures.

crystal and porcelain. What started out as a single assignment which he agreed to "have a try at" developed into one of his major activities, to which he devoted a substantial part of his time each year.

Besides the few collectibles he authorizes each year—such as those from Gorham, his pencil-signed lithographs, or projects for organizations like Hallmark Cards with which he has been associated for decades—the marketplace has been flooded with a seemingly endless variety of others. People often ask, "Why does he make all those things?"

Strange as it may seem, Rockwell doesn't get a plugged nickel for many of the products bearing his name that you may see on the shelves of stores. Often they are based on old pictures he sold years ago without reserving any reproduction rights. The present owners can resell permission to reproduce them. Even though the resulting products may bear Rockwell's signature, and even though his name and picture may be used in advertising, Norman may not ever have seen the products. Sometimes he is advised of such reproductions and given a royalty. At other times, he may be surprised to see some old painting of his appear on an item such as a whiskey bottle.

In general, though, Rockwell found his new popularity both pleasant and stimulating. It's so much better to be rediscovered at seventy-five than to be stuck away on the shelf. On every visit, I found Rockwell's studio crowded with new assignments—large paintings, portraits, a calendar picture for the Scouts, drawings for the Mint. He seemed to be getting his second wind. At any rate, he showed no signs of slowing down under the weight of his years.

An example of the amazing energy displayed by the Rockwells, both Norman and Molly, is provided by their activities on a trip they took in 1971. In the fall of that year, my wife and I happened to be in Europe at the same time as the Rockwells, so the four of us arranged to meet for a few days in Switzerland. Molly and Norman planned to head north after their usual first stop in Rome with son Peter, who lives there with his family. We had been in England and France and planned to go south, so it seemed a good idea to let our paths cross in the Alps at a restful spot where we could draw breath for a while before continuing our respective trips. It proved to be a delightful respite for everyone and also gave me a rare opportunity to see Norman completely relaxed, away from the tensions of work that were always present to some degree during our frequent meetings in Stockbridge.

On the very day that we arrived, an incident occurred which demonstrated again the surprising energy and resiliency of our friends the Rockwells.

We reached the hotel, El Mirador, on a Thursday; the Rockwells had checked in on Wednesday. We arrived in the early evening, after a long but enjoyable limousine ride from the

Geneva airport along the lake toward Montreux and then up the slopes of Mont Pelerin. We twisted through quaint little mountain villages, strung one after another like beads on a necklace along the road that crinkled its way through the luxuriant vineyards. As the road climbed higher and increased its convolutions, it seemed as if the long Mercedes limousine could not possibly avoid scraping against the picturesque stone-wall outcroppings we were whizzing past, not to mention the bicyclists who meandered around the curves with complete confidence that our driver would miss them by a few inches.

When we commented to the chauffeur on the hazards he was negotiating so beautifully, he confided to us that this was really the less hilly of the two roads to the hotel and that the manager had ordered him to take it when driving any guests. When he was alone, he said, he always drove a shorter and much steeper route. With that reassurance, we settled back to enjoy the scenery, to speculate on what we'd do when we got together with Molly and Norman, and to wonder what they had been up to all day.

We asked about them as soon as the limousine pulled up to the door of the hotel and our luggage was taken into the lobby. We were told by the manager that the Rockwells had gone "up the mountain" late that afternoon, but had not returned yet, though twilight was beginning to blue the clear Alpine air. After our ride, I thought we were *already* up the mountain, but as I peered out from the portico, it was apparent that there was still a lot of Mont Pelerin looming above us.

"Up there?" I asked, a bit incredulously. "They couldn't ride a bicycle up there, could they?" The hillside above looked like strictly goat country to me.

No, I was told, the Rockwells had not taken a bicycle on the path, for that would be a bit difficult where it really became steep; they preferred to hike up the hillside. I also learned that the paths up to the top of the mountain were marked, but perhaps not clearly enough for a stranger to follow now that the light was failing.

There was little to do but unpack and wait. We did that, hoping that dinner time, which Norman always looks forward to, would

soon pull him back to the gastronomic delights of the dining room at the hotel. After we had changed clothes and returned to the lobby again, however, the Rockwells had still not appeared. The manager was getting as worried as I. It was dark now. The lights in the hotel and in the villas scattered below us on the mountainside presented a beautiful picture, but not a reassuring one.

After about another half-hour of pacing back and forth, I saw a small car whip up to the hotel entrance and stop. I could hear Norman's deep husky voice and Molly talking as the two of them tried to maneuver out the narrow door of the compact automobile. They were effusively thanking the driver and what seemed like half-a-dozen friends who were still packed inside the car. There was a jumble of gay voices in a mixture of French and English as the Rockwells disengaged themselves from their new-found acquaintances.

My wife and I greeted the Rockwells with relief, while the hotel manager mopped his brow after helping to extricate them from the car and expressing his satisfaction at their safe return.

"We were all getting very worried about you," I told the Rockwells. "Where on earth have you been—not climbing mountains this late in the day?"

"Sure," Norman exulted. "It's a great place to climb, but we got lost. Must have taken the wrong turn somewhere, so we just kept going and going." He turned to the manager, "That's a long way up there, you know."

"Well, how'd you get back?" I asked. "Who were the people in the car?"

"Oh, those are some people from a wedding party. It was great fun. We met them in a forest area up the mountain a ways."

"Yes," Molly interjected. "When we were lost we came upon this clearing in the woods, sort of a picnic area. And these people were celebrating after a wedding. They invited us to join them—would drive us back here later because they were afraid we'd never find the way again ourselves. Such delightful people."

"Yeah, they sure are," Norman agreed. "It was fun. But I'm tired. I'm not going to hike that far tomorrow."

We had a quiet dinner that night, and everyone slept well.

The next night at dinner, we were treated to another amusing instance of the Rockwells' easygoing ways, which often confound those who don't know them well.

That afternoon, while we were sunning on the terrace and enjoying the breathtaking view down the steep slope to Lake Geneva, the hotel manager drew me aside. I could tell something was troubling him. He found it a bit difficult to explain. Gradually it became clear that his problem was that he wanted to treat his distinguished guests, the Rockwells, to the very finest examples of his cuisine, but he found it hard to do anything really special for them.

As background, you should know that El Mirador is one of the choicest hotels in all of Switzerland, which automatically makes it one of the most superb anywhere. For example, when Emperor Hirohito of Japan was in the midst of his much-publicized world tour late in 1971, he stopped with all his retinue at a secluded Swiss hotel on a mountaintop for a quiet day of rest from the rigors of his travels. This was the place. Its cuisine, as you'd expect, is a work of art in which the staff takes great pride. The manager, Victor Cerinini, has poured much of his life into developing a unique hostelry, and he wants everyone to enjoy it fully.

As Cerinini explained it to me: "My chef is very sad. He knows that Mr. Rockwell is one of the most famous artists in all the world. He would like to cook something unusual for M. and Mme. Rockwell. The owner of our hotel, Mr. Segel, sent a wire from America advising us that the Rockwells were to be treated as his special guests, so he too wants them to have the very best we can offer. But each night at dinner, M. Rockwell does not want us to do anything out of the way for him. He merely points to one of the regular items on the menu, and says, 'That will be fine for us.' I don't know what I can do."

I laughed, remembering that was what had happened on the preceding night. "We had one of your regular dinner items last night and it was delicious."

"Thank you, but some dishes can be even more delicious than others. We would like to prepare something really special, made to order, tonight."

"That sounds wonderful. What do you have in mind?" I asked.

Cerinini began to describe some blue trout which had been caught fresh that morning, the special sauces he could prepare, and the accompanying vegetables. "It all sounds great," I told him. "You just go ahead and plan to serve whatever you wish in any way you wish. I'll take care of Rockwell. Just don't worry about it."

That evening, I told the Rockwells there would be no menu because the staff wanted to treat them to a special meal. Norman began to demur that he didn't require anyone to fuss for him, but I assured him that it would please the people at the hotel to do so. That made all the difference.

After an appetizer and cocktail, we were treated to an exceptional exhibition of culinary skill, with the headwaiter mixing sauces and flambéing at our table and presenting with a flourish one after another of a succession of delicious treats which we leisurely floated down with a delicate white wine the local vintners cherish too much to export. Despite his original objections about causing anyone any extra trouble, Norman enjoyed the feast as much as anyone. *More*, in fact. He was the only one who finished his dessert.

A trip overseas is nothing unusual for the Rockwells. They generally take one about every four months. As Norman once told me, "Travel is like a tonic to me. It's more than just getting away from the studio for a brief rest. I need it to recharge my batteries. It stimulates me, you know—the meeting new people, getting a new viewpoint on things."

One place the Rockwells return to frequently is Italy. Aside from the fact that the land of the Romans has a matchless charm, it is a favorite with them because four of Norman's grandchildren (and, incidentally, a son and daughter-in-law) live there. Peter Rockwell went to Rome in 1962 to study sculpture. He liked it so well that he and his wife just stayed and began to raise a family there.

The overseas trips almost invariably occur because Norman has become worn down from months of unremitting painting and is much in need of a rest. A few days in Rome with Peter and his family is, therefore, a relaxing place to start. From Rome, the

Rockwells often take side trips to other cities, such as Venice, or Agrigento or Palermo in Sicily. Peter's wife, Cinny, may rent a car to drive them to other cities. They may also visit other Mediterranean countries, like Greece, Egypt, or Turkey. They may head north to Switzerland, Holland, England, or Scandinavia on the route home, if the trip is a long one, although Norman generally begins to get itchy if he stays away from his studio too long.

As Molly once explained, "Norman likes to travel—insists on going *right now* when he decides we need a vacation—but then he simply can't stand being away for any great length of time. It starts about ten days or so after we arrive, usually. I'll still be enjoying myself, but he'll get so fidgety there's just no living with him. So back we go."

Sunny, warm climates appeal to the Rockwells, especially Norman. In midwinter in Stockbridge, when the snow is deep and the winds cold, he'll say, "I have to warm my bones pretty soon." Then you know the Rockwells will soon be taking off for some tropical spot.

The Caribbean is a favorite area of the Rockwells. They have visited many of the islands there, some of them several times. They've been going to Nassau since 1966. They enjoyed a trip to Jamaica early in 1970. They've also stayed at the island of St. Croix and at Little Dix.

On these island vacations, the Rockwells try to get away from the big commercial hotels and find a quiet spot that isn't overrun with tourists and souvenir shops, but this is becoming increasingly difficult. They especially like to be off the beaten track because they go bicycle riding everywhere (yes, *everywhere*) they travel, and it's downright hazardous to pedal along the crowded streets of many resort towns these days.

How do they manage to find bike-riding trails on the occasions when they can't avoid being stuck in a town where traffic is heavy? Simple—though not inexpensive. They hire a taxi, of course, to carry their bikes out to the country for them. The taxi driver delivers them to a good riding path, unties their bikes from the back or top of his vehicle, points them in the best direction, and waits an hour or so until they've had their fill of pedaling and return to be transported back into town. Some of the taxi drivers

on small Caribbean islands still remember the crazy habits of that strange American couple, but Norman has always believed it's important to get outdoor exercise every day without fail. And no doctor would dispute that.

Another unfailing habit of Norman's has been to buy a souvenir at every place he visits. Each time they would return from a trip, another curio would go up on the wall in his studio; Molly never would allow them in her house. Often they'd run to rather garish colors; after all, you should pick happy colors on a holiday. Norman also has indulged his penchant for picking up old, worn items of clothing—things like beat-up hats, of which he must have acquired a dozen from various countries.

Once, in Nassau, Norman was photographed casting a covetous eye upon a rose-covered bonnet worn by a hackie's horse. (I don't know if he was able to buy it or not; I've never seen it in his studio. Maybe Molly burned it.) Molly told me the hansom driver couldn't believe that Norman really wanted to buy an old horse's hat, perhaps thought he wished to purchase the nag instead. This habit of buying old costume items may hark back to Norman's practice over the years of keeping items of clothing handy for use by his models. He always wanted costume items that looked worn and therefore realistic. But a horse's hat?

In addition to the Caribbean islands, another warm spot that always attracted the Rockwells is Mexico. They've been to Cuernavaca once though they found it too commercial. They tried Oaxaca in 1971, hoping to find a more unspoiled place, but then moved on farther out in the countryside to Mitla. They loved it there.

At Mitla, the Rockwells stayed at an old hacienda where the guests consisted mostly of archaeologists working in the surrounding country. It was a charming place, built around a large courtyard filled with flowers.

As you might suspect, the Rockwells' vacations often turn out to be busman's holidays. It's not that Norman particularly wants to work while he's away from the studio, but he sees new scenes he simply can't resist painting.

Knowing that he has produced many loose, sketchy landscapes on his trips—both watercolors and oils—I once asked Molly if

Norman always takes his paint box or sketch pad along. That brought forth an explosion of indignation from her.

"No, he doesn't," she exclaimed. "He leaves his paints and pad at home because he's so stubborn. And then we spend two or three days trying to find some art materials after we get to our destination. I was just furious with him on our trip to Wyoming [in August, 1973]. He said, 'I'm not going to lug that big sketch box with me this time. I haven't used it the last couple of trips so what's the use.' But no sooner did we get out to the Grand Tetons than he said, 'I never imagined they would be like this. I have to paint this scenery.'

"Now, mind you, I had shown him pictures of the Tetons before we left, so he certainly should have known they were very scenic. And I reminded him that he might have some watercolors already in his suitcase; he'd said he was going to pack some. But Norman told me, 'No, I can't find any watercolors in my luggage. And this is no country for watercolors anyway.' So off he went to town. And you know what he came back with? A box of watercolors because he hadn't been able to locate anything else in the shops. Well, *I* looked in his suitcase then, and, sure enough, there were a few things—two or three brushes, some pencils, a pad too small to use and one other that had been water-soaked before he put it in, so he really couldn't use it.

"He looked at those things and the watercolors he'd just wasted a day shopping for, and he said, 'Watercolors are no good anyway here. I'll go back into town tomorrow. There must be another art store somewhere.' It was another day then before he finally located a little set of oils. The sketch he did of the mountains is in oils. He *always* has to spend time shopping for paints, it seems."

At home in Stockbridge, Rockwell never paints landscapes. He is essentially a "people" painter, and he not only has the local townsfolk to pose for him but also many interesting models who come from far and wide to sit in front of his easel. They want their portraits painted, and Rockwell has an inflexible rule—he will not go outside his studio to do the portrait of *anyone* with the single exception of the president of the United States. Not only would it waste the artist's precious time, but, more important, he can't do as good a job on location. And so they come to him. If you

could watch outside the red-barn studio and identify the people who come knocking on the door, you might see the governor of Massachusetts, a famous industrialist or financier, a movie star. Norman welcomes them all with equal graciousness, enjoys getting acquainted with them, gets them more relaxed than some of them have been for many a year. He possibly has more famous friends than Henry Kissinger.

One day at the studio after our work was done, we talked about some of the famous people Rockwell has painted, and also about how he poses them or other models to get the facial expressions he wants. We went back into his storage room at the rear of the studio to leaf through some of the photos from modeling sessions which he keeps in a row of files there.

I had seen him pose models many times, and I knew that those sessions were intense ones in which he wore himself out, yet somehow managed to get his subjects to forget they were on camera so they would pose unconsciously. He is a marvelous mimic, with a "rubber" face which he can move around at will to duplicate any expression. He has the rare ability to make people laugh or smile, and then they're pliable to his demands. This rapport is especially great with children. He really goes all-out as he demonstrates to them, in an exaggerated, slapstick manner, how he wants them to pose. They love it, and they respond beautifully.

We looked at a photo of Rockwell hamming it up with a young model—a Boy Scout who had posed for one of a set of Scout medals. I remembered that photo session and commented on the fun everybody seemed to have that day. Rockwell stated, "That's important—not just with kids, but with older people, too. Maybe even more with them because they're more inhibited. They come in here all stiff and afraid to let themselves go. So I have to act the clown a bit to let them see there is nothing to be afraid of. When they see me capering around, why then gradually they join in a little too."

"They forget where they are, you see, and after that I can get them to take on any expression and not be trying to look dignified. Dignity is not a good expression—not for my pictures anyway."

We came across several more photos which were excellent

At left and below, Norman Rockwell displays the enthusiasm he wants his models to show for a painting of a baseball scene.

At left, Rockwell can be irate. In this and the scenes above, he demonstrates one of the requisites he seeks in a model—the ability to raise one's eyebrows to extreme heights.

At right, two youngsters have a good time. "You must first spend some time getting your model to relax," Rockwell says. "Then you'll get a natural expression." The Boy Scout shown here appeared on a silver medal.

examples of the way Rockwell demonstrates to his models in an overdone burlesque style that gets them to laughing. One, of a young boy all dressed up and heading for Sunday School, made us smile as we noted the grin on his face. We also noted how the toe of his one shoe and the heel of the other had been propped up on ashtrays to give them the right "walking" angle. Rockwell commented that he liked to get everything in the photo in the right position somehow—even the shoes.

In our delving, we uncovered pictures of several celebrities whose portraits had been painted by Rockwell. "The technique of posing them is a little different, of course, than when you're dealing with paid models," he admitted. "I have to get them relaxed, too. But I do it by talking—chatting about most anything at the start so the two of us can get acquainted. And I talk as I sketch, too, in order to keep their minds off what I'm doing so I'll get the most natural expression I can from them. Also, the talking helps me to size up the subject's personality, so I can figure out better how to portray him."

He referred to a photo of himself with President Eisenhower. "It wouldn't be right for me to clown around when I'm painting a president," he said, "like I do when I'm with kids or other models here in my studio. He was a marvelous man to work with though."

Pressed to name a personal favorite among all the presidents of the United States he had painted, Rockwell hesitated to pick out any one above the others. "They were all very nice to me," he maintained. "In spite of being so busy, too. There I was, just an artist, coming along to interrupt them when they had a thousand important things to do. And they were always so understanding. Golly, I don't think I would have been all that patient if I had been in their place."

Finally he did admit to some special partiality toward President Eisenhower. "Of all the people I ever painted, he was just about the kindest, gentlest man I ever came across. Always at his best every time he talked to me. He was very quiet-spoken, and you felt that he was very interested in what you were doing. He would ask questions about what you were doing, like most sitters

do. But he would make you feel like he really appreciated that you were painting his picture. The president, mind you."

"Some of the other presidents were a little more changeable," he observed. "Not that they didn't have the right, when some fellow named Rockwell came barging into their office with his paint box."

"One time when I painted Lyndon Johnson, you know that we sort of had a few words when he wouldn't smile for me. But the second time I did his portrait he was nice as pie. That was after Peter Hurd had painted that picture that Johnson didn't like. Wouldn't have it in the White House. It was a fine portrait, but it showed the wattles on his cheeks, and Johnson didn't like that. I thinned his cheeks down considerably when I painted the president, and he loved that. He wanted the original oil, and I gave it to him, and he hung it in his private office."

"I wrote a letter to Peter Hurd after that," Rockwell continued. "I told him, Peter, you're a wonderful artist, but when you paint somebody's portrait you have to make 'em look ten years younger and ten pounds lighter, at least! Ha, ha, ha," he laughed in between puffs at his pipe which happened to be in need of its regular every-ten-minutes relighting.

"And the Kennedys, they were great," said Norman, as he held up a photo taken at the Old Corner House with Senator Edward Kennedy in front of a Peace Corps painting which included his older brother, the late president. "Ted stopped down here not too long ago to see me. Course, he's the senator from Massachusetts, you know. I always admired President John Kennedy very much. He had a marvelous personality. A great, strong face to paint, too. I painted his wife also—Jacqueline—a very beautiful lady."

"Robert Kennedy was the one though I guess I enjoyed painting the most. His hair fascinated me. That wild, curly hair was something else again. I made a real study of his hair. They all have wonderful smiles, too, that whole family. I felt just awful when the president was killed. And then Bobby. What a terrible thing. Two fine young men."

Rockwell was silent for a long while. He continued to leaf through the sheaf of pictures I had put before him without making any comments. Then he picked up one of Walter Brennan.

"Omigod," he said, "look at this one. That Walter Brennan was a scream. We had so much fun I couldn't get any painting done when he was up here at the studio."

"And you know," he continued, "when Brennan first came in the door, I didn't think he looked like a cowboy at all. I was disappointed in him. He was all dressed up in a neat business suit with a tie and everything, just like a conservative businessman. I was supposed to paint a picture of him for the Cowboy Hall of Fame out in Oklahoma City. He's been in cowboy movies for so many years you know, and on television.

"I said to myself, he doesn't look like any cowboy I ever saw. Well, he fooled me. Soon as he got in the door, he took off his tie and coat, and he put on a big Texas hat and a leather sort of jacket. And he let out a whoop like a wild Indian. So I put on one of my old Western-type hats, too—that one hanging near the stairway—and we whooped 'er up like a couple of cowpokes.

"Walter really had been a cowboy, too, in his younger days. While he was with me in the studio, he told a lot of stories about the old West. I don't know if you could believe 'em all, but they sure were entertaining.

"He was a tremendously powerful fellow, too, that Brennan. A big man and even at his age—he was as old as I was—still strong as a bull. He and Louie tried some Indian wrestling while he was here, and he beat Louie. And you know, Louie used to be a lumberjack.

"I went to the Cowboy Hall of Fame out in Oklahoma City when the portrait was put up. Had a fine time there—great people, all of them. Did you know that Brennan died, though, a couple of years after I painted him? I think it was in 1972 that he was here."

A photo of Colonel Sanders, the fried-chicken magnate, brought forth a comment. "He showed up here at the studio all dressed in white, just like you see him in the ads. And with that white hair and beard, he really looked spectacular. He's one of the handsomest and most picturesque men I've ever met. No spring chicken either—oh, that's a bad joke. But he's about three years older than I am, you know, though it's hard to realize anyone is."

We examined a photo of astronaut Frank Borman and his wife with Rockwell at the studio. The artist commented that he had

At right, Norman Rockwell, painter of astronauts, visits the Space Center at Cape Kennedy before a rocket launching. Buzz Aldrin wrote of him, "I greatly appreciate the human touch his work portrayed in our space program."

PHOTOS BY M. ROCKWELL

Photos above and at right show an interested citizen at the entrance of a space capsule, then going in, and finally emerging at the top hatch to wave proudly to his less adventuresome friends.

painted many of the astronauts, but generally at the Space Center at Cape Kennedy.

I was particularly interested in a photograph of Rockwell with Adlai Stevenson, because it showed Rockwell making a sketch as they talked, using a magazine as a support for his sketch paper. The artist remarked that the senator had been an exceptionally charming and interesting man to meet.

"They mostly all are, though," he reflected. "One of the best parts of my job is to meet so many famous people. They seem to be relaxed and extra friendly when they're having a portrait done. Maybe because it's a little break in a busy day. Even the tough ones have been nice to me. They make wonderful models, too. That's because they got where they are because they're strong individualists, and that shows in their faces.

To provide some idea of the scope of Rockwell's famous friends, I asked him to recollect a partial list. It consisted of Presidents Eisenhower, Johnson, Kennedy, and Nixon, as well as their First Ladies. It contained senators such as Hubert Humphrey, Barry Goldwater, Robert Kennedy, and George McGovern and Governors Reagan, Nelson Rockefeller, Sergeant, and Saltonstall. It included heads of state like Nehru, Nasser, and Tito; U.S. astronauts and space scientists, including Gus Grissom, Neil Armstrong, Edwin Aldrin, Michael Collins, James Lovell, Wernher von Braun; leading sports figures such as Brooks Robinson, Stan Musial, Joe Garagiola, Eddie Arcaro, and Arnold Palmer; and movie stars Frank Sinatra, Bing Crosby, Jack Benny, Bob Hope, John Wayne, Ethel Barrymore, Loretta Young, Linda Darnell, Van Johnson, Walter Brennan, Boris Karloff, and many more. Lassie, too. And I'm sure we missed some other famous personalities.

One of Rockwell's famous visitors in the early 1970s who was enchanted with the artist was Frank Sinatra. In a letter he wrote to me when I informed him about this book, Sinatra said:

When I found he [Rockwell] was going to paint me, I felt like I was dipped in gin. I arrived at Stockbridge on a very hot August afternoon, walked into this marvelous homey studio, and there stood the man in the center of the room . . . open-neck shirt, pair

of trousers that were lovingly aged, and dark brown Keds that had seen better days, battered briar hanging from the corner of his mouth, and truly a twinkle in his eye that would have made St. Nicholas envious. It was love at first sight. We shook hands and I knew I had made a new friend.

Norman and his helper, Louie Lamone, also remembered the Sinatra visit vividly. They knew he planned to fly from Palm Springs to the town of Pittsfield, Massachusetts, in his private plane. He seemed to be just a bit behind schedule on that August Saturday morning in 1972. All of a sudden they heard the explosions of a noisy automobile engine out in the yard. The vehicle clanged to a stop, and they could hear the car doors slam.

Louie recalled that as he moved quickly to the window to see what in the world was happening, he exclaimed, "Migod, it's Frank Sinatra in that old heap—and some other fellow who's all dressed up." Sinatra was very tanned and casually dressed in a yellow pullover sweater.

After the pair in the studio greeted Sinatra and his business agent, they kidded him about his transportation, saying they had expected him to drive up·in a big limousine. The singer told them, no such luck, he was just glad they hadn't had to thumb it to Stockbridge. When they had landed at the tiny Pittsfield airport, they had discovered that it had no rent-a-cars nor· any taxis readily available. Sinatra didn't want to keep Norman Rockwell waiting, so he made a quick deal with one of the airport mechanics, who had his car parked outside the hangar. They rented the car. It was an ancient jalopy, but they didn't care about that so long as it would carry them to Rockwell's studio and back. It had served the purpose halfway, and they trusted that it would make it back to Pittsfield before falling apart.

Sinatra was concerned about the color of his sweater, but Rockwell thought it would be good to have the yellow against the singer's darkly tanned skin. He started his sketches, and Louie set up a camera and took a couple of dozen reference pictures too.

During the sitting, they talked about golf, among many other things. Rockwell told his sitter that he had painted another golfer recently—Arnold Palmer. And Sinatra invited Rockwell to come

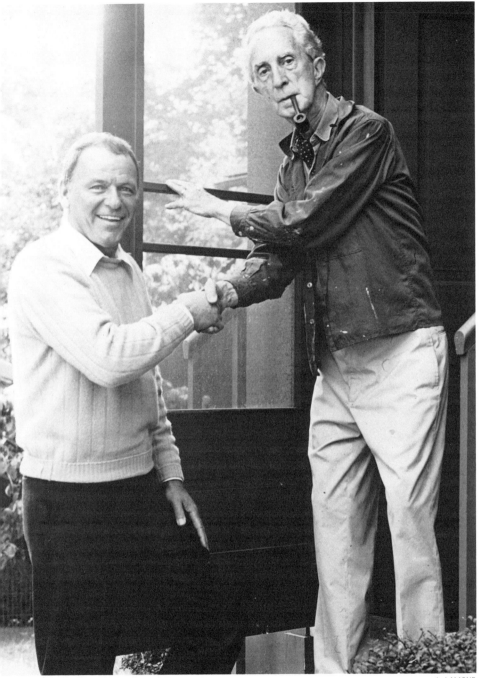

L. LAMONE.

In 1972, Frank Sinatra flew to Stockbridge to meet a man he had long admired. Sinatra's recollection to Walton, "When I found he was going to paint me, I felt like I was dipped in gin."

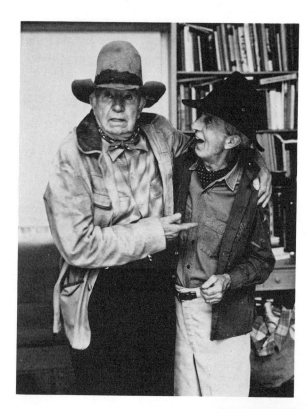

Two old cowpokes laugh it up. The big one on the left is Walter Brennan, whose portrait was to be painted for the Cowboy Hall of Fame. Photo made in 1972.

The king of fried chicken, Colonel Sanders, presents a commission as an honorary Kentucky colonel. Rockwell assesses him as "one of the handsomest and most picturesque men I ever met." This photo was taken in 1973. Sanders was eighty-three at the time.

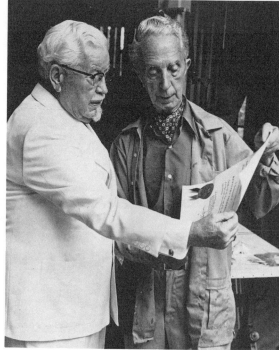

PHOTOS BY L. LAMONE

out and play a game with him sometime at Palm Springs. He was thanked for the invitation but assured that bicycling, slowly, was more the artist's choice these days. Rockwell reminisced that he had played a little golf at one time, but that was fifty years or more ago. Like Sinatra, when the sitting was over, Rockwell knew he had made a new friend.

Another Californian with a movie background came to the red studio in 1973. This was John Wayne, the cowboy actor, who, like Walter Brennan the previous year, was to have his portrait painted for display at the Cowboy Hall of Fame in Oklahoma City. Big Duke Wayne made quite a stir in town the couple of days he stayed in Stockbridge. Reaching skyward six-foot-three, plus about another foot for his high-crowned cowboy hat, and "carrying about thirty pounds extra weight on or off the saddle," Wayne was a truly imposing figure.

He wore his leather western jacket, boots, neckerchief, and hat wherever he went. Walking coatless in the near-zero New England winter weather, he was a figure not to be overlooked as he strolled down the street. In the dining room of the Red Lion Inn, he could be instantly identified by his booming voice.

Artist Rockwell shared one secret about John Wayne with me: "He won't ever take his hat off because he's bald. And that's a good idea because he sure looks imposing with it on."

Naturally, the arrival of someone like Duke Wayne or Frank Sinatra caused a flurry of excitement in Stockbridge. Having Norman Rockwell and his guests around was more fun than a three-ring circus and great for the town's tourist industry. If it wasn't a movie star showing up for a portrait sitting, it might be someone like the fried-chicken tycoon Colonel Sanders, a big-wheel politico, or just some run-of-the-mill Texas oil multimillionaire or Wall Street mogul. In the early years of this decade, there seemed to be a never-ending stream of them coming to visit Rockwell. Along with his other commissions, the portrait trade kept him close to the easel whenever he wasn't off on a vacation break to some new corner of the world.

Although he is polite and considerate to everyone, Norman is not awed by anyone. The only people I've ever seen him treat a bit

brusquely are important clients who overestimate their importance and become unduly demanding.

One instance of this was a telephone call I overheard in his studio a few years ago. The person on the other end of the line was evidently insisting that Norman come to Washington to paint his portrait. The artist had politely tried to explain a couple of times that the sitter must come to Stockbridge instead. He pointed out that this was necessary to insure the best results and also that he had neither the time nor inclination to travel at this particular time.

Finally, after several interruptions, Norman snapped, "Look, I just don't plan to go down there. I only go to Washington to paint the president's portrait. That's because he's too busy to come up here to see me."

"Who was that?" I asked.

"Oh, some senator," Rockwell replied. "I can't remember his name."

Although Norman likes to travel to new places and seldom goes back to the ones he has left, he did allow himself to be coaxed back to New Rochelle for a special occasion. In 1973, the town where he first achieved fame and where he lived for twenty-five years wanted to hold a big celebration for him. They proposed to call it Norman Rockwell Day and even to rename one of its streets Norman Rockwell Boulevard. That was too much to turn down.

It was quite a homecoming for Norman, featuring a ride through town with a police escort to lead the way through the crowds. The car stopped and he spoke to the people briefly, just around the corner from North Avenue, where he had one of his early studios. About a dozen of his former models showed up for the occasion. As the *New Rochelle Standard Star* reported the events (in a column by local writer Dick Tracy), Norman greeted all his old friends who appeared there that day. "Sure, sure, I remember you," he'd say gently to a white-haired lady who in her youth had graced the cover of the *Saturday Evening Post*, "and you're still beautiful."

It was a memorable day for the seventy-eight-year-old artist. He still has in his studio the street sign they gave him to verify that a boulevard in New Rochelle is named after him. But it was a

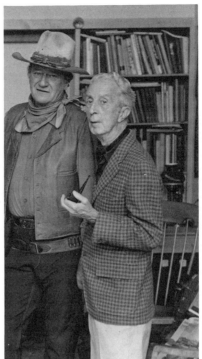

Big Duke Wayne created a stir in Stockbridge in his tall cowboy hat, neckerchief, leather jacket, and boots. He disdained wearing a coat in the bitter New England winter weather.

L. LAMONE

wearing day for a man who hates public appearances and takes little pleasure in looking back. "I felt strange there in New Rochelle," he admitted to me on my next visit with him. "It was like I never lived there, almost. And there were so few people left that I knew. I guess most of them must have died of old age or something." He smiled, ever so slightly and a bit wryly, at himself and at the fact that somehow he was still managing to fight off the braking action of his years and keep the old engine chugging at a respectable speed.

In 1973, a film producer made a movie of him. Someone was always wanting to put Norman and Stockbridge on film. This was a particularly good job, though. It won an Academy Award as the best documentary movie of the year. With a long-experienced actor like Norman in it, what would you expect?

Another movie was made, about a year later, on Norman Rockwell and fellow New Englander Robert Frost. That film, on

"I'm the oldest antique in town," says Rockwell with his wry humor. Here he poses in front of a shop on Main Street, just a few doors from the Old Corner House Museum. As can be seen from reflections in the window and in the photo at right, this is the winter season when the trees are bare and there are few visitors on the streets of Stockbridge.

which I acted as associate director, was also a prizewinner. It was fun for me to work on, because it gave me an opportunity to show my friend Barry Nemcoff and his camera crew some of the marvelously picturesque places I had discovered over the years around Stockbridge. They agreed that my choices were ideal for our shooting and fit the script we had worked out, so we tackled the job in high spirits. The results were well worth while. The film was awarded not only the New York Film Festival gold medal, but also the International Film Festival award as the best documentary of the year.

The year 1974 had a special significance for Norman. The third of February marked his eightieth birthday. As the date approached, he seemed to relish telling people that he would be eighty soon. But he became increasingly aware that the ladies and gentlemen of the press and a throng of well-wishers would be descending on him when the day arrived. That he didn't look forward to.

I happened to be in his studio just a few days before the heralded birthday arrived. At that time, Norman mentioned casually that he was going to be out of town for a week or so. Going down to one of his favorite spots, Little Dix on Virgin Gorda Island, for a rest, he told me, but begged that I not let anyone else know where he was headed.

"You're running away, aren't you?" I analyzed. When he started to grin a bit, I continued with my accusation. "You don't want to be around where anyone can find you when your birthday arrives."

Norman lit his pipe (a great cover-up when he doesn't want to talk). But he was chuckling to himself all the while he was doing it. Finally he took the briar out of his mouth. "Sure," he admitted with a laugh. "I'm not going to be caught around here for any fool celebration. *To hell with birthdays!*"

The trip didn't prove to be a happy one, however. I had an appointment to see him as soon as he came back. Just before I caught the plane to go up to Massachusetts, I received a brief, cryptic telephone call from Norman, who stated little more than that he had "hurt himself" on the trip and would be a little late in seeing me. "Come on up to the studio as scheduled," he said, "but

I'll be delayed a bit in getting there. Have to stop at the doctor's for an examination. If you don't mind hanging around for about an hour, till about three o'clock, I should be back by then."

When I arrived, I saw Norman for a couple of minutes before he left for his doctor's appointment, and he looked very old, scared, and ill. Then I received a rundown from Molly on what had happened during their vacation trip.

One evening shortly before sundown, Norman had left the hotel on the island by himself for what was to be a brief bicycle ride. He hadn't come back, and when darkness had descended and the gates of the hotel had been locked for the night, Molly became really worried. She went to the low wall just inside the gates and called Norman's name as loudly as she could. There was no response, so she climbed over the wall and headed up the road to find her lost husband. You have to know Molly to appreciate the fact that this woman, then seventy-six years old, wouldn't hesitate a minute to scale a wall if it were necessary.

She trudged up the dark road calling for Norman. Finally there was a faint answer from the edge of the ditch beside the road. Norman was sitting there on a rock, exhausted. His bike was still in the bottom of the ditch where it had landed after he had somehow steered off the edge of the road in the half-light of the evening.

After comforting him a bit, Molly headed back to the hotel entrance, climbed over the fence again, and enlisted the help of the hotel staff. A truck was dispatched to pick up the bent bicycle and the slightly bent, but not broken, rider. A doctor who lived on the island was persuaded to come to the hotel to attest to that. He opined that Mr. Rockwell was in pretty good shape, considering.

Norman wasn't too sure of that opinion, however. Every bone in his body ached during the succeeding days, and he couldn't wait to get home and get a confirming opinion from his own physician. He must have received a very thorough going-over from that gentleman, because he was considerably later in returning from the doctor's office than he had estimated he'd be. But when he did get back to the studio, effusive with apologies for keeping me waiting so long, I knew instantly that all was well. Norman was now perky and smiling; he looked ten years younger

than he had when he had departed just a few hours earlier to learn what he expected would be bad news.

He told me then that the fall hadn't amounted to much—really more of a scare than anything. And he declared stoutly that he'd be on his bicycle again in no time. "Because you can't let things of that sort get to you. Like an airplane crash; have to go up again right away before you get afraid to."

He did what he predicted. In a few weeks, he was out bicycling again. But that was a mistake. Evidently his reflexes were far from being back in good working order, because, the next I heard, he had fallen again. And that second fall shook up his whole system badly.

This time, Norman was flat in bed for days, with nursing care around the clock. It was weeks before he could get around by himself, with the help of a walker he could hold onto. But even before then, he kicked up such a storm about being kept out of his studio that he had to be rolled out there each morning. He sat in a wheelchair at his beloved easel. True, his shaken-loose old bones would only let him stay there for a couple of hours, but he stubbornly managed to do some painting each day. He was still a working artist, by God, and nobody was going to forget it!

It was a slow road back to recovery this time—a bad summer. By the fall, though, Norman was beginning to look more like his old self. He was working sporadically again on some big paintings that had been in the back room, partially finished, for a long while. He was doing some new medal designs to commemorate the works of Mark Twain. And he had lined up enough portrait work to keep an ordinary young artist busy for a whole season. No matter what the doctor said, he was prescribing for himself the medicine that had always carried him over the rough spots in his life. *Don't worry; just work.*

For a long time, he kept the wheelchair in his studio. It became a handy means of moving about at the easel without getting up or expending any effort. Another new contraption appeared in the back room. It was a sturdily bolted-down exercise bike. No more freewheeling down the hazardous highways. He pedaled on the machine faithfully every day until his legs and back gradually became stronger and he could get around quite well again.

Then he and Molly decided to do some traveling again. In August of 1974, they went to Quebec; to Granada in October; to Nice in December. In February of the following year, it was to Puerto Rico; to Vancouver in July and August. Then in May, they took off for a trip to Rome where they could see Cinny, Peter, and the grandchildren and soak up some healing sunshine away from the chill October breezes of New England. The trip did Norman a world of good. He returned with a beautiful tan, and about as relaxed as he ever lets himself become.

Gradually he accelerated back into the swing of his work. He kept painting away at a large oil of Abraham Lincoln posing for early photographer Matthew Brady. At intervals he'd bring out another large painting of one of the founders of Stockbridge, the Reverend John Sergeant, talking to an Indian chief. This was also a long-term project. In 1975, he completed his fifty-sixth Boy Scout calendar, to be issued in the following year. He labored away industriously at various smaller jobs, too. Although he never recovered his old stamina and speed, he never stopped trying. In February of 1976, his eighty-second birthday came and departed, but he was still out at the easel for a good part of each day, doing his best.

In this respect, he reminded me of the many other master painters who simply would not give up their art no matter what Father Time or their infirmities did to dissuade them. His doggedness was much like that of Titian, who reportedly retained his interest in his workshop until his death in his eighties or of Renoir, who in his seventies strapped his brushes to the arthritic fingers that could no longer hold them.

One day at the studio while I was helping him lift a heavy, framed painting (the one of John Sergeant) back up onto his easel for some additional touch-up, I made reference to the fact that old artists never quit and seem generally to live to an exceptional age. That brought a smile to the face of the frail old man, even though he was puffing from his exertions in securing the easel clamps on the huge painting. When we had everything adjusted to his liking, he plopped himself down in his chair and expounded briefly on the longevity of his peers.

"I guess a lot of us painters do last longer than most folks," he

L. LAMONE

A quiet walk in the yard with Molly. The tall north windows of the barn-red studio form a backdrop. Just a few yards to the right, the ground drops off steeply to a broad meadow where the Indians used to hold their council meetings.

observed. "Why is it? Well, maybe the secret to so many artists living so long is that every painting is a new adventure. So, you see, they're always *looking ahead* to something new and exciting. *The secret is not to look back.*"

Sometimes, though, it is pleasant even for a Norman Rockwell to take a day off to look back over the memories of a satisfying career. The admiring citizens of Stockbridge and environs asked him to do that on Sunday, May 23, 1976. They wanted to hold a celebration in his honor on that day.

The occasion of Norman Rockwell Day went very well. The sun shone warmly on Stockbridge that Sunday afternoon. More than ten thousand people turned out to honor the distinguished neighbor who had made them and their streets and buildings famous through his pictures. There was a parade that lasted

nearly two hours: bands; balloons; floats recalling subjects he had painted, such as Lindbergh's flight over the Atlantic, the Boy Scouts, the Four Freedoms. Many floats attempted to reconstruct favorite magazine covers from long ago.

Norman watched the whole proceeding while seated in a comfortable wicker chair on the reviewing stand. With him were his wife, Molly, and his two sons who live nearby, Jarvis and Thomas. They often waved at people they knew in the line of march, and there were many of those—including people who had driven all the way from Vermont to honor their old friend on this special day.

It was an exhausting day. Much harder than working with his paints in the quiet of the studio in the back yard on South Street. But Norman wouldn't have missed any of it.

At the end of the afternoon, when the last float had passed by and the barbershop quartet and the high-school band and the Girl Scout and Boy Scout troops had headed for home, the guest of honor was helped down off the high reviewing platform. The photographers and reporters were still there. His comment to them was, as usual, brief but sincere.

"I'm tired but proud."

The Rockwells, with their dog, send you best wishes, in a Christmas card design used by them several years ago.

Epilogue

Few artists have ever created a body of superlative work to compare with that of Norman Rockwell. He poured his energy, and his heart, into his painting, without stint and seemingly without end. But for any man, even a giant among men, there comes a time to rest. Though we might like Norman Rockwell to continue to create his gladsome pictures for us forever, no one can begrudge him the quiet time he enjoys these days, now that he visits his studio but seldom. There are many happy memories for him to recall. We are pleased at that, for he has been a source of pleasure, and of inspiration, to a multitude of us. Certainly he has been an inspiration to the author, who hopes, above all, that this book may serve to give readers a closer insight into a very special person. We love you, Norman.

A Rockwell Portrait: An Intimate Biography
by Donald Walton
Designed by Emily Schossberger.
Photo layouts by Dorothy Chaisson.
Composition was done by "Letters" Inc., Wichita, Kansas, in various sizes of VIP Aster.
Color separations were done by Chroma-Graphics, Inc., Kansas City.
The color insert and jacket were printed by McWhirter Company, Kansas City, on Warren's Lustro Offset Enamel Dull Cream, 80 lb.
The text paper is Warren's antique, 60 lb.
The printing and binding were done by Interstate Book Manufacturers, Inc., Kansas City.
The cover material is Joanna Western Kennett.
Endsheets in Multicolor Antique Cafe by Process Materials.